GLAMOUR

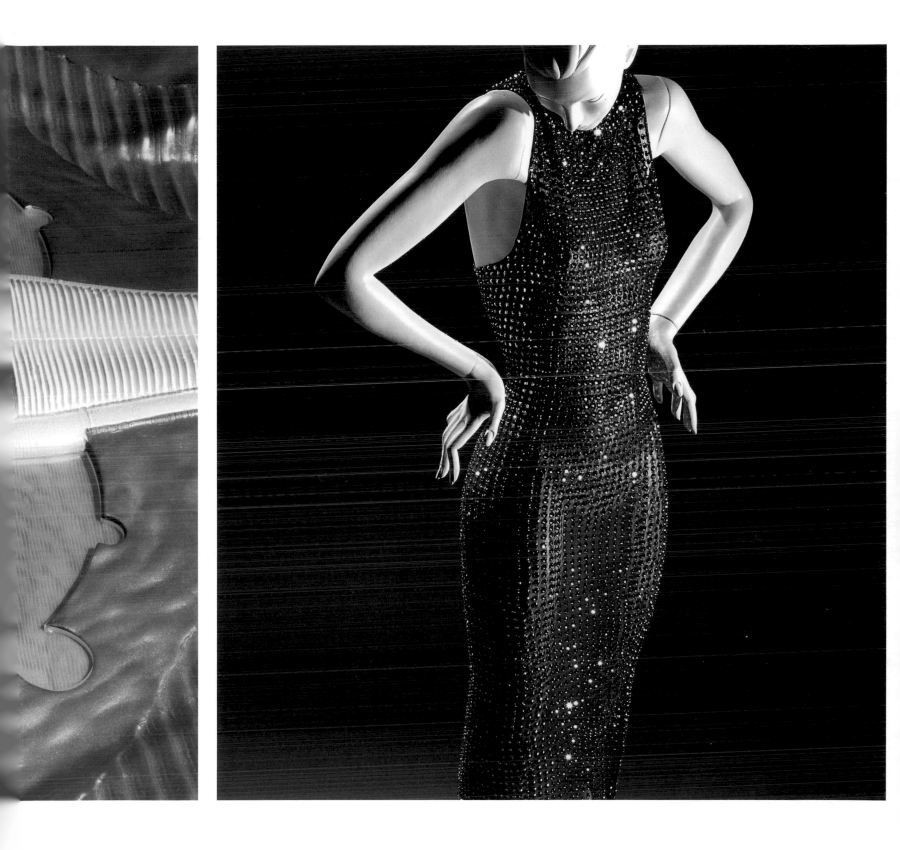

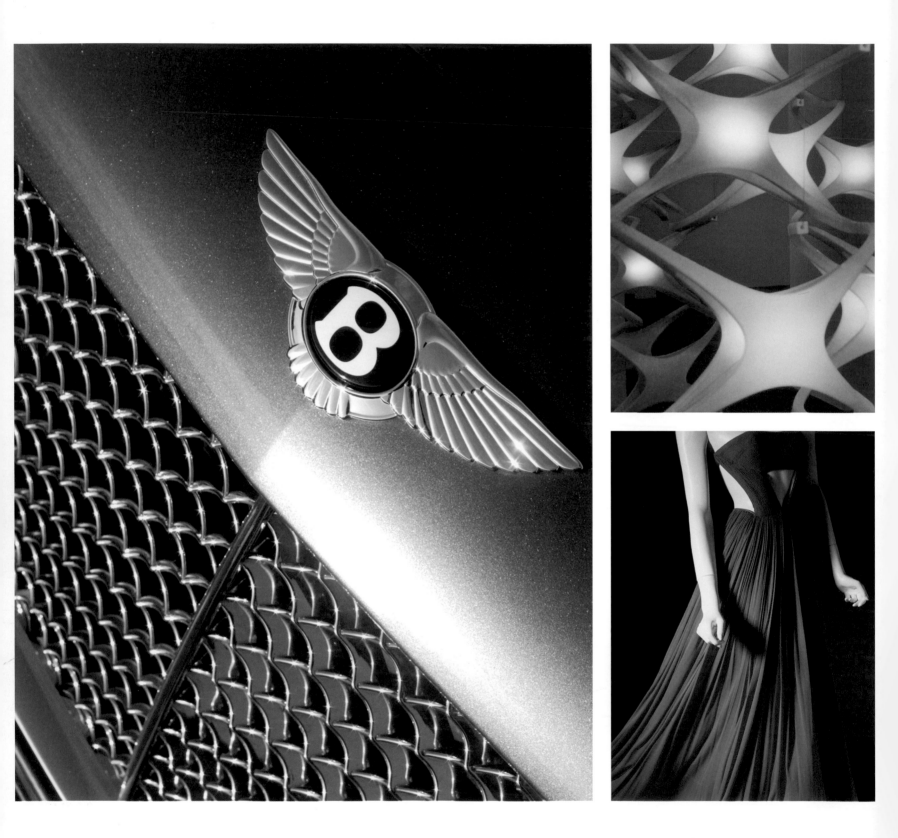

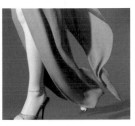

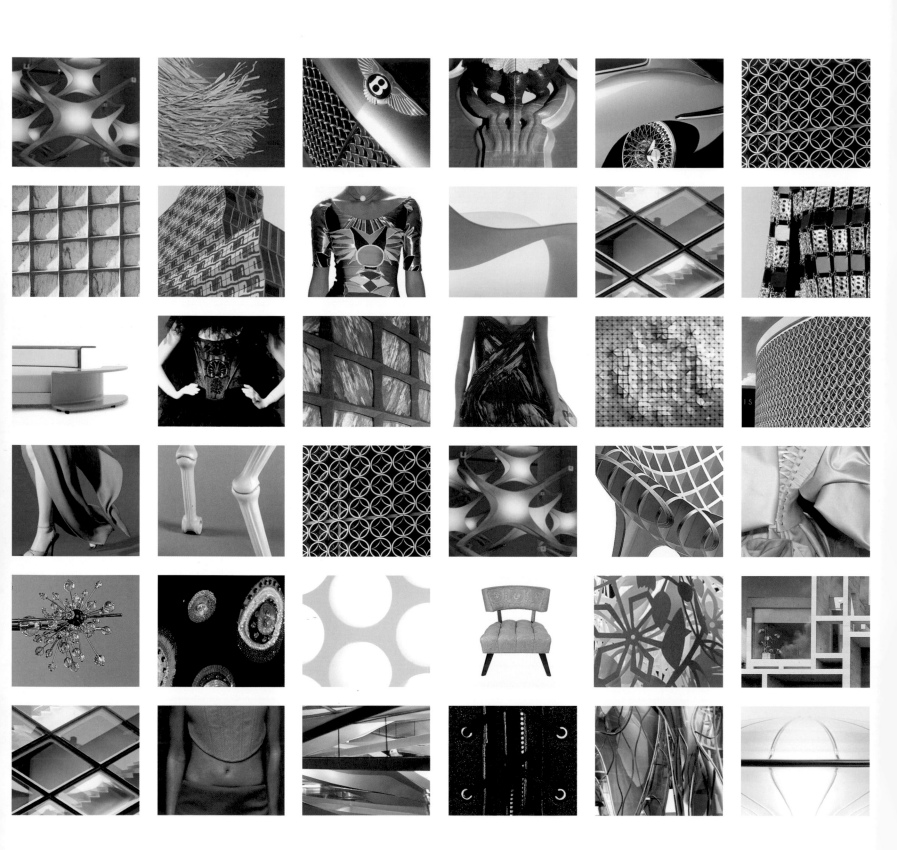

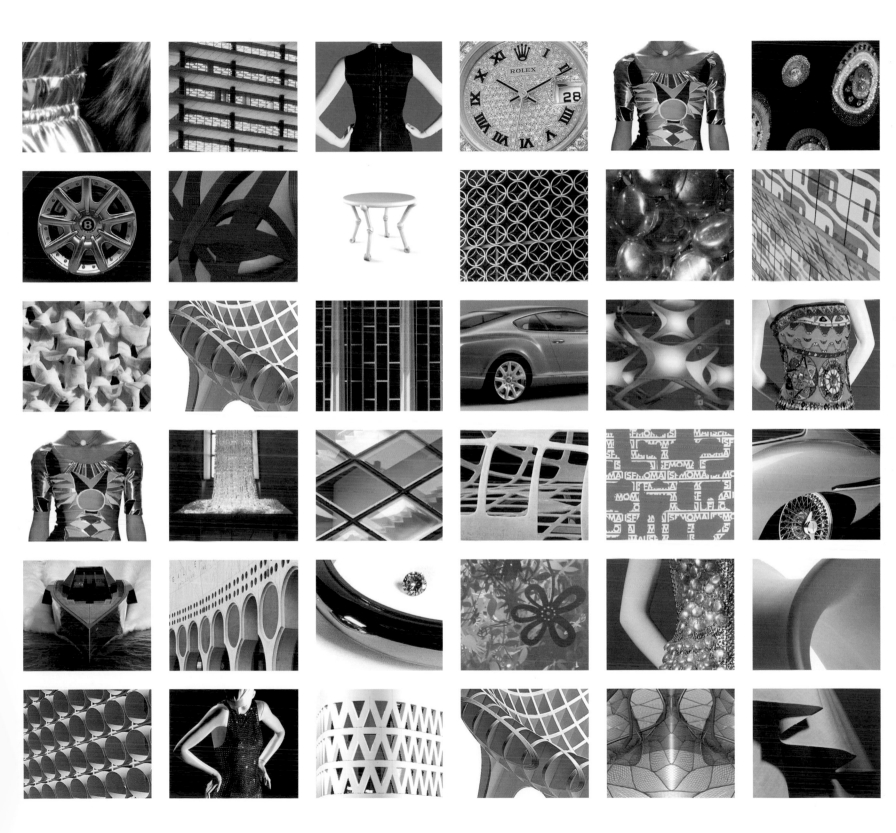

EDITED BY

JOSEPH ROSA

PHIL PATTON VIRGINIA POSTREL VALERIE STEELE

GLAMOUR

fashion + industrial design + architecture

SAN FRANCISCO MUSEUM OF MODERN ART

IN ASSOCIATION WITH

YALE UNIVERSITY PRESS, NEW HAVEN AND LONDON

This catalogue is published by the San Francisco Museum of Modern Art in association with Yale University Press on the occasion of the exhibition *Glamour: Fashion, Industrial Design, Architecture*, organized by Joseph Rosa for the San Francisco Museum of Modern Art and on view from October 9, 2004, through January 17, 2005.

Support for this exhibition has been generously provided by Elaine McKeon, the Estates of Emily and Lewis S. Callaghan, Carolyn and Preston Butcher, and an anonymous donor with additional funding from AT&T.

This publication is supported by a grant from the Graham Foundation for Advanced Studies in the Fine Arts.

Library of Congress Cataloging-in-Publication Data

Glamour : fashion, industrial design, architecture / edited by Joseph Rosa ... [et al.].
 p. cm.
 Catalog of an exhibition at the San Francisco Museum of Modern Art Oct. 9, 2004–Jan. 17, 2005.
 Includes bibliographical references.
 ISBN 0-300-10640-8
 1. Fashion design—History—20th century—Exhibitions. 2. Design, Industrial—History—20th century—Exhibitions. 3. Architectural design—History—20th century—Exhibitions. 4. Architecture, Modern—History—20th century—Exhibitions. 5. Aesthetics, Modern—20th century—Exhibitions. I. Rosa, Joseph. II. San Francisco Museum of Modern Art.
 TT507.G553 2004
 745.2'09'0407479461—dc22
 2004010757

Director of Publications: Chad Coerver
Managing Editor: Karen A. Levine
Designer: Jennifer Sonderby
Production Manager: Nicole DuCharme
Publications Assistant: Lindsey Westbrook

Printed and bound in Italy by Graphicom

Jacket, clockwise from top left: Emilio Pucci, Two-Piece Gown, ca. 1965 (detail of pl. 10). Malcolm Sayer, Jaguar Series 1 E-Type Fixed-Head Coupe, 1965 (detail of pl. 31). Herzog & de Meuron, Prada Aoyama Tokyo, 2003 (detail of pl. 65). Giorgio di Sant'Angelo, Gown, ca. 1986 (detail of pl. 14). Greg Lynn, Ark of the World Museum Project, 2002 (detail of pl. 73). Rolex, Oyster Perpetual Lady Datejust Watch, 2002 (detail of pl. 45)

Page 12: Hernán Díaz Alonso, Landmark Tower/U2 Studio Project, Dublin, 2002

Pages 2–7, 186–91: see photography credits on pages 184–85

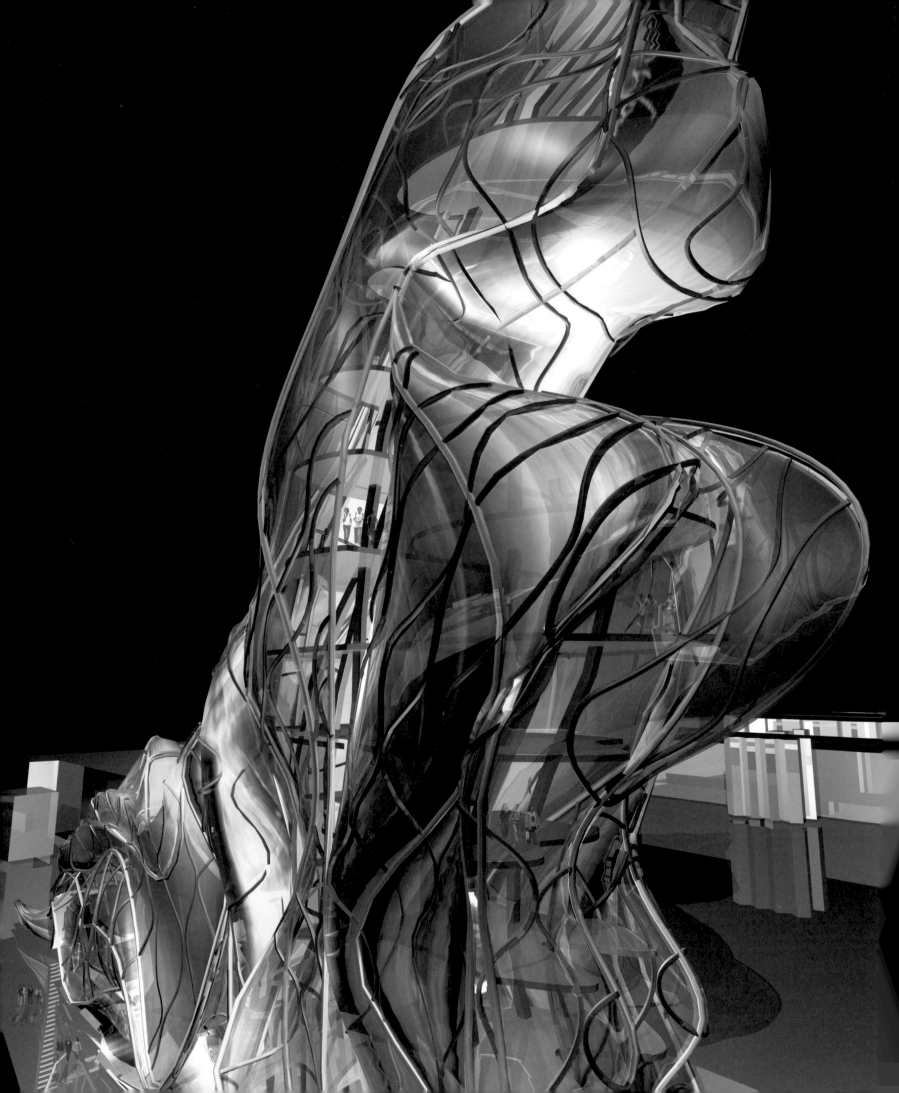

DIRECTOR'S FOREWORD

by NEAL BENEZRA

Most of us think we know glamour when we see it. Conditioned by cinema, advertising, and other aspects of visual culture, we tend to associate glamorous people, places, and things with a certain aura of luxury, perfection, and unattainability, both idealized and alluring. Readers who opened this book expecting to find the legends of the silver screen or other such archetypes of glamour should prepare to be surprised. For Joseph Rosa, SFMOMA's Helen Hilton Raiser Curator of Architecture and Design, glamour has much richer connotations. This ambitious exhibition puts forth glamour as a new critical category for designs distinguished by extravagant patterning and complex structural forms, from the flamboyant creations of couturier John Galliano to the imposing civic architecture of Rem Koolhaas.

Glamour: Fashion, Industrial Design, Architecture, one of the largest design presentations ever mounted at SFMOMA, brings together a diverse selection of more than one hundred examples of gowns, cars, jewelry, lighting, furniture, installations, digital drawings, and architectural models that together give concrete form to this intriguing curatorial thesis. Addressing glamour's origins in the boom years of postwar America as well as its more recent innovations in the hands of digitally savvy avant-garde designers, the exhibition offers a vivid exploration of the aesthetic as it has evolved over the past half-century, demonstrating how tendencies such as ornate decoration, seriality, tattooing, and scalelessness flouted modernist dictates of "form follows function" while crossing disciplinary boundaries.

Providing a fitting complement to the exhibition itself, this handsome catalogue underscores the wealth of sources and methodologies that inform the glamour aesthetic. Following an introduction by curator Joseph Rosa, economist and cultural critic Virginia Postrel investigates glamour's mechanisms of meaning and cultural dissemination. Valerie Steele, one of our foremost fashion historians, traces glamour's roots from the costumes of the nineteenth-century demimonde through the golden age of Hollywood and beyond, exploring glamour as a convergence of gender, performance, and celebrity. Noted design critic Phil Patton addresses postwar culture's fixation on consumer goods as a means of expressing identity, with a particular focus on the glamour of branding and customization. Finally, the exhibition's curator identifies the emergence of the glamour aesthetic in projects by postwar architects who eschewed the "purity" of the International Style in favor of visual expressions of "sensual delight." Once considered vulgar or merely decorative, such work has proven highly influential for contemporary architects, who are exploiting digital technologies to transform features that were once simply ornamental into elements that are integral to a building's structure. These

13

informative essays are accompanied by abundant plate reproductions and focus texts by curatorial associate Ruth Keffer, who does much to illuminate how the glamour aesthetic has progressed in each discipline. We are grateful to all of the catalogue contributors for sharing their ideas during the development of the exhibition and for lending their time and expertise to the publication.

An exhibition of this scope cannot be undertaken without significant financial support. On behalf of everyone at the Museum, I would like to thank Elaine McKeon, former chair of SFMOMA's Board of Trustees, for championing *Glamour* from the project's inception. Additional funding for the exhibition was provided by the Estates of Emily and Lewis S. Callaghan, Carolyn and Preston Butcher, an anonymous donor, and AT&T, and the publication was underwritten by a prestigious grant from the Graham Foundation for Advanced Studies in the Fine Arts. We are grateful to all of the exhibition's sponsors for their generous support.

A dedicated group of SFMOMA staff members helped to bring this presentation to fruition. Ruth Keffer, curatorial associate for architecture and design, was closely involved in every aspect of the project, and her insights have been vital to the conception of the installation and catalogue. Ruth Berson, deputy director, exhibitions and collections, oversaw the complex logistics of mounting the exhibition, aided by Jennifer Spilly, exhibitions coordinator, and Jessica Woznak, administrative assistant. From mirrored runways to crystal chandeliers, Kent Roberts, exhibitions design manager, helped to translate the *Glamour* concept into three dimensions. Alexander Cheves, senior museum preparator; Steve Dye, exhibitions technical manager; Noah Landis, exhibitions technical assistant; and Greg Wilson, senior museum preparator, served crucial roles in the installation process. Jill Sterrett, director of collections and head of conservation; Michelle Barger, objects conservator; and Gwynne Barney, Elise S. Haas Advanced Fellow in Conservation, dedicated considerable resources toward the safety and preservation of a wide range of design media, from delicate peau de soie to vintage automobiles, and their colleague DeAnn Barlow, assistant registrar, exhibitions, resolved the sizeable challenges related to transporting the works. Libby Garrison, acting director of communications, generated significant media exposure for *Glamour* in advance of its opening, while Gregory Sandoval, manager of adult interpretive programs, developed the educational programming that accompanies the exhibition. Andrea Morgan, associate director of development, foundation and government support; Lynda Sanjurjo-Rutter, associate director of development, individual giving; Stacey Silver, associate director of development, corporate partnerships; and Jeanna Yoo, associate director of

14

development, membership, facilitated the financial and community support that made this presentation possible. In the Department of Architecture and Design, curatorial associate Darrin Alfred and administrative assistant Amy Ress played significant roles in the development of the exhibition, as did interns Alexandra Magnuson and Kristin Tang. Working closely with SFMOMA staff, consultant Cara Storm oversaw the Museum's marketing efforts on behalf of *Glamour*.

Thanks are also due to SFMOMA's talented publications and design team, overseen by director of publications Chad Coerver, for their painstaking work on the catalogue. Karen Levine, managing editor, supervised all matters related to content and production, working closely with the curator and contributors to develop their essays. Jennifer Sonderby, head of graphic design, devised the book's innovative design, proving that glamour's characteristic patterning and complex folding motifs can also be translated into graphic form. Production manager Nicole DuCharme helped to make this vision a reality, cheerfully accepting the challenge of printing a book with such unusual processes and materials. Lindsey Westbrook, publications assistant, proved herself to be a photo editor extraordinaire, tracking down everything from concept cars to paparazzi pictures with her typical thoroughness and eye for detail. We are also grateful to Patricia Fidler and her colleagues at Yale University Press for their unflagging enthusiasm for the project.

The *Glamour* project has benefited from the input and assistance of dozens of museum colleagues, historians, and members of the design community. Joseph Rosa would like to extend his personal thanks to the following individuals for their advice, friendship, and support: Mardges Bacon, John Crawford, Brad Dunning, Brooke Hodge, Alan Lapidus, Jane Loeffler, Judy McKee, Frédéric Migayrou, Garth Norton, Liz O'Brien, Jennifer Raiser, Terence Riley, Mark Robbins, Louise Lavenstein Rosa, Katherine Ross, Peter Schifando and J. Jonathan Joseph, J. Lucian Scott, R. E. Somol, Erica Stoller, Ned Topham, Rita Watnick and Michael Stoyla, Esther Zumsteg, his fellow SFMOMA curators, and the students in his spring 2003 and 2004 seminars at California College of the Arts in San Francisco. The Museum is also indebted to the numerous designers, collectors, and other lenders who have so generously shared their work with the institution.

These acknowledgments would not be complete without warm recognition of SFMOMA Trustee Helen Hilton Raiser for her unfailing support of Joseph Rosa's curatorial vision and of all activities undertaken by the Department of Architecture and Design.

introduction: FABRICATING AFFLUENCE

by JOSEPH ROSA

*Beauty is not glamour…. It is about the persistence of longing. Glamour is about the
external sign—the commercial logo—and has little to do with the inner-direct concerns
of artists other than as subject matter for some expropriation of popular culture.*
—Robert C. Morgan, "A Sign of Beauty," in *Uncontrollable Beauty: Toward a New Aesthetics*[1]

*[Under John] Galliano's [direction there is] a changing idea of who the Dior customer
might be, with the notion of Lil' Kim as the woman of glamour, as opposed to the
"old" couture notion of taste and aristocracy that [once] defined the lady of fashion.*
—Caroline Evans, *Fashion at the Edge: Spectacle, Modernity, and Deathliness*[2]

Glamour is a culturally loaded word that, depending on its context, can have either complimentary or pejorative nuances. While the significations and interpretations of glamour are vast in scope (indeed, this volume's contributing essayists come at the topic from a variety of viewpoints), it is most closely equated with visual spectacle, and it gains power from its position outside normative culture.

16

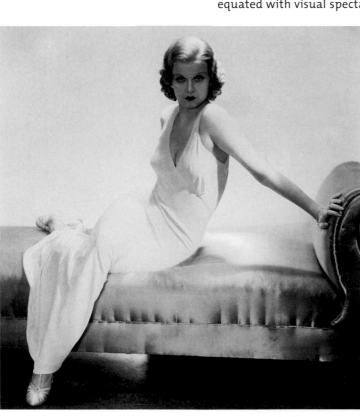

Historically, glamour has figured as the ugly stepsister to elegance, a word that evokes not just old money but etiquette. Today, having shed its somewhat gauche connotations, glamour embraces elegance as well as aspiration, upward mobility, the flexibility of class boundaries, and the state of being self-made, both monetarily and culturally.

While the evolution of glamour is quite complex, its origins are most commonly linked to Hollywood and early representations of women in film. Prior to enforcement of the Motion Picture Production Code in the 1930s, many Hollywood directors depicted the liberated lifestyle of independent single women.[3] Glamour became identified with actresses such as Jean Harlow (fig. 1), Marlene Dietrich, and Joan Crawford, who specialized in playing a certain kind of femme fatale: Wrapped in opulent silk gowns and dripping in diamonds, she toyed with men and ignored the law; her habitat was inevitably a sprawling home or lavish penthouse furnished in the Moderne style. By the mid-twentieth century, however, glamour's associations with "immoral" behavior

figure 1 **Jack Conway**
Promotional photograph for *Red-Headed Woman*, 1932
Jean Harlow as Lillian Andrews Legendre

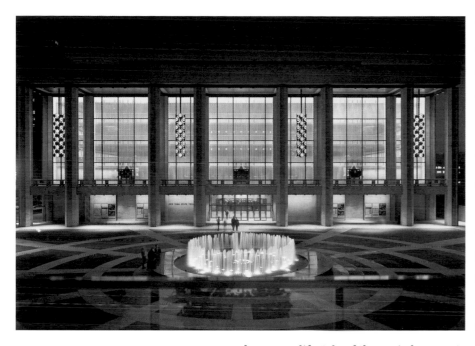

had significantly weakened, and it came to be equated with the industrial renaissance of postwar America, which bestowed unprecedented standards of living on the average nuclear family.

In the 1950s glamour's cachet was firmly bound up in the trappings of the affluent American lifestyle. Although haute couture was considered to be inherently French, its primary clients were wealthy Americans and Hollywood celebrities, and the filmic spectacle of glamour was central to redefining modern fashion. The same could be said of modern architecture and the industrial design sector, which increasingly churned out luxury products for the same audience. The glamorous lifestyle of the period was not complete without a wardrobe of couture by Christian Dior, Adrian, Jacques Fath, and Paco Rabanne; a home in the modern aesthetic, preferably designed by Wallace Neff or Paul Williams and with custom furnishings by William Haines; and a choice of automobiles, including a Jaguar E-Type or Studebaker Avanti. Needless to say, luxury brands and handmade apparel played an essential role in constructing the mid-century notion of glamour.

Meanwhile, operating outside the mainstream spectacle of glamour was the minimalist aesthetic championed by International Style architects. When the movement first emerged in the 1930s, its adherents denigrated any elements that were ornamental or unessential to a design as excessive or ideologically offensive. However, the International Style lost its avant-garde edge in transit from Europe to the American universities, and by mid-century it had become the face of corporate American architecture. In the 1960s the buildings produced by second-generation Modernists were deemed overly decorative and promptly relegated to the margins of architectural discourse. Critical censure, however, did not halt the construction of numerous public and civic buildings that drew on this new decorative modern vocabulary. Two examples that today can be reconsidered as embodying a glamour aesthetic in architecture are Welton Becket's 1964 Dorothy Chandler Pavilion in Los Angeles (pl. 53) and the 1962–68 Lincoln Center complex in New York, designed by Wallace K. Harrison, Max Abramovitz, and Philip Johnson (see fig. 2).

17

figure 2 **Philip Johnson**
New York State Theater, Lincoln Center, New York, 1964

Not until the early 1980s do we see a departure from the model of glamour established by mid-century designers. Predictably, the first significant transition occurred in fashion, as well-known couture houses began hiring young designers to revamp their respective images. The first company to do so was Chanel, with its momentous hire of Karl Lagerfeld in 1983. Lagerfeld's reinterpretation of Coco Chanel's design philosophy repositioned the venerable fashion house and rejuvenated the entire industry. In subsequent years, many other couture houses followed suit as they attempted to appeal to larger shares of the market. The most successful has been Christian Dior, which hired John Galliano

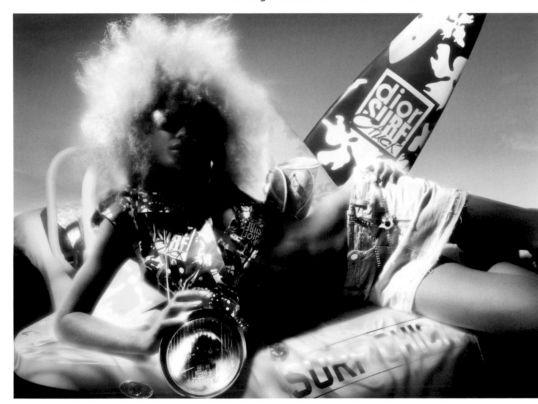

in 1997. Galliano's reinterpretation and deconstruction of the classic 1947 "bar suit"—famous for its extravagant use of fabric—started a new trajectory for Dior. The house now filters its traditional brand through the lens of youth culture, a strategy that informs Dior's spring/ summer 2004 ad campaign (see fig. 3), with its aggressive blend of casual beach-wear and high-end glitz.

As established couture houses were busy retooling their identities, a variety of new personalities arrived on the scene. Designers Gianni Versace, Jean Paul Gaultier, Thierry Mugler, Vivienne Westwood, and Alexander McQueen explored alternative notions of beauty and excess, expanding high fashion's repertoire with references to erotic bondage and punk. Their runway shows became spectacles informed by complex conceptual narratives, displaying little—if any—regard for brand recognition and creating a completely new audience for fashion: people who might not be able to afford it but were well schooled in its languages. Indeed, the notion of glamour in fashion has changed radically since its Hollywood inception; today the glamour aesthetic presupposes familiarity with the history of upscale design, an affinity for street culture, and a desire to take risks. In many ways, the depth and breadth of the contemporary fashion lexicon reflect what may be the most democratic and youth-based culture to date.

figure 3 **Nick Knight**
Photograph for Christian Dior's Surf Collection ad campaign, 2004

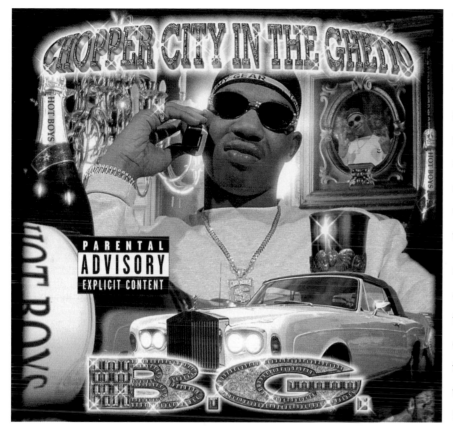

The youthful demographic certainly plays a larger role in the construction of brand identity than ever before. From sports logos to luxury cars, young consumers have been raised on brand recognition. Teenagers know more about status and upward mobility than their parents, and companies are now marketing products directly to them. This age group has been central to the suburban appropriation of "ghetto style" and hip-hop music, which have been widely embraced by consumers who may never experience the realities of urban or inner-city life.

One of the most significant trends to grow out of hip-hop culture is bling-bling—a slang term used to describe all forms of extravagant style, especially ostentatious, diamond-encrusted jewelry. Coined in the late 1990s by the New Orleans rap family Cash Money Millionaires, the word was popularized by former Cash Money member B.G. "Bling Bling," a single off his 1999 album *Chopper City*

In the Ghetto, speaks of striking it rich, material acquisition, and "iced-up," "trillion-cut" jewelry; the design of the album cover itself (fig. 4), with its slick Rolls-Royce, gilded champagne goblet, and dazzling, "bejeweled" typefaces, is an excellent expression of the bling-bling aesthetic.[4] The term has since traveled outside the realm of hip-hop, appearing in the parodies of British comedian Sacha Baron Cohen (aka Ali G.), the *New York Times* column of lexicographer William Safire, and even the *Oxford English Dictionary*. In many ways, bling-bling is the natural culmination of the excessive, in-your-face tendencies of glamour, democratizing and popularizing the aesthetic.

Since its inception, industrial design has operated under two different demographic and economic conditions, fulfilling the demand for handmade luxury items as well as mass-produced objects. In the early days of the discipline, Modernism's minimalist aesthetic was closely tied to the cost-efficient technology of mass production; glamour thus existed only in the rarified realm of handmade furnishings, custom automobiles, and boats. However, by the late twentieth century, the machine aesthetic was ubiquitous and its manufacturing processes dated, threatening its viability as a style for general consumption. At the same time, new digital technologies

figure 4 **B.G.**
Chopper City in the Ghetto, 1999

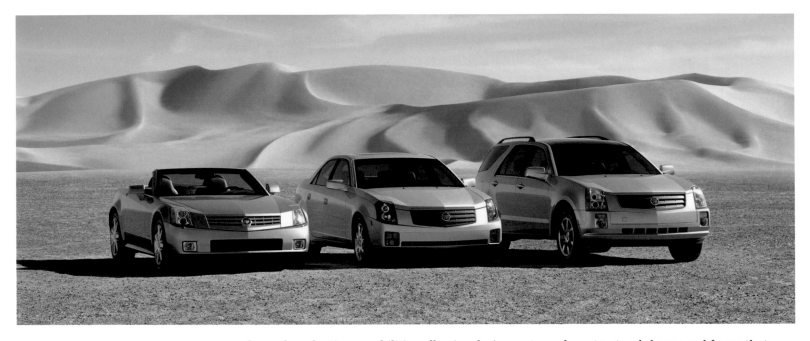

enhanced production capabilities, allowing designers to explore structural shapes and forms that had been anathema to Bauhaus and other modernist ideologies. Many of these digital designs featured gridded or patterned structures or expressed a sense of fluidity of form, as in works by Petra Blaisse, Ronan and Erwan Bouroullec, Ross Lovegrove, Jürgen Mayer H., and Mark Newson. More recently, digital fabrication techniques have allowed the worlds of the handmade and the mass-produced to merge, resulting in hybrid, mass-customized objects—an idea that would have seemed oxymoronic only a decade ago.

The young consumers who have been so influential in expanding the lexicon of contemporary fashion have also had an effect on glamour in industrial design, as demonstrated by General Motors' recent makeover of its Cadillac line (fig. 5)—one of the most successful repositionings of an automotive brand to date. Hoping to attract a more youthful clientele, Cadillac set out to create a concept car uniting aesthetic characteristics that would comprise the brand's future image. Elements from the 1999 Evoq—specifically the grille, headlights, and taillights—were selected as emblematic of the new Cadillac customer. From the features' first deployment on the redesigned Escalade sport utility vehicle to their latest incarnation on the XLR two-seat roadster, they have played a pivotal role in Cadillac's sleek remake of its entire line. More importantly, they have seduced a significant market share of young consumers who would otherwise have purchased a Mercedes or BMW.

figure 5 **General Motors**
Left to right: Cadillac XLR, 2004; Cadillac CTS, 2003; Cadillac SRX, 2004

Another demographic that has helped to shape the aesthetic of glamour is the recently defined "creative class." Richard Florida's 2002 book *The Rise of the Creative Class* traces the growing role of creativity in our economy, a phenomenon driven by the nearly 38 million Americans—more than 30 percent of the workforce—who make their living by creating new ideas, technologies, or content within the fields of science, engineering, architecture, design, education, arts, music, and entertainment. Paying homage to Thorstein Veblen's 1899 publication *The Theory of the Leisure Class* (which played a pivotal role in the critical understanding of glamour and leisure in the early modern period), Florida posits the emergence of a new consumer demographic that is creatively based and aesthetically informed. His argument charts the migration of creative couples, both heterosexual and gay, who are changing the cultural fabric of cities as well as business practice itself. Today companies move to where the employees they want are living; hence, without even knowing it, the creative class is establishing trends that can revitalize a community or even force a company bankrupt.[5]

Other recent publications have played significant roles in documenting similar cultural shifts. Virginia Postrel's 2003 book *The Substance of Style* repositions the value of aesthetics and style as essential commodities for mainstream culture. David Brooks's 2000 work *Bobos in Paradise* looks at newly affluent "bourgeois bohemians"—mainstream products of the 1960s counterculture who celebrate transparency and the lack of hierarchy in work, life, and leisure.[6]

Transparent processes and nonhierarchical frameworks are precisely what distinguish the radical new ideologies ushered in by architecture's adoption of digital technologies in the mid-1990s. Adjectives such as *excessive, tattooed*, and *scaleless*—words once employed to criticize mid-century architecture displaying nonfigurative patterning—may now be used describe the formal characteristics of a new glamour aesthetic in avant-garde architecture, where digital methods of conception and production are enabling architects to translate decorative forms or surfaces into load-bearing structural elements. This approach, which can result in deceptively simple, repetitively patterned abstractions or complex, figuratively articulated forms, inevitably blurs the boundaries between formal characteristics and structure, surface, and occupiable space. While few designs that reflect the glamour ideology have been built to date, projects by Bernard Tschumi, Herzog & de Meuron, Greg Lynn, and Hernán Díaz Alonso, among others, illustrate the potential of digital fabrication in architecture (a tendency that parallels current trends in industrial design, most notably mass customization).

As the essays and plates in this catalogue demonstrate, today's progressive architects, industrial designers, and couturiers are addressing a wide range of visually literate demographics, producing some of the most exciting buildings, objects, and fashions we have seen in more than a decade. From well-heeled fashionistas to Hollywood celebrities, from the creative class to the bling-bling set, glamour's many constituents and complex histories will continue to converge, fabricating new signs of affluence for the increasingly aestheticized and economically empowered masses.

22

notes

1 Robert C. Morgan, "A Sign of Beauty," in *Uncontrollable Beauty: Toward a New Aesthetics,* ed. Bill Beckley (New York: Allworth Press, 1998), 81.

2 Caroline Evans, *Fashion at the Edge: Spectacle, Modernity, and Deathliness* (New Haven, CT: Yale University Press, 2003), 114.

3 The Motion Picture Producers and Distributors of America (now the Motion Picture Association of America, or MPAA) adopted the Motion Picture Production Code in March 1930, but it was not officially enforced until June 1934. Intended to discourage narratives, dialogue, characters, and costumes that were considered vulgar or immoral, the Code effectively censored thousands of movies before directors such as Otto Preminger began to challenge it in the 1950s. In 1968 the Code was replaced by today's MPAA film rating system. For the full text of the Code, see http://www.artsreformation.com/a001/hays-code.html.

4 For information on B.G. and the bling-bling aesthetic, I am grateful to my student Vincent Sol, who wrote on "Hip-Hop and Glamour: The Rap Lifestyle as the Ultimate Glamour" for my spring 2004 seminar at the California College of the Arts, San Francisco. For his thesis, Sol is designing a collection of furniture for the "gangsta rapper" set.

5 See Richard Florida, *The Rise of the Creative Class: And How It's Transforming Work, Leisure, Community, and Everyday Life* (New York: Basic Books, 2002).

6 See Virginia Postrel, *The Substance of Style: How the Rise of Aesthetic Value Is Remaking Commerce, Culture, and Consciousness* (New York: HarperCollins Publishers, 2003) and David Brooks, *Bobos in Paradise: The New Upper Class and How They Got There* (New York: Simon & Schuster, 2000). Also see Postrel's contribution to this catalogue for an incisive take on the complex significations of glamour and its cultural forms of dissemination.

by VIRGINIA POSTREL

Hollywood did not invent glamour. From Malibu to Pasadena, Southern California displays glamorous treasures centuries old. Before movie stars and supermodels, there were gods and saints. Their other-worldly glamour radiates from religious art.

With her perfect features, flawless complexion, and long, slim fingers, Filippino Lippi's Saint Apollonia (fig. 6), today ensconced in the galleries of the Norton Simon Museum, is as lovely as a red-carpet fashion queen. Amid the grime and disease of the fifteenth century, what worshipper ever would have beheld a living woman so ideal? And while any twenty-first-century runway model can look extraordinary, Apollonia offers more.

Her downcast eyes withhold the secrets of her soul, paradoxically inviting us to imagine her inner life. She maintains an otherworldly tranquility even as she grasps the iron instruments of her torture and martyrdom. Her physical perfection is but an outward and visible sign of inward, invisible grace. The painting suggests the possibilities of another, better world, one we can contemplate but cannot enter in this life. Apollonia is not only beautiful. She is *glamorous*—graceful, mysterious, and transcendent.

Glamour is not just beauty or luxury. It is not a style but an effect, a quality that depends on the play of imagination. Its power is not sensation but inspiration. War can be glamorous; so can police work or garage entrepreneurship or laboratory science. Their glamour includes the risks but omits the tedium, the sore feet, the dirt, the accounting. Glamour is never boring.

Its grace makes the difficult seem achievable, available to all. Its mystery invites identification without the distracting or deflating details of intimate knowledge: You could be like this, it suggests. You could have this life. Through its grace and mystery, glamour transports us from the world of compromises, constraints, and disappointments. It is, to quote a recent fashion blurb, "all about transcending the everyday."[1]

Yet for all its breathtaking qualities, glamour does not strike awe. Unlike grandeur or magnificence, it operates on a human scale. God, omniscient and omnipotent, cannot be glamorous. The Virgin Mary can. (Michelangelo's *Pietà* may be among the most glamorous artworks ever created.) Apollonia maintains her distance, but at the same time she is one of us, a representation of what we could be.

Glamour gives utopia a tactile presence, a human connection. Hollywood's golden-age "portraits were romanticized ideals caught frozen in time: lasting objects of perfection *to hold in your hands*," writes Tom Zimmerman in his study of photographer Ray Jones's studio portraits, taken from the 1920s to the 1950s.[2]

figure 6 **Filippino Lippi**
Saints Benedict and Apollonia, ca. 1483
Courtesy the Norton Simon Foundation

24

Glamour invites just enough familiarity to engage the imagination. In its mysterious blend of accessibility and distance, it is neither transparent nor opaque. It is translucent. Dramatically photographed in the right light, the ubiquitous concrete screens of mid-century modern architecture—those of Charles Luckman's Parke-Davis Building (pl. 54), Wallace Neff's Groucho Marx House, and Edward Durell Stone's Stuart Company Plant and Office Building—evoke the glamour of a partially revealed setting. We only glimpse the life behind them.[3] Contemporary architects and designers use similar forms, such as the diamond grid of Herzog & de Meuron's Prada Aoyama Tokyo boutique (pl. 65), and, less concerned with "honest" construction, employ translucent materials more inherently glamorous than dingy concrete.

Glamour comes in many styles, depending on the ideals it embodies. Consider two glamorous cars. The Jaguar E-Type (fig. 7, pl. 31) is beautiful and luxurious. Its teardrop shape promises frictionless transportation through life. A car so streamlined must belong to a world without troubles, one in

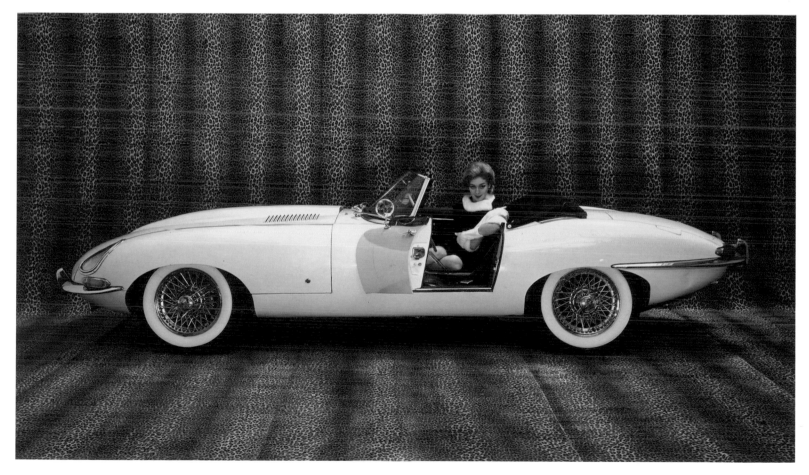

figure 7 **Malcolm Sayer**
Jaguar 3.8 E-Type Roadster, ca. 1961

which every woman is charming and beautiful and every man dashing and handsome, in which neither clothes nor people ever wrinkle and love and work never disappoint. With such a car, the viewer muses, my life would be perfect. As sculpture that sparks imaginative longing, the Jaguar epitomizes grace; it effortlessly takes us to perfect places, never spending time in the repair shop. In the real world, of course, it requires constant maintenance.

While the Jaguar creates glamour from sleek luxury, the cute, inexpensive MINI (in both its original and contemporary versions) does just the opposite. Instead of frictionless progress, its squat, baby-faced form embodies youth, making it an equally powerful symbol of a better future (or an inaccessible, idealized past). Let's motor, says the MINI. Let's take off for a world of fun, in an adorably unpretentious vehicle with all the power and maneuverability of the grown-ups' cars. Sometimes glamour lies in escaping luxury and its attendant responsibilities, as Audrey Hepburn's princess demonstrates in *Roman Holiday*.

Here, too, is an essential quality of glamour: It is an escape, an illusion, an ideal, a dream. Glamour is not quite real. For centuries the word denoted a magic spell, an illusion cast by gypsies and witches. The *Oxford English Dictionary* cites a 1721 glossary of poetry: "When devils, wizards or jugglers deceive the sight, they are said to cast glamour o'er the eyes of the spectator."[4]

This real and powerful magic was dangerous. Glamour led people to believe things that were not true and thus to act against their own interests. Under its influence, one might, as in William Shakespeare's *A Midsummer Night's Dream*, fall in love with an ass or, worse, like Christopher Marlowe's Doctor Faustus, embrace a succubus as Helen of Troy. Before its magic became metaphorical, glamour had no good purpose. Its pleasures were entirely baleful, literally the work of the devil. Religious icons may have possessed glamour, but no one used the term to describe them.

In the twentieth century, glamour—exotically spelled with the *u* even in American English—became a metaphor and an aspiration. The movies did not invent glamour, but they permanently changed the meaning of the word, tying it not to witchcraft but to the benign and inspiring illusions of stagecraft. "I loved the stage," wrote architect Morris Lapidus, recalling his original inspiration to create idealized settings, "for it was a world of illusions, of dreams, a mirror of all human emotions, of romance, of love and hate, a world that had nothing in common with the everyday world I lived in, a world from which I wanted to flee."[5]

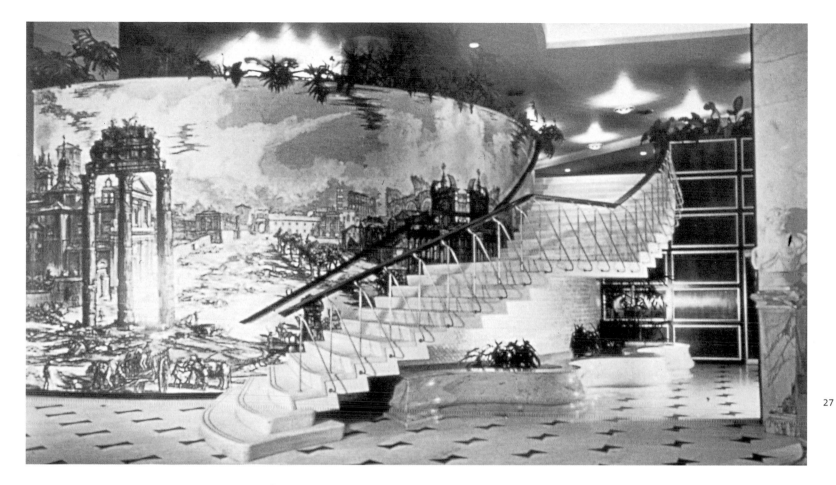

The hotels Lapidus designed in the 1950s (see fig. 8, pl. 56) consciously packaged theatricality as escape, giving patrons a chance to feel like movie stars. "I was selling them the idea that, for the short time that they were guests, they were really royalty—they were on stage," he wrote. "They were living the kind of life they had dreamed of."[6] The affluent resort guests of the 1950s had been the young, often impoverished, rarely cosmopolitan movie patrons of the 1930s and 1940s. The films that inspired them not only heightened the illusions of the stage but sold glamour to anyone with a nickel.

Movies made glamour a mass commodity and its tangible accessories desirable consumer goods. "Paris fashion shows had once been accessible only to the chosen few," noted Cecil B. DeMille's brother, William. "C.B. revealed them to the whole country, the costumes his heroines wore being copied by hordes of women and girls throughout the land, especially by those whose contacts with centers of fashion were limited or nonexistent."[7]

figure 8 **Morris Lapidus**
Fontainebleau Hotel, 1954
Lobby and "stairway to nowhere"

The mythmaking of displaced meaning gives cultures the characters, artifacts, geography, and emotions that make their cherished abstractions seem attainable and true.

Individuals, too, use unreachable ideals to give meaning and purpose to their lives. Some of these ideals are those of the general culture. But many are more personal and specific: my notion of the perfect family, the perfect career, the perfect body, the perfect self. For individuals, McCracken argues, consumer goods often serve as "bridges to these hopes and ideals."[23] Unlike precepts or myths, goods are tangible. We can see and touch them, even when they are financially or otherwise out of reach. We thus can fantasize about owning the perfect wardrobe, the perfect car, the perfect house—and, with it, the perfect life.

"Goods help the individual contemplate the possession of an emotional condition, a social circumstance, even an entire style of life, by somehow concretizing these things in themselves," writes McCracken.[24] We cannot visit Eden, but we can drive by our dream house or mentally redecorate our actual dwelling, imaginatively transforming not just the physical place but our entire domestic life. Owning a component of that dream—a cool car, a Gucci dress, a fabulous necklace, a vacation at the Eden Roc Hotel—makes the entire ideal it represents seem like something we can someday claim.

Crucially, however, we must never get everything we picture. Some goods, like the ideals they represent, must remain out of reach. Only then can tangible things remain bridges to intangible, and impossible, goals. That is why luxuries often take on displaced meaning. We cannot afford them, or, in the case of Vincent Van Duysen's Cascade chandelier (pl. 35) or countless haute-couture dresses, they require a setting or a physique few people will ever possess. Glamour adds other qualities—mystery and grace—that cannot be bought with cash.

Glamour gives displaced meaning visual form, making it beautiful and real. It shows us a picture to spark our imaginative longings, and it fills that picture with tangible objects we might possess. We gaze at the star's portrait, copy her hairstyle, and envision wearing her clothes. We mentally enter her perfected world. We also enjoy ourselves. Before it evokes ideals, glamour offers untainted aesthetic pleasures: the whiter-than-white stucco, the gown uncompromised by the need to sit down, the model's airbrushed complexion.

Indeed when critics use *glamorize* as a pejorative verb—denouncing movies that "glamorize violence," for instance—it is this aesthetic selection they fear. They worry that the audience will mistake art for

life. Propagandists want us to do just that. Many a mid-century housewife wondered why, unlike the glamorous women in magazines and ads, she did not find personal fulfillment cleaning her floors or making lunch for her kids.

Glamour is magic, after all, and magic, warns economist and literary scholar D. N. McCloskey, "claims to have solved scarcity," the central problem of economic life.

> [Magic] leaps over the constraints of the world. If you desire a ride to Baghdad, here is a magic carpet; if you desire your enemy dead, here is a magic doll; if you desire unlimited riches, here is a forecast of interest rates. As the expressive jargon of economics puts it, magic leaps outside our "production possibilities." The "fiat" in a spell is the desire to get outside what is ordinarily possible.

The unglamorous, unmagical world of economics—the world in which we actually live—forces us to make tradeoffs. "The grown-up way to satisfy the desire to avoid evil or achieve riches is to work within the world's limitations and satisfy it," writes McCloskey. "Robinson Crusoe did not spend time casting spells (though he mourned a while), but stripped the wreck and built a stockade, reinventing the arts and sciences and retraining his desires."[25]

33

Glamour in the wrong hands poses dangers far greater than mere disillusionment. In the 1930s and 1940s, Hollywood produced its greatest glamour—unabashedly escapist entertainment that never pretended to be literally true. This "calculated image-making" delighted audiences and harmed no one. It was just make-believe. In the same period, however, Adolf Hitler imagined the glamour of a purified world and embarked on a murderous campaign to make it real.[26] As McCloskey notes, "the Nazis drew much of their power from a modernist science grown magical."[27] Not all ideals are humane or worthy, and not all techniques benign.

Glamour suggests that the good, the true, and the beautiful are one and the same. But the association is only symbolic, an artistic representation. Saints are not necessarily beautiful; beautiful people are not necessarily saints. Mistake art for reality and you may indeed fall for a femme fatale or, much worse, embrace a scheme to glamorize society by removing all unpredictable or discordant elements, from ethnic minorities to market exchange. As imagery, glamour is evocative and wondrous. As social reality, it is totalitarian. What political artist can we trust with the power of selection? A literal golden world is barren of life.

"If glamour is magic, if it's really about casting a spell, one should happily confront the manipulation of it all," says designer Isaac Mizrahi. "It's adult to manipulate and only human."[28] His insight contains both an appreciation of glamour and a warning: Accept glamour for what it is. Value the effort it requires and the messy human realities that in fact make it possible. Understand that glamour is art. Do not pretend it is not manipulation. Enjoy the spell, be inspired by it, but do not mistake it for reality.

After all, as Morris Lapidus said, "No one would want a steady diet of an indefinite vacation at the Fontainebleau [Hotel]. Once in awhile, O.K., that's what it was designed for." Glamour's escapist pleasures are only meant to be temporary.

notes

1 *New York*, August 25–September 1, 2003, 9.

2 Tom Zimmerman, introduction to *Light and Illusion: The Hollywood Portraits of Ray Jones*, ed. John Jones (Glendale, CA: Balcony Press, 1998), 16 (emphasis added).

3 A half-century later, the concrete is too grungy and the motif too associated with parking garages for the screens to maintain their glamour, except in those powerful photographs.

4 *Oxford English Dictionary Online*, http://dictionary.oed.com.

5 Morris Lapidus, *An Architecture of Joy* (Miami: E. A. Seemann, 1979), 44.

6 Ibid., 219–20.

7 Quoted in Howard Gutner, *Gowns by Adrian: The MGM Years 1928–1941* (New York: Harry N. Abrams, Inc., 2001), 22.

8 Bevis Hillier and Stephen Escritt, *Art Deco Style* (London: Phaidon, 1997), 72–73, 76.

9 Steve Castle, *Great Escapes: New Designs for Home Theaters by Theo Kalomirakis* (New York: Harry N. Abrams, Inc., 2003), 53.

10 See John R. Stomberg, *Power and Paper: Margaret Bourke-White, Modernity, and the Documentary Mode* (Seattle: University of Washington Press, 1998).

11 Ronald L. Davis, *The Glamour Factory: Inside Hollywood's Big Studio System* (Dallas: Southern Methodist University Press, 1993), 214.

12 Julius Shulman, *Photographing Architecture and Interiors* (Glendale, CA: Balcony Press, 2000), 4.

13 Baldesar Castiglione, *The Book of the Courtier*, trans. Charles S. Singleton (Garden City, NY: Anchor, 1959), 43.

14 Pamela Clarke Keogh, *Audrey Style* (New York: HarperCollins, 1999), 61.

15 Carolina Herrera, "Age of Elegance," *New York*, August 25–September 1, 2003, 75.

16 Richard Lawton, *Grand Illusions* (New York: McGraw-Hill, 1973), 9.

17 Plato, "Book X," *The Republic*, in *Criticism: The Major Texts*, ed. Walter Jackson Bate (New York: Harcourt Brace Jovanovich, 1970), 46.

18 Martin Wroe, "Prophet with a Beautiful Way Out of Consumerism," *London Sunday Times*, December 21, 2003.

19 Daniel Bell, *The Cultural Contradictions of Capitalism: Twentieth-Anniversary Edition* (New York: Basic Books, 1996), 283.

20 Ibid., 293–94 (emphasis added).

21 Sir Philip Sidney, "An Apology for Poetry," in Bate, 85.

22 Grant McCracken, *Culture and Consumption* (Bloomington: Indiana University Press, 1988), 106.

23 Ibid., 104.

24 Ibid., 110.

25 Donald N. McCloskey, *If You're So Smart: The Narrative of Economic Expertise* (Chicago: University of Chicago Press, 1990), 98–99.

26 See Peter Cohen's documentary film *The Architecture of Doom*, DVD (New York: First Run Features, 1991).

27 McCloskey, 109.

28 Isaac Mizrahi, "All the Things We Like As Human Beings Are Either Immoral, Illegal, or Fattening," *Harper's Bazaar*, March 2003, 236.

FASHION

37

fashion

by VALERIE STEELE

"I love glamour and I thought 'Oscars,'"
Valentino said to explain the videos
of Hollywood moments that preceded
a show destined for the glitterati.
—Suzy Menkes, *International*
Herald Tribune[1]

The word *glamour* is ubiquitous in the mass media, where it alludes to a potent combination of sex appeal, luxury, celebrity, and wealth. Yet it is never entirely clear just what glamour is. Certainly, glamour is strongly identified with fashion, especially in conjunction with Hollywood. The fashion designer Valentino is not alone in associating glamour with movie stars dressed in couture gowns and glittering with jewels, walking down the red carpet, watched by millions of viewers. But glamour is not synonymous with fashion, or even the fashions worn by movie stars. As Jeanne Basinger writes in her book on classic Hollywood films and their female audiences, "Glamour goes beyond mere fashion. Although the concept of glamour includes fashion, it ultimately involves more than what a woman puts on her body. It deals with the lady herself."[2]

The role of the star system in the golden age of Hollywood was central to the creation of glamour as we understand it today. But it would be naive to assume that glamour is simply a quality intrinsic to certain beautiful women ("the lady herself"), for we know how much work goes into manufacturing a star's glamorous image. The performance of sex and gender is also an issue—though men may be glamorous, the term is usually applied to women and their fashions.

Certain fashion designers, such as the late Gianni Versace, have been widely regarded as masters of "glitz and glamour," as Réka C. V. Buckley and Stephen Gundle note in their pioneering essay "Flash Trash: Gianni Versace and the Theory and Practice of Glamour."[3] Whereas a designer such as Giorgio Armani is best known for his discreetly elegant styles, Versace is famous for dramatically eye-catching, even somewhat vulgar fashions. Armani's clothes may be equally expensive and popular with Hollywood celebrities, but Versace's fashions are more likely to be perceived as glamorous because of stylistic excesses such as intense color and lavish surface decoration, and especially their hypersexuality, which is expressed through revealing cuts (see fig. 11) and overt references to sexual fetishism (the notorious 1991–92 Bondage Collection, with its emphasis on straps and buckles [see pl. 17]).

Significantly, Versace was often accused of dressing women like prostitutes. "The hallmark of Versace's clothes is an overpowering sexuality that turns men into studs and women into hookers," writes Fiametta Rocco.[4] Of course, there are many kinds of prostitutes, and despite certain deliberately "trashy" details, a woman wearing Versace usually looks less like a common streetwalker than an expensive call girl. Nevertheless, the element of overt, even excessive sexuality is central to both Versace's work and the aesthetic of glamour in general.

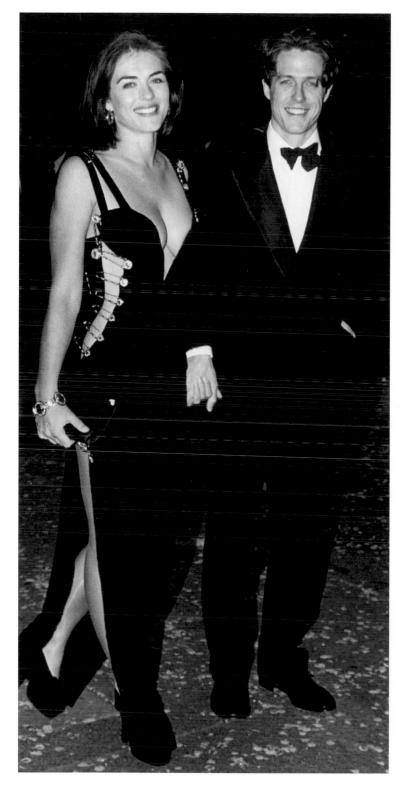

39

It may be useful at this point to consider the etymology of glamour. The word is Scottish in origin and derives from *grammar*, which is related to the old word *gramarye* ("occult learning, magic"). Glamour entered the English language in the eighteenth century with the meaning of "magic, enchantment." By the mid-nineteenth century it had acquired its contemporary dictionary definition as "a deceptive or bewitching beauty or charm" or "a mysteriously exciting or alluring physical attractiveness, especially when artificially contrived."[5] Notice the ambivalence at the heart of the word: on the one hand, beauty, charm, and allure; on the other, deception and artifice.

Historically, "the social bearer of glamour was the aristocracy," as Buckley and Gundle observe. But over the course of the nineteenth century, as this class lost power to the capitalist bourgeoisie, "the semblance, or reproduction, of distinction [and] stylishness . . . could be manufactured by commercial culture or through the media. *This artificial aura, detached from the class that had created it and turned into a manufactured property, was the essence of glamour.*" Moreover, there emerged a new elite, "which consisted of those who were photographed . . . [and] talked about in the press." Social status might permit access to this elite, but increasingly "notoriety and photogenic beauty" were at least as significant. "Furthermore, artifice played an important part in attracting and holding attention and in creating the effects of dazzle and excitement."[6]

The adjective *glamorous* may be traced back to the late nineteenth century, when the figure of the prostitute—especially the high-class courtesan—assumed new cultural significance. The rise of modern capitalism and consumer culture ushered in a new era of human relations involving the public visibility of desirable objects. Just as lavish window displays featured commodities such as shoes and corsets, theaters and cafés put performers and even audience

figure 11 **Gianni Versace**
Safety-Pin Dress, 1994
Worn by Elizabeth Hurley at a May 1994 film premiere

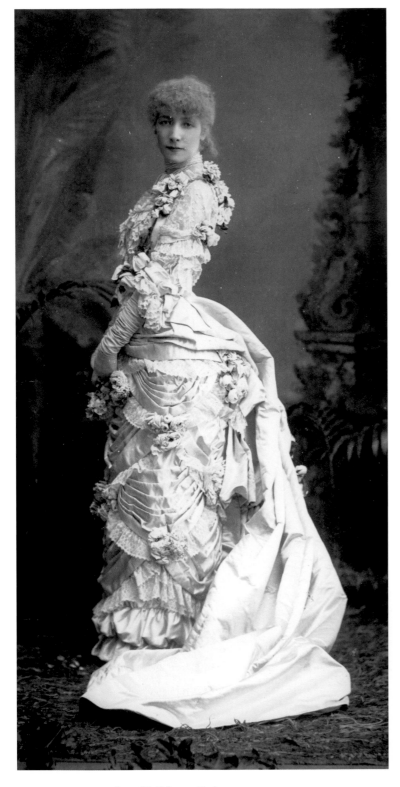

figure 12 **Unknown Designer**
Gown, ca. 1890
Worn by Sarah Bernhardt

members on display. Fashion may have been capitalism's favorite child, but the commercialization of sex and the sexualization of consumer desire made women, as well as dresses, into commodities.[7]

Sex and money united in the spectacle of the prostitute, who was "commodity and seller in one," as Walter Benjamin famously wrote. But whereas the streetwalker or brothel inmate was all too obviously a sex worker, the courtesan or *demi-mondaine* was widely regarded as a glamorous figure. On first impression, she was every bit as fashionable and aristocratic as the greatest lady in the *grand-monde*. And yet there was something a little too perfect in her mode of self-presentation. "Her business was dominance and make-believe," writes the art historian T. J. Clark. "[The courtesan] seemed the necessary and concentrated form of Woman, of Desire, of Modernity. . . . It was part of her charm to be . . . a woman whose claim to classlessness was quite easily seen to be false."[8]

Spectacular excess was a *strategy* for the courtesan, since a glamorous appearance attracted attention—and wealthy men. According to Larousse's *Grand dictionnaire universel* (1867), "The *courtisane* knows that she needs a *mise-en-scène* that will bring her close to the man who pays her. In other words, she is a gambler who constantly doubles her stake. She receives one thousand francs . . . [and] by spending three thousand on entertainment and clothing expenses, she rarely fails to catch the eye of a spendthrift, who hastens to offer her three or four thousand, assuming that such a woman could not cost less."[9]

Like courtesans, actresses were unconstrained by the dictates of modesty or financial prudence that governed respectable women. Stage performers, such as actresses and dancers, were often famous and seductive public figures who served as an unofficial caste of mistresses to elite men. The press and the burgeoning photographic

industry gave extensive coverage to the couture gowns and jewelry that famous actresses such as Sarah Bernhardt wore both on- and offstage (see fig. 12). To keep a courtesan or actress (and the terms were virtually interchangeable) was said to be as expensive as maintaining a yacht or a racehorse. Men often spent more on their mistresses' dresses than on their wives' clothes, and "professional beauties" thus became fashion trendsetters. Even if she had to rent her dress and borrow her jewels, it was important for the courtesan to look rich and seductive.

The same "strategy of appearances," to use Baudrillard's expression, would later apply to movie stars. It is no accident that MGM's motto was "Make it big! Do it right! Give it class!" Diana Vreeland, the longtime editor of *Vogue* and later a special consultant to the Costume Institute of the Metropolitan Museum of Art, explores the subject in *Hollywood Costume: Glamour, Glitter, Romance*, the catalogue of the 1974 Costume Institute exhibition *Romantic and Glamorous Hollywood Design*. Writes Vreeland, "I don't think you can really understand the effect those designs had on the actresses until you've seen the costumes. Can

you imagine how they felt surrounded by real chinchilla and satin and how it must have felt to touch the embroidery so much like jewels? Why, they must have felt like the most important women on earth. And in a way they were."[10]

Classic Hollywood films of the 1930s, such as *Fashions of 1934* (1934), *Artists and Models* (1937), and *The Women* (1939), often used fashion as spectacle, drawing on the traditional feathers and rhinestones worn by scantily clad showgirls as well as on the elite tradition of couture. Costume designer Howard Greer recalled: "New York and Paris disdainfully looked down their august noses at the dresses we designed in Hollywood. Well, maybe they were vulgar, but they did have imagination." Unlike Paris couture or custom dresses from New York salons, Hollywood movie costumes were not known for their craftsmanship or elite "good taste." Even the "imagination" that Greer extolled referred not to originality in the sense of the couturier as artist, but rather in the sense that movie costumes could look over-the-top as long as they were flattering. As Greer continued, "Into this carnivalesque atmosphere I was plummeted. There I wallowed in rhinestones and feathers and furs and loved every minute of it."[11]

Greer's verbs—plummet, wallow—are highly evocative, conveying the notion that his immersion in rhinestones, feathers, and furs constituted a veritable sartorial orgy. Perhaps significantly, he fails to mention anything as humdrum as cloth (be it silk, wool, or velvet), giving the inaccurate impression that Hollywood stars wore only faux jewels, feathered headdresses, and fur coats. In fact, Hollywood moguls also drew on the prestige of Parisian haute couture, sometimes importing designers such as Coco Chanel—with mixed results, since cinema, like the theater, tends to require costumes that are larger than life.

Writing in 1939 about Hollywood film stars, Margaret Farrand Thorp defined glamour as "sex appeal plus luxury plus elegance plus romance." Although "elegance" seems dubious and "romance" a euphemism, Thorp was surprisingly candid about the role of the media in manufacturing and disseminating fantasy images of glamour to a mass audience. She went on to say that "The place to study glamour today is the fan magazines. . . . Clothes of course are endlessly pictured and described usually with marble fountains, private swimming pools or limousines in the background. . . . Every aspect of life, trivial and important, should be bathed in the purple glow of publicity."[12]

Thorp's evocation of the "purple glow of publicity" tacitly admits that fantasy images directed toward a mass audience are not very subtle and can even verge on bad taste. Interestingly, her description of images in Hollywood fan magazines strongly recalls Versace's fall 2000/winter 2001 advertising campaign. Photographed by Steven Meisel, the advertisements depict the kind of nouveau-riche women immortalized on television shows such as *Dallas* and *Dynasty*. Drenched in jewels and heavily made-up, the perfectly

coiffed women pose near swimming pools, limousines, and in other opulent surroundings, sometimes accompanied by uniformed servants. Although undeniably beautiful, the women are expressionless, which has led some observers to describe them as Eurotrash Stepford wives. It is highly likely that this effect was intentional, aimed at fashion-world insiders who could be counted on to understand that bad taste can be good.

Many contemporary fashion designers still draw on "old-fashioned Hollywood glamour" to present their ideal woman as a "golden goddess"—a beautiful and sexually alluring star. Descriptions of Versace's fashions emphasize their erotic glamour. "Gianni helped women discover a taste for glamour," declares Franca Sozzani, the editor of *Italian Vogue*. "The Versace woman does not dress for her own pleasure; her aim is to conquer men."[13]

Glamour is emphatically *not* elite "good taste." It is the kind of high drama appreciated by celebrities. "Stars loved wearing [Versace's] clothes," recalls photographer Mario Testino, "because for some of them, putting on a Versace dress was the first time they *felt* like stars."[14] Glamorous jewelry is "bling-bling," big and bold, gold and diamonds (see pl. 45). It may be fake, all surface and illusion, but it is never discreet or ladylike. Furs are almost always said to be glamorous—or "glam," to use a term that has become ever more popular ("Bring on the glam," proclaimed *Women's Wear Daily*. "It was a banner season for lavish furs"[15]). The glamour of fur derives, of course, both from its expense and its strong association with female sexuality. Karl Lagerfeld, for one, understands this well, as evidenced by one of his designs for Fendi: a strapless silver leather gown with fox-fur trim at the hem and a matching hooded fox-fur jacket (pl. 18).

Fashion theorist Caroline Evans describes this approach as an "unproblematical image of glamour." She contrasts it with other, more

fashions would appear more suitable for the sadistic dominatrix in Leopold von Sacher-Masoch's notorious 1870 novel *Venus in Furs*. However, Evans argues that even the soothing Hollywood image of glamour is implicitly threatening inasmuch as it embodies "an artificial and constructed vision of femininity that . . . seem[s] unhuman, even deathly."[16]

In order to understand the evolution of glamour, it is necessary to try to distinguish between its different styles. An older fashion designer such as Valentino obviously identifies strongly with the traditional Hollywood approach to glamour, which largely conceals its manufactured character, emphasizing the intrinsic beauty of the female star. But younger, openly gay designers often take an edgier approach, associating glamour with the kind of hyperfemininity performed by drag queens. Thierry Mugler, for example, has been strongly influenced by the iconography of sexual fetishism and gender "confusion," creating fashion ensembles such as the red, rhinestone-studded corset, chaps, and cowboy hat worn down the Paris runway in 1992 by the black drag performer RuPaul (fig. 13).

"The glamour image is central to drag performances," writes Esther Newton, a sociologist who studies female impersonators. She argues that drag presents women "at their most desirable and exciting to men." Whereas heterosexual cross-dressers often impersonate their mothers or sisters, drag performers base their looks on images of glamorous femininity. Indeed, they often impersonate particular stars. "Glamour is stylized pornography, and the style is fundamentally in the clothing," Newton asserts. "The flip side of glamour is prostitution. This relationship is laid bare (literally) in the strip, which begins as a clothing show and ends as a skin show."[17]

Fashion journalists often criticize Mugler's creations as parodies of femininity. (The designer himself has associated his fashions with

excessive or parodic images of glamour created by designers such as Thierry Mugler and Alexander McQueen (see pls. 19–20), who evoke disturbingly aggressive images of femininity. If Hollywood's fur-clad heroines were sexy gold diggers à la Marilyn Monroe, some of McQueen's

figure 13 **Thierry Mugler**
Cowboy Corset and Chaps, 1992
Modeled by drag performer RuPaul

43

fetishism and fantasy.) But what would authentic femininity be like? In her famous 1929 essay "Womanliness as Masquerade," Joan Rivière suggests that womanliness can "be assumed and worn as a mask."[18] Yet, significantly, Rivière refused to draw a line between "real" femininity and its facsimile. Subsequent writers have elaborated on the idea that fashion and makeup can function as part of gender masquerade, not only when men dress up as women (transvestism) but also, at least in some cases, when women dress up as women (homeovestism). Certain commodities, such as high heels and red lipstick, seem especially important in conferring femininity.

As psychoanalyst Louise Kaplan writes in her book *Female Perversions*, "In the fashion industry, a cornerstone of modern industrial economy, the female perversion of dressing up as a woman [is], like Poe's purloined letter, nicely disguised by being right out in the open."[19] The exaggerated glamour poses of 1930s Hollywood stars or 1950s fashion models would seem laughable to most young people today, accustomed as they are to a more casual style of self-presentation. But this does not mean that glamour has disappeared. Rather, there is an increasing tendency to

adulterate images of old-fashioned glamour with a deliberate undercurrent of irony or ambiguity. Madonna, for example, has drawn on Marilyn Monroe's glamorous image while also putting it in quotation marks. Modern versions of glamour thus seek to avoid the taint of obviousness while implicitly attesting to the superior sensibilities of those able to appreciate its nuances.

Alternatively, glamour has been revitalized through allusions to eroticized violence or "decadence." Versace's choice of the Medusa head as a logo is an obvious example, conjuring, as it does, the ultimate monstrous, castrating femme fatale (how glamorous can you get!). Much more controversial in the 1990s was the "heroin chic" aesthetic in fashion photography, which seemed to some observers to "glamorize" drug abuse. In 1997, after the death of fashion photographer David Sorrenti from a drug overdose, President Bill Clinton famously warned the fashion world: "You do not need to glamorize addiction to sell clothes."[20]

Some kind of glamour, though, does seem to be necessary to sell clothes, at least in the quantity required to maintain the fashion system. As fashion analyst Elizabeth Wilson points out in her pioneering book *Adorned in Dreams: Fashion and Modernity*, "Fashion is as much a part of the dream world of capitalism as its economy."[21] The dreams may be of ultraviolence, ultrasexuality, or ultrafemininity, but there is always something excessive, fantastic, and magical about the process of transformation that fashion promises to provide.

The fashion show itself is a major incubator of glamour. However boring or ridiculous the clothes may be, the event still seems glamorous, not only to the masses of television viewers, but also to otherwise cynical fashionistas. However, thanks to "the magic of film," a much more potent mise-en-scène is provided by the parade of fashions on Oscar night, which is widely perceived as "glamour on the red carpet."[22]

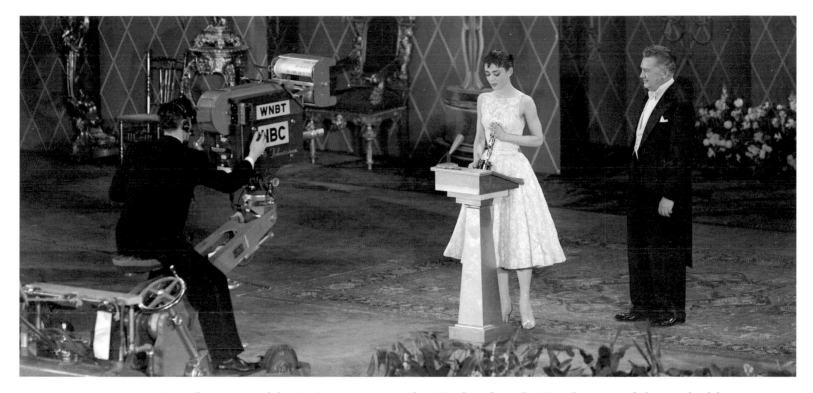

From the ceremony's beginnings as a small, private gathering, the Academy Awards have become a media spectacle and the world's greatest fashion show. By the 1950s fashion designers had all but replaced Hollywood costumers as "designers to the stars." Whereas MGM costume designer Adrian created the gown Norma Shearer wore to the Oscars in 1930, Audrey Hepburn accepted her 1954 Oscar for Best Actress in *Roman Holiday* wearing a dress by couturier Hubert de Givenchy (fig. 14).[23] In 1958, when Joanne Woodward designed and made her own dress for the Academy Awards, Joan Crawford sniped

that Woodward was "setting the cause of glamour back by twenty years."[24]

During the 1970s, designers such as Halston and Valentino were best known for their celebrity clients (the strapless red dress Halston made for Elizabeth Taylor in 1976 was especially glamorous). However, press coverage of Oscar ceremonies paid relatively little attention to fashion designers per se. Things began to change in the 1980s, when Hollywood celebrities, both male and female, began talking about their favorite fashion designers. Armani, in particular, became (and remains) one of the most popular designers in Hollywood. Cher's 1986 and 1988 outfits by Bob Mackie received a great deal of publicity, but this was because they were so revealing and flamboyant, not because they were glamorous in any ordinary sense of the word. (Indeed, the number of unfortunate dresses in the 1980s seems to have contributed to the rise of the Hollywood stylist in the 1990s.)

figure 14 **Hubert de Givenchy**
Dress, 1954
Worn by Audrey Hepburn to the 1954 Academy Awards

The Oscars featured a lot of Versace in the 1990s. For example, in 1991 super-model Cindy Crawford, then married to actor Richard Gere, wore a red Versace with a plunging neckline, while in 1999 Catherine Zeta-Jones wore a strapless red Versace. It was especially striking when Courtney Love, hitherto known for her grunge style, wore a Hollywood-glamorous white silk Versace in 1996. Other actresses appeared in Armani, Valentino, Karl Lagerfeld for Chanel, Calvin Klein, and Vera Wang.

Miuccia Prada was among the most influential designers of the 1990s, but her clothes tended to be too unconventional for most actresses aspiring to achieve a typically glamorous look (see pl. 24). Although greatly admired by fashionistas, Prada's clothes can seem odd or even ugly to members of the general public. When Uma Thurman wore a lavender Prada dress to the 1995 Academy Awards, most viewers seemed slightly puzzled, though representatives of the fashion industry were delighted. A year later Nicole Kidman wore a slim blue Prada gown with an empire waistline. A recent history of Oscar fashion claims that Kidman deserved "the purple heart for bravery in fashion" for wearing the dress, though Prada "was gaining a reputation for designing softly romantic yet elegant evening gowns, perfect for actresses who wanted to stand out among the hyper-glamorous Oscar-night crowd."[25]

Also regarded as an unusual Oscar gown was Cate Blanchett's 1999 John Galliano, a vivid purple sheath featuring delicate, hand-embroidered floral and bird motifs over a sheer back—an effect that evoked tattooing (fig. 15). Unlike Prada, Galliano is regarded as one of the world's most successful exponents of glamorous fashion. But he is almost always judged within the context of high fashion, where designers are expected to show something new and original every season, even if it looks strange to the average viewer. According to fashion journalist Colin McDowell, "Galliano's concept of femininity [is] about woman as *femme fatale*."[26] However, his ideal is too aggressive and peculiar to fit into the ordinary Hollywood version of glamour and sex appeal. "John, we are told, loves women," writes McDowell, "but it is not easy to avoid the thought that within that love lurks a fear which must be laid to rest by pastiche or, even more compelling, the suspicion

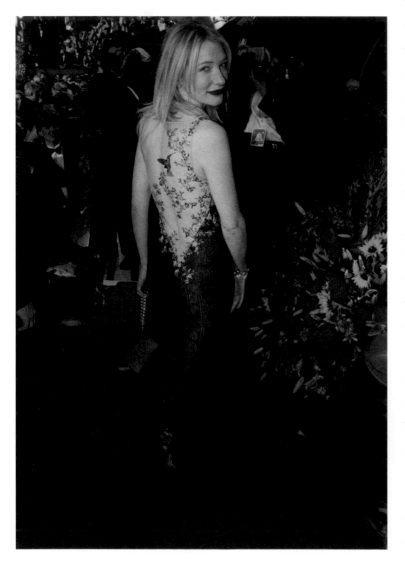

figure 15 **John Galliano**
Gown, 1999
Worn by Cate Blanchett to the 1999 Academy Awards

that it is a love so intense that it also encompasses a degree of hatred."[27]

Whether his inspiration begins with Cleopatra, Marlene Dietrich, or a fin-de-siècle courtesan, Galliano almost always mixes multiple sources, so his work is not easy to characterize (see pl. 16). He builds up a picture that may draw on stereotypes but cannot be reduced to one: "She's a screen goddess!" "It's only a B-movie!" "But she's given her all!"[28] Galliano's fashion shows are characterized by decorative extravagance heightened by Hollywood-style glamour, with a large dollop of rock-and-roll raunchiness and more than a dash of glam-rock camp. In 1997 he designed a collection for Christian Dior that was inspired by 1930s Shanghai. Perhaps because the bias-cut gowns of the 1930s are so closely associated with Hollywood glamour, Galliano was praised in Hollywood as well as in *Vogue*, and Nicole Kidman triumphed at the 1997 Oscars in a stunning Asian-inspired chartreuse gown from his collection.

We have seen how glamour has been a strategy for certain fashion designers, either throughout their careers or when it comes to designing for Oscar night. But glamour has also been important in other sectors of the fashion business, such as luxury ready-to-wear from Milan or the haute couture of Paris. Within the world of "beauty" and cosmetics, glamour is never associated with minimal or natural-looking makeup, but rather with "high-glamour eighties makeup," especially vivid red lips or even more fantastic maquillage. "From Versace to Galliano . . . make-up artist Pat McGrath adds glamour to all the top catwalk shows," reports one journalist, adding, "Oh, and she also does Gwynny and Nicole."[29] Notice how glamour is here associated not only with fashion, but specifically with the spectacle of the fashion show and with movie stars such as Gwyneth Paltrow and Nicole Kidman. Glamour is also associated with certain "lifestyles," as is made abundantly clear by the long-running television show *Lifestyles of the Rich and Famous*.

But artists, bohemians, and criminals have also sometimes been perceived as "glamorous outcasts."[30] The concept of dark glamour has a long history, stretching back to the gothic romances of the eighteenth century. Within contemporary youth subcultures it has considerable allure, not unlike the charisma of deviancy. If one aspect of contemporary glamour looks toward gangsters (limousines, gold chains, eroticized violence), another looks toward poets (black clothes, artifice, eroticized death). The British designer Alexander McQueen draws on both kinds of dark glamour. His fashion shows bear names like "Highland Rape," and his collections have been inspired by subjects such as Jack the Ripper, vampires, and broken dolls. Not surprisingly, many fashion journalists have reacted by accusing McQueen of misogyny. Others, however, argue that McQueen's women might be terrifying subjects, but they are hardly passive objects.[31] In recent years McQueen has increasingly been heralded as a transgressive creator of darkly glamorous fashions. Another designer who has mined this vein is Olivier Theyskens, who is perhaps best known for the gothic black dress that Madonna wore to the Academy Awards in 1998.

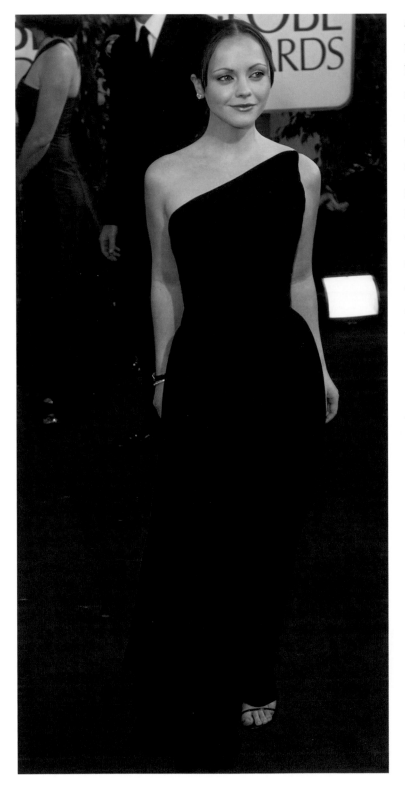

As fashion has become more of a spectator sport and its audience more knowledgeable, the definition of glamour has expanded at least a little bit. In recent years, fashion-forward stars such as Kidman and Thurman have worn couture dresses by Chanel and Jean Paul Gaultier that go beyond the usual glittering sheaths. At the same time, however, there has been a movement toward wearing vintage couture, which may convey more directly the familiar siren song of glamour. Renée Zellweger famously wore a 1950s gown by Jean Dessès to the 2001 Oscars. More recently, Christina Ricci appeared at the 2004 Golden Globes wearing a 1970s one-shouldered goddess dress by Madame Grès that evoked the designer's more famous 1930s gowns (fig. 16). Although both dresses were immediately evocative of golden-age Hollywood glamour, the same really could not be said of the actresses.

Kidman and Thurman seem much more glamorous than Zellweger and Ricci (even when their dresses don't look especially glam) because they have the classic ice-goddess look: cool, blonde, and untouchable. If glamour emerges from the conjunction of the woman and the dress, certain characteristics must adhere to the individual and to the gown—she should have the cold, hard allure of the classic femme fatale, while the dress should evoke sex, money, and fame. But beyond that, it should also emphasize an artificial aura of distance. A glamorous sheath dress of white satin or gold lamé transforms the right wearer into a kind of goddess.

figure 16 **Madame Grès**
Gown, ca. 1975
Worn by Christina Ricci to the 2004 Golden Globe Awards

48

notes

1 Suzy Menkes, "Behind a Shield of Steely Glamour," *International Herald Tribune,* July 11, 2003.

2 Jeanne Basinger, *A Woman's View: How Hollywood Spoke to Women, 1930–1960* (London: Chatto & Windus, 1994), 137.

3 Réka C. V. Buckley and Stephen Gundle, "Flash Trash: Gianni Versace and the Theory and Practice of Glamour," in *Fashion Cultures: Theories, Explanations, and Analysis,* ed. Stella Bruzzi and Pamela Church Gibson (New York: Routledge, 2001), 331.

4 Fiametta Rocco, "Death of an Italian Dream," *Independent on Sunday,* September 20, 1997, 17.

5 *The Shorter Oxford English Dictionary* (Oxford: Oxford University Press, 1993).

6 Buckley and Gundle, 334–35 (emphasis added)

7 See Peter Bailey, "Parasexuality and Glamour: The Victorian Barmaid as Cultural Prototype," *Gender and History 2* (1990): 148–72; Stephen Gundle, "Mapping the Origins of Glamour: Giovanni Boldini, Paris, and the Belle Époque," *Journal of European Studies* (September 1, 1999): 269–95.

8 T. J. Clark, *The Painting of Modern Life: Painting in the Art of Manet and His Followers* (London: Thames & Hudson, 1990), 102.

9 Quoted in Charles Bernheimer, *Figures of Ill Repute* (Cambridge, MA: Harvard University Press, 1989), 97.

10 Dale McConathy with Diana Vreeland, *Hollywood Costume: Glamour, Glitter, Romance* (New York: Harry N. Abrams, Inc., 1976), 22–23.

11 Quoted in Sarah Berry, *Screen Style: Fashion and Femininity in 1930s Hollywood* (Minneapolis: University of Minnesota Press, 2000), 47.

12 Margaret Farrand Thorp, *America at the Movies* (New Haven, CT: Yale University Press, 1939), quoted in Jeffrey Richards, *The Age of the Dream Palace* (London: Routledge, 1984), 157–58.

13 Quoted in Buckley and Gundle, 345.

14 Quoted in Lisa Armstrong, "Gianni Versace," *British Vogue,* October 1997, 292.

15 *Women's Wear Daily: The Magazine,* Fall 2003, 46.

16 Caroline Evans, *Fashion at the Edge: Spectacle, Modernity, and Deathlessness* (New Haven, CT: Yale University Press, 2003), 120.

17 Esther Newton, *Mother Camp: Female Impersonators in America* (Chicago: University of Chicago Press, 1979), 57.

18 Joan Rivière, "Womanliness as Masquerade," *International Journal of Psychoanalysis* 10 (1929): 303–13.

19 Louise Kaplan, *Female Perversions* (New York: Nan A. Talese, 1990), 262.

20 Quoted in Rebecca Arnold, *Fashion, Desire, and Anxiety* (New Brunswick, NJ: Rutgers University Press, 2001), 48.

21 Elizabeth Wilson, *Adorned in Dreams: Fashion and Modernity* (Berkeley: University of California Press, 1987), 14

22 Reeve Chace, *The Complete Book of Oscar Fashion: Variety's Seventy-Five Years of Glamour on the Red Carpet* (New York: Reed Press, 2003), 8.

23 Shearer first wore the Adrian gown in *The Divorcée* (1930), the film for which she received her Oscar for Best Actress. Givenchy later designed Hepburn's wardrobes for *Sabrina* (1954) and *Breakfast at Tiffany's* (1961), films that greatly influenced the world of fashion.

24 Quoted in Chace, 54.

25 Chace, 155.

26 Colin McDowell, *Galliano* (London: Weidenfeld & Nicolson, 1997), 38.

27 Ibid., 117.

28 Ibid., 52.

29 Jamie Huckbody, "The Eyes Have It," *The Independent,* August 10, 2002.

30 See Elizabeth Wilson, *Bohemians: The Glamorous Outcasts* (London: I. B. Tauris, 2000).

31 See Evans.

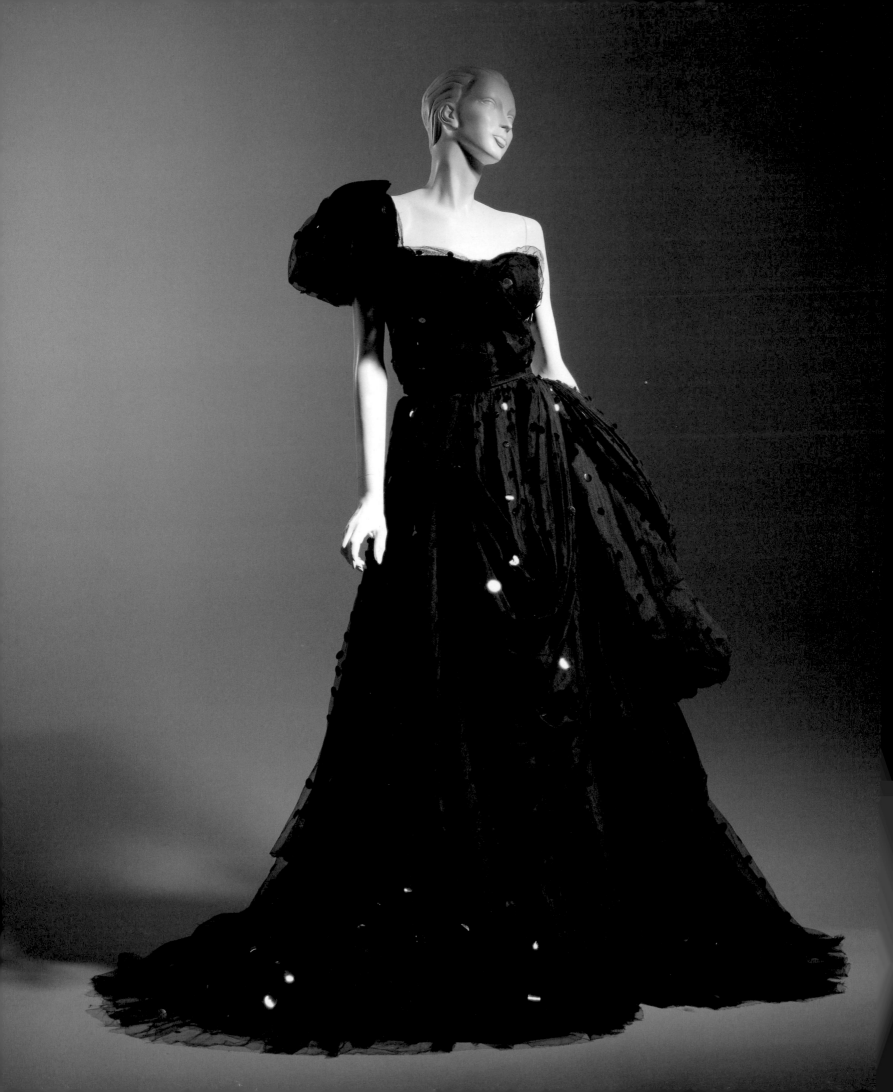

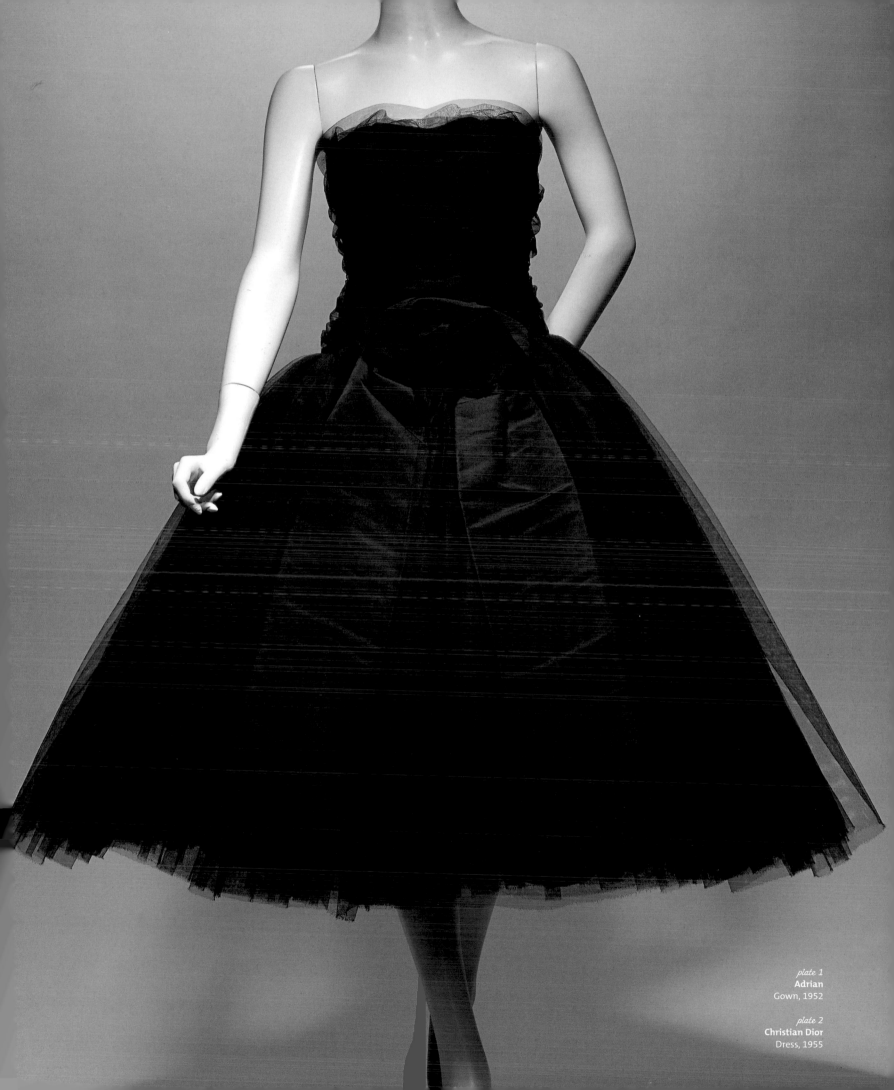

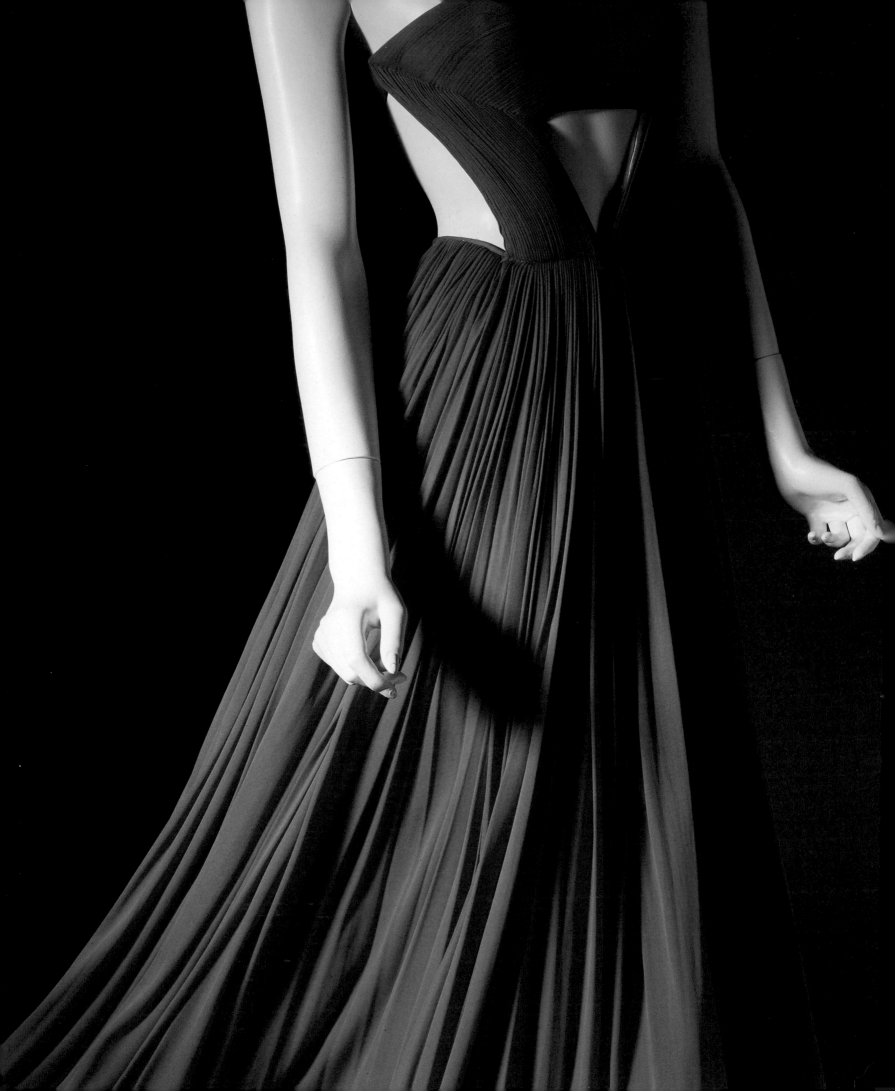

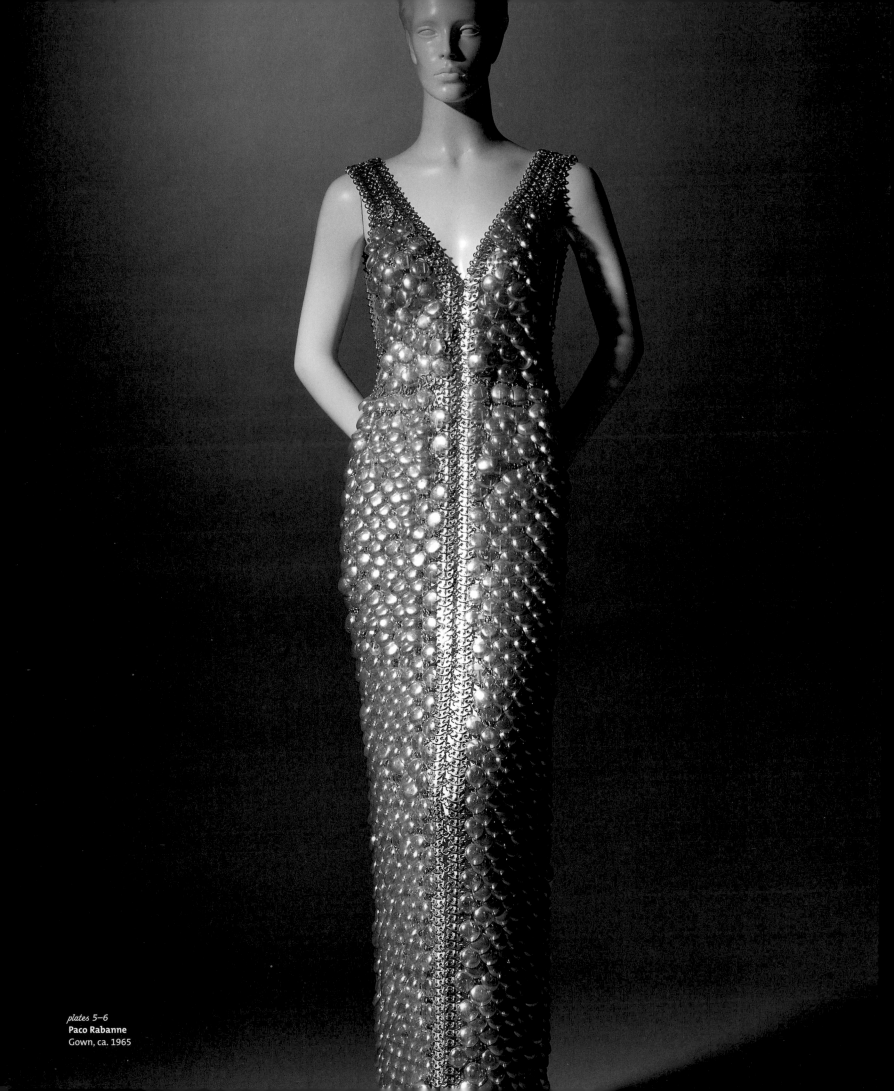

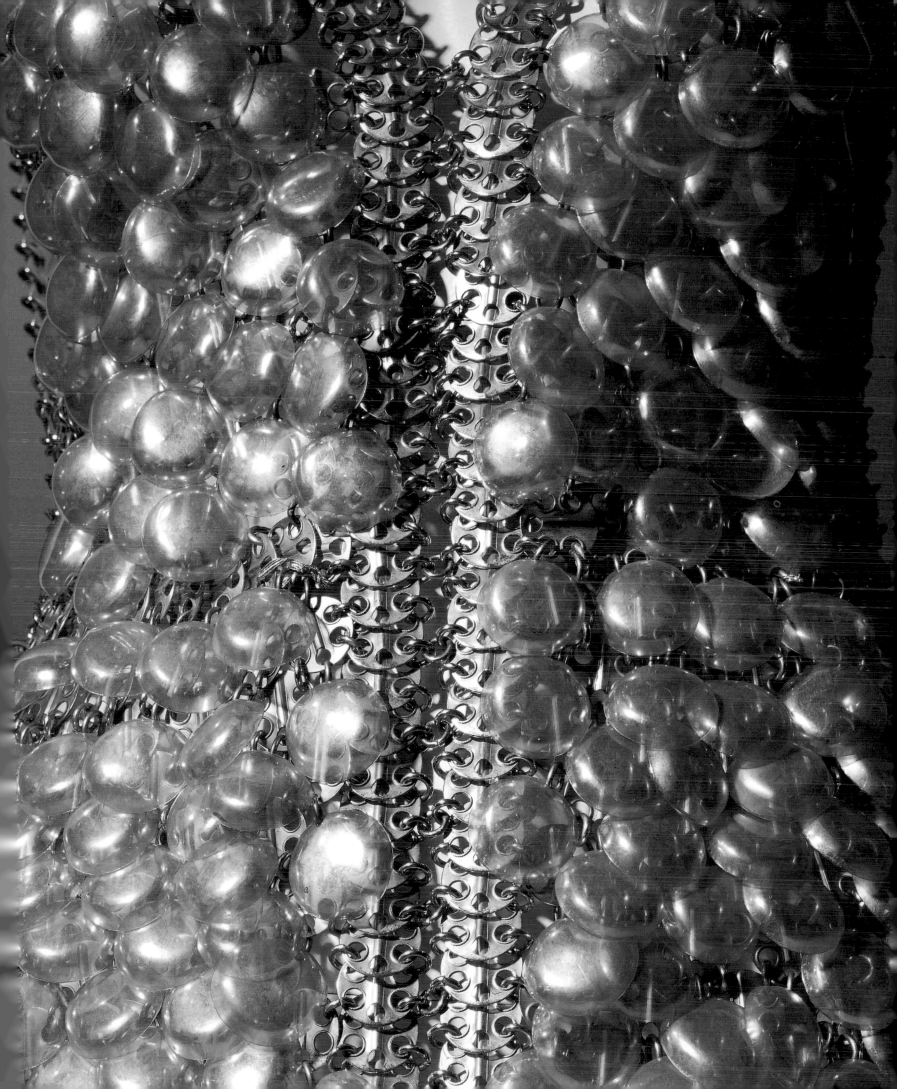

plate 7
Yves Saint Laurent for Christian Dior
Dress, 1957

plate 8
Paco Rabanne
Gown with Tunic, ca. 1975

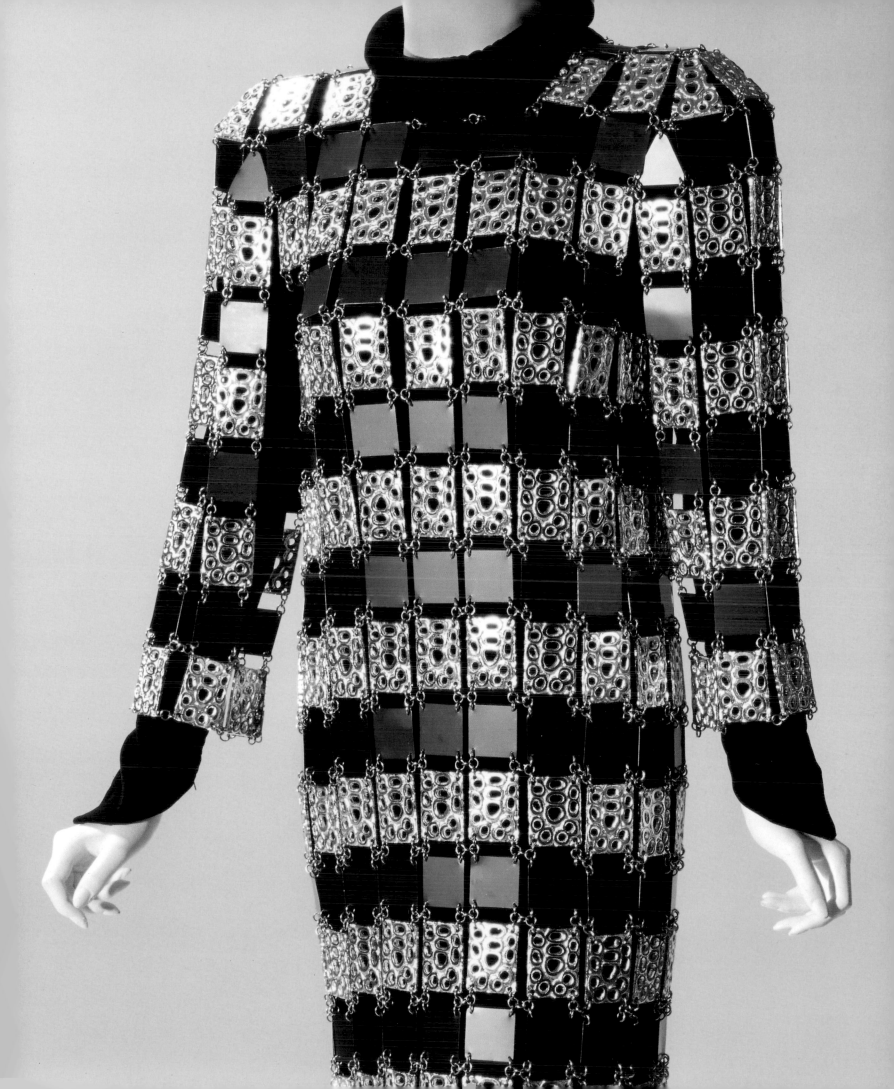

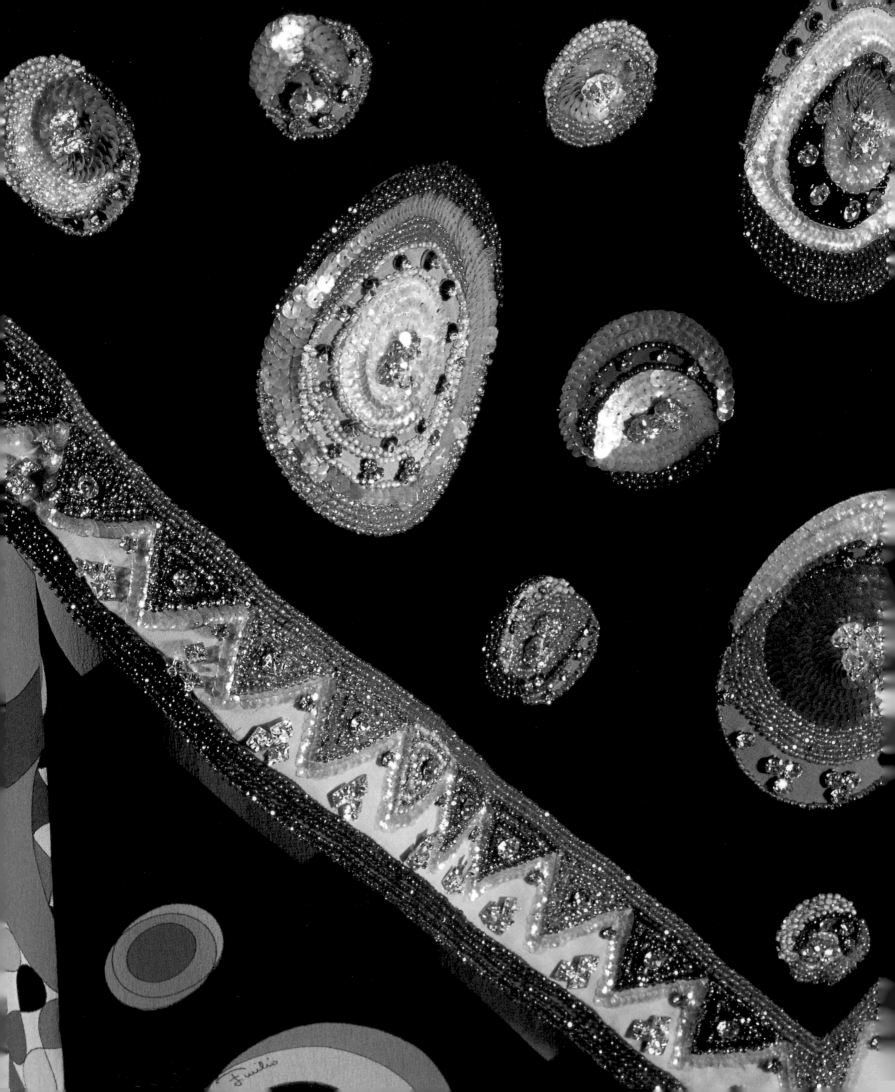

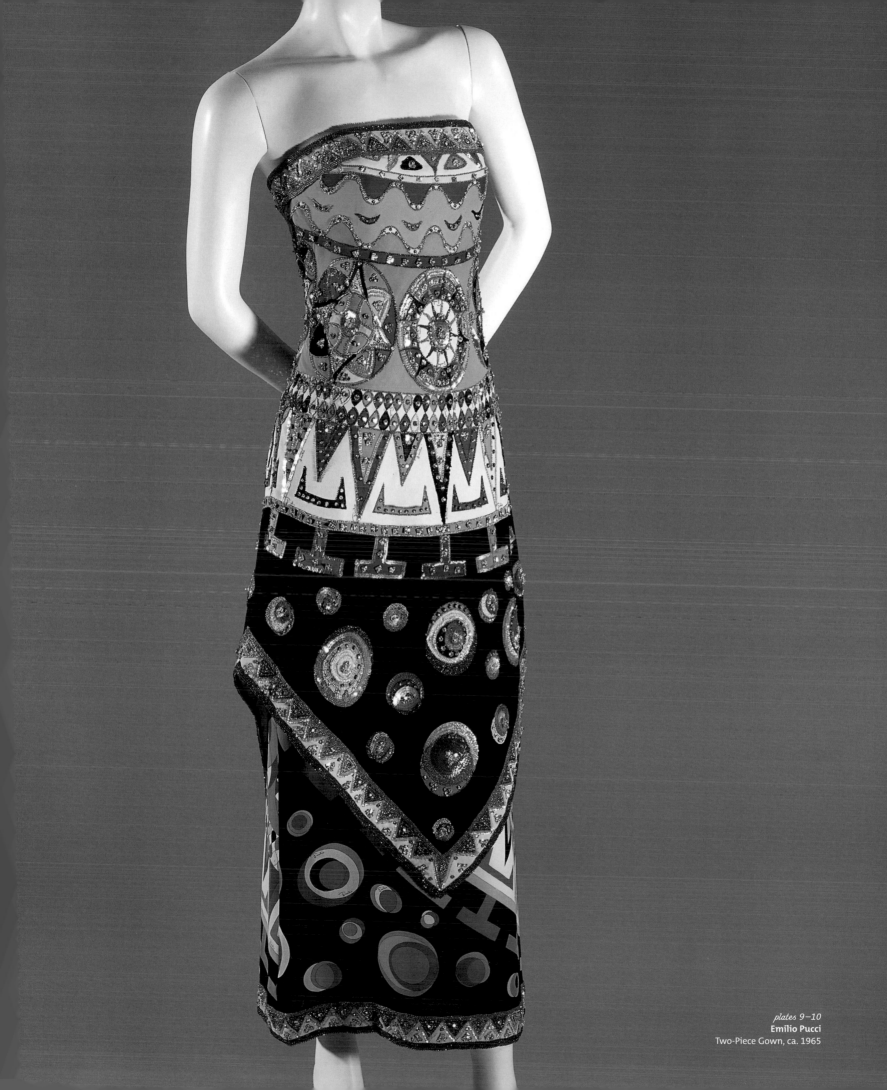

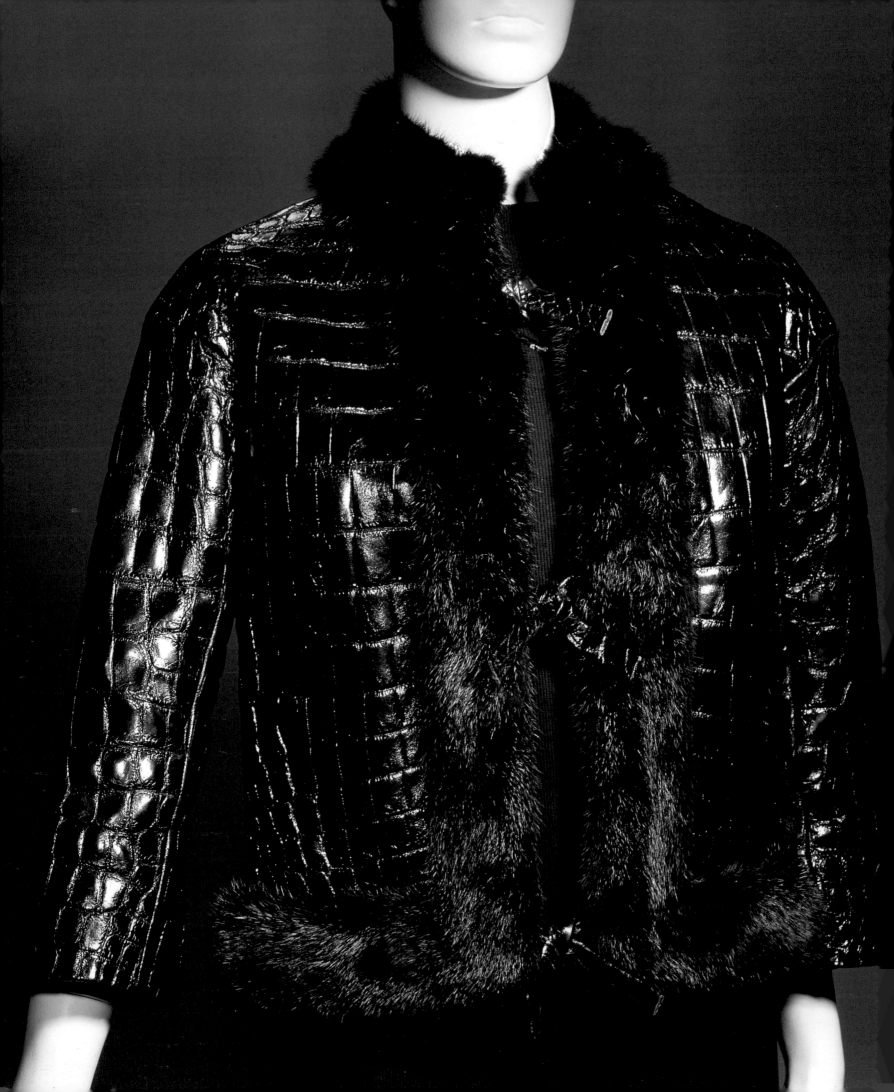

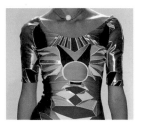

62

FASHION *in focus*

by RUTH KEFFER

In the decade immediately following World War II, when fabric and a variety of other materials had been strictly rationed, couture fashion houses built their reputations through an emphasis on extravagance and excess. After enduring years of conservative styles, women were eager to indulge in clothing as an expression of affluence, sophistication, and freedom. Designers such as Adrian, who began his career as a Hollywood costume designer, transposed the fantasy and theatricality of 1940s film culture into the realm of fashion (see pl. 1). Though glamour had always been closely linked with couture and with the public display of personal style, it was not strictly synonymous with elegance. A hint of raciness and a good measure of showmanship defined the most provocative styles of the postwar decades.

With Christian Dior leading the charge, mid-century designers renewed their obsession with the classic hourglass silhouette and other traditional signs of femininity. A 1955 design by Dior (pl. 2) typifies the style: A strapless bodice wraps the upper body tightly, accentuating the breasts and waist, while a cocktail-length skirt made from multiple layers of sheer tulle billows around the legs like a cloud. In a 1950s gown by Cristóbal Balenciaga (pl. 4), who was known for his precisely cut patterns, the hourglass form is achieved through a deceptively simple layering of parts: A bodice adorned with a bow joins an extravagant skirt that cascades to the floor in descending tiers of yellow silk.

As the postwar economy surged with mass-produced goods, designers sought to emphasize their specialized skills as artisans. Attention began to shift from the shape of the body wearing the dress to the structure of the garment itself. A strapless 1957 design by Yves Saint Laurent for Christian Dior (pl. 7) is gathered at the bust instead of the waist, with the remainder of the fabric falling away in two long pleats that encircle the front of the body. The gravity-defying effect of this slightly slimmer silhouette was as striking on the female body as classic curves. Saint Laurent's mastery of tailoring was shared by Madame Grès, a couturier known for minimalist but highly engineered designs. A Grès dress from the 1960s (pl. 3) exemplifies the seductive lines of her streamlined gowns. The bodice is a single band of lightweight silk jersey that is pleated rather than cut and sewn, and the form reveals as much as it conceals. Mimicking the lines of a Greek column, the pleats continue down the length of the skirt, elongating and accentuating the body.

Exotic or unusual materials could also make a design aesthetically daring. Saint Laurent, in his last collection for Dior in 1960, introduced an alligator biker jacket trimmed with mink (pl. 11). The juxtaposition of luxurious fur with a material traditionally reserved for banal items such as purses and shoes was so radical a gesture that it got the designer fired. However, by marrying the couture aesthetic to elements of popular culture, the jacket signaled a fundamental shift in the world of fashion. In the 1960s and 1970s Paco Rabanne championed the use of unconventional materials as a means of pure visual expression. For a series of garments he referred to as "Unwearables," Rabanne created dresses from elaborately fastened lattices of plastic buttons or small aluminum tiles (see pls. 5–6, 8). These experiments, playfully disregarding the question of functionality, achieved the glamour of inutility—of art for art's sake. Emilio Pucci also strove to redefine the parameters of the couturier's art. Structurally, his designs (see pls. 9–10) were clean, loose, and almost untailored, but his colorful, wildly patterned fabrics were as radical as anything produced by the psychedelic artists who were his contemporaries.

Today's designers reinvent as often as they invent—established and upstart fashion houses unapologetically mine the profession's history in search of fresh ways to seduce consumers. The traditional look of a company such as Christian Dior or Chanel may be transformed in the hands of a new chief designer, who will often assert his or her own aesthetic while preserving signature details as essential marks of the brand. In the past two decades, as older houses retool themselves and emerging designers struggle to compete, the most persistent strategy has been the appropriation of "low" culture: athletic wear, thrift-shop bohemianism, risqué club attire, "heroin chic," and other trends in which contempt for luxury or disdain for decorum is a salient characteristic. In this context, glamour has been redefined as a declaration of fashion savvy.

In updating styles of the past, contemporary designers often exaggerate and embellish traditional traits of glamour, creating looks that fetishize femininity or luxury. A 1999 dress by John Galliano for Christian Dior (pl. 16) has the statuesque presence of an Adrian gown, but the skirt is so elongated that it gathers in piles on the floor, an obstacle to the sweeping movement it is meant to imply. Christian Lacroix's designs treat the hourglass figure as a kind of hypercondition. One example from 1996–97 (pls. 21–22) joins a tightly cinched corset with billowing sleeves and skirt; within this fabrication of femininity the natural female form seems to disappear.

Seeking inspiration from trends outside the fashion milieu, contemporary designers have manipulated a range of unconventional materials in their quest for a radically new aesthetic. A mid-1990s Jean Paul Gaultier design (pl. 26), made from nylon, polyurethane, and spandex, is meant to suggest neoprene, the substance used for wet suits. Ribbed through the bodice and zippered tightly up the back, the form-hugging dress is an interpretation of the lean, sexy look of an athlete in peak condition. A slinky purple gown designed by Giorgio di Sant'Angelo in the mid-1980s (pl. 14) evokes the casual decadence of nightclub attire. Made of sheer stretch fabric studded with plastic and metal sequins, the dress makes reference to the more earnest experiments of Rabanne, but its principal appeal is its glitz.

The relationship between glamour and sexuality has become increasingly overt in recent fashion. No designer was more aggressive than Gianni Versace in exploiting the shock value of sexually provocative styling. With a nod to Madame Grès, a 1991–92 Versace dress (pl. 17) features a bodice structured from strips of fabric that interwine over the breasts in an unsubtle reference to bondage straps. The dress is pure spectacle—of the female form it barely contains and of the designer's daring. A 1980s Thierry Mugler suit (pl. 19) asserts a certain conservative elegance; below oversize shoulders, the fabric wraps the torso and gathers smartly at the waist. Yet the design is something of a caricature—the material is a couture approximation of latex, a substance whose allure for sexual fetishists enhanced the novelty of many Mugler creations.

In recent years designers have continued to resurrect and transform traditional elements of glamour. A 1999–2000 Donatella Versace design (pl. 28) reinterprets the classic evening gown in a dazzling fuchsia color with an aggressively slit skirt. In 2004 Zac Posen fashioned an hourglass silhouette by joining a cleverly tailored bodice to a thicket of palm fibers (pl. 25). Contemporary couturiers create self-consciously and frequently flout the rules, but the primary ideals of glamour—theatricality and extraordinary beauty—persevere.

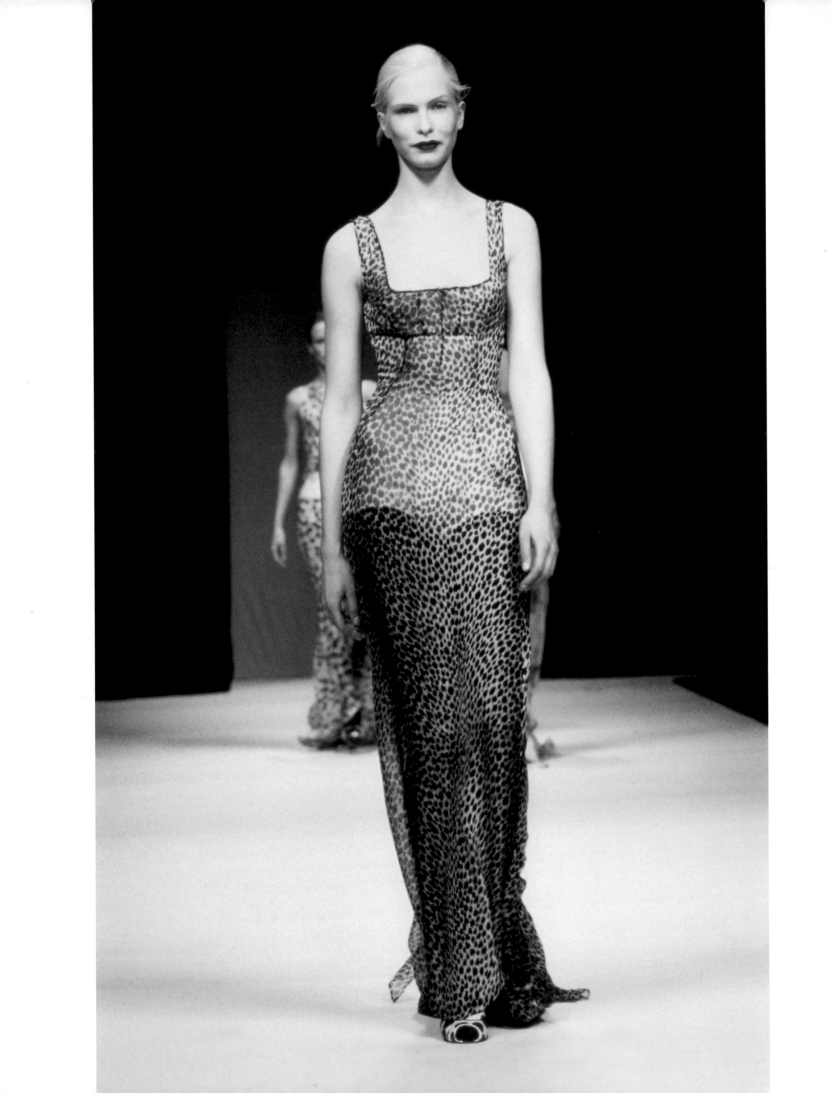

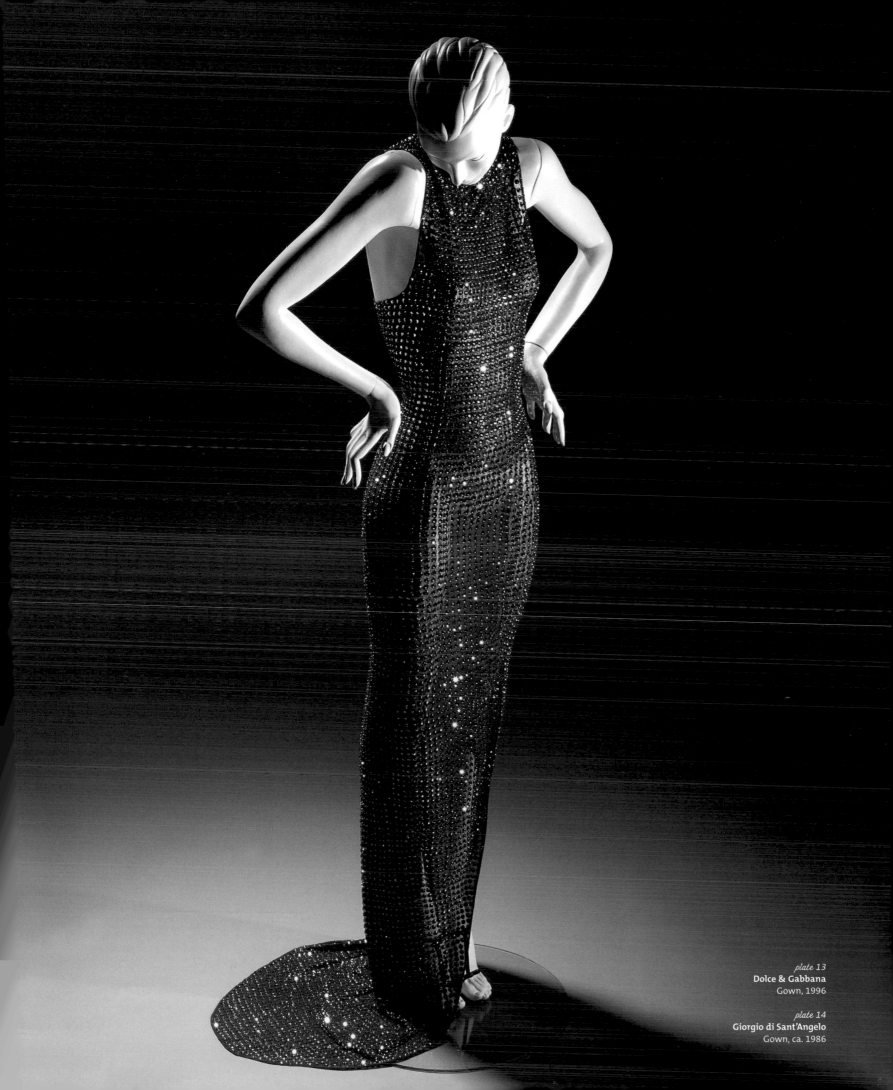

plate 13
Dolce & Gabbana
Gown, 1996

plate 14
Giorgio di Sant'Angelo
Gown, ca. 1986

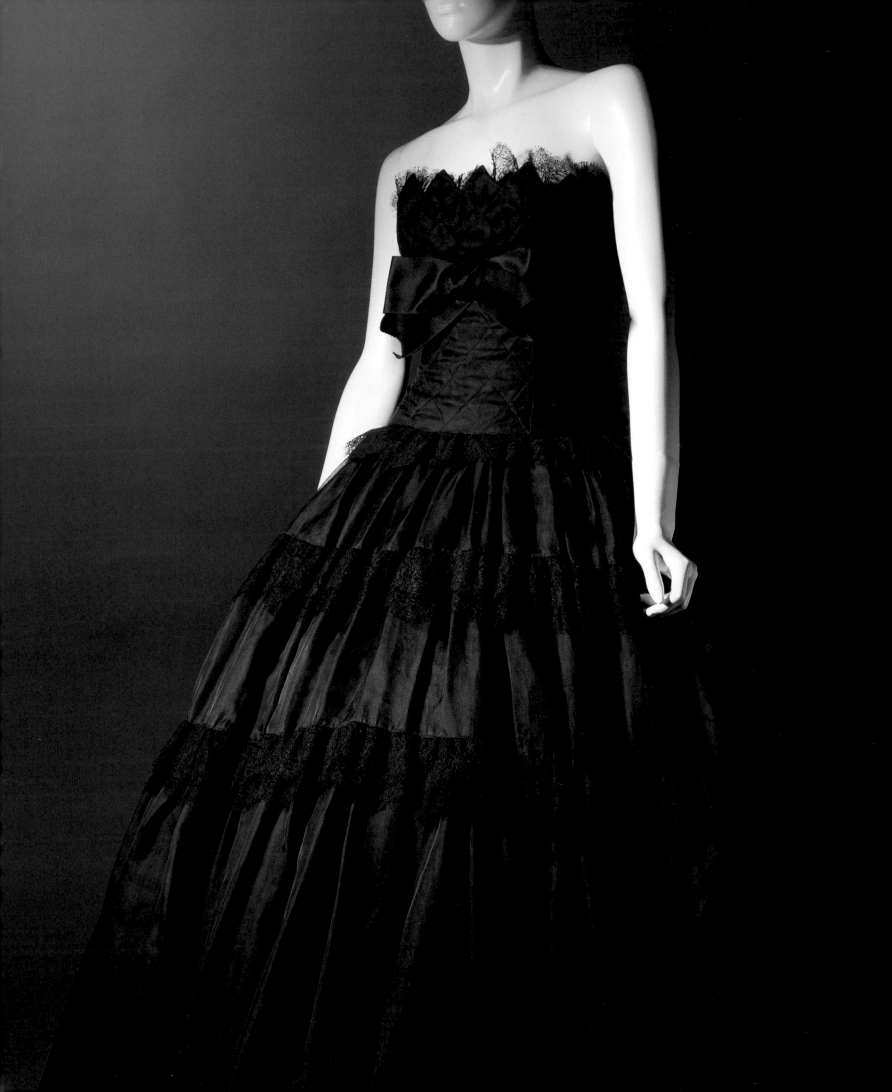

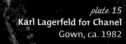

plate 15
Karl Lagerfeld for Chanel
Gown, ca. 1982

plate 16
John Galliano for Christian Dior
Gown, 1999

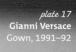

plate 17
Gianni Versace
Gown, 1991–92

plate 18
Karl Lagerfeld for Fendi
Gown with Hooded Jacket, ca. 1985

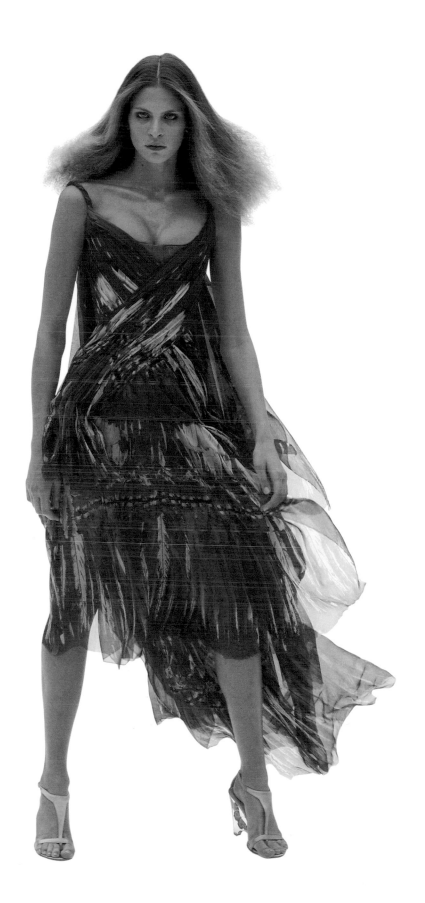

plates 21–22
Christian Lacroix
Gown, 1996–97

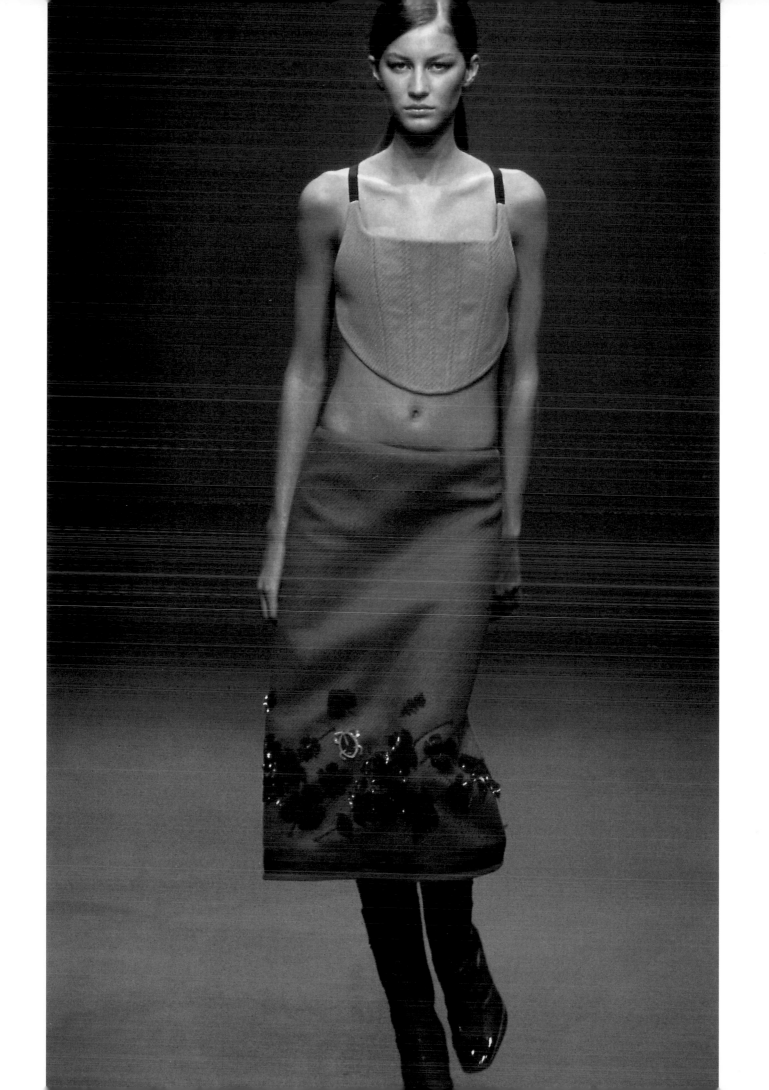

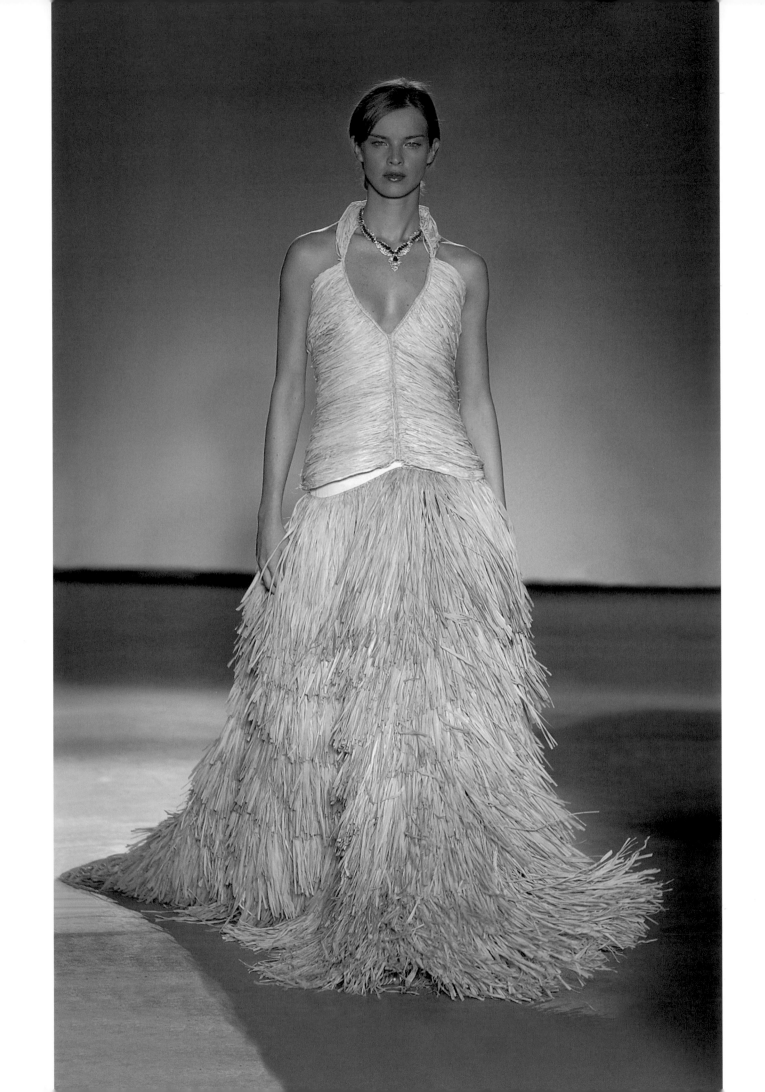

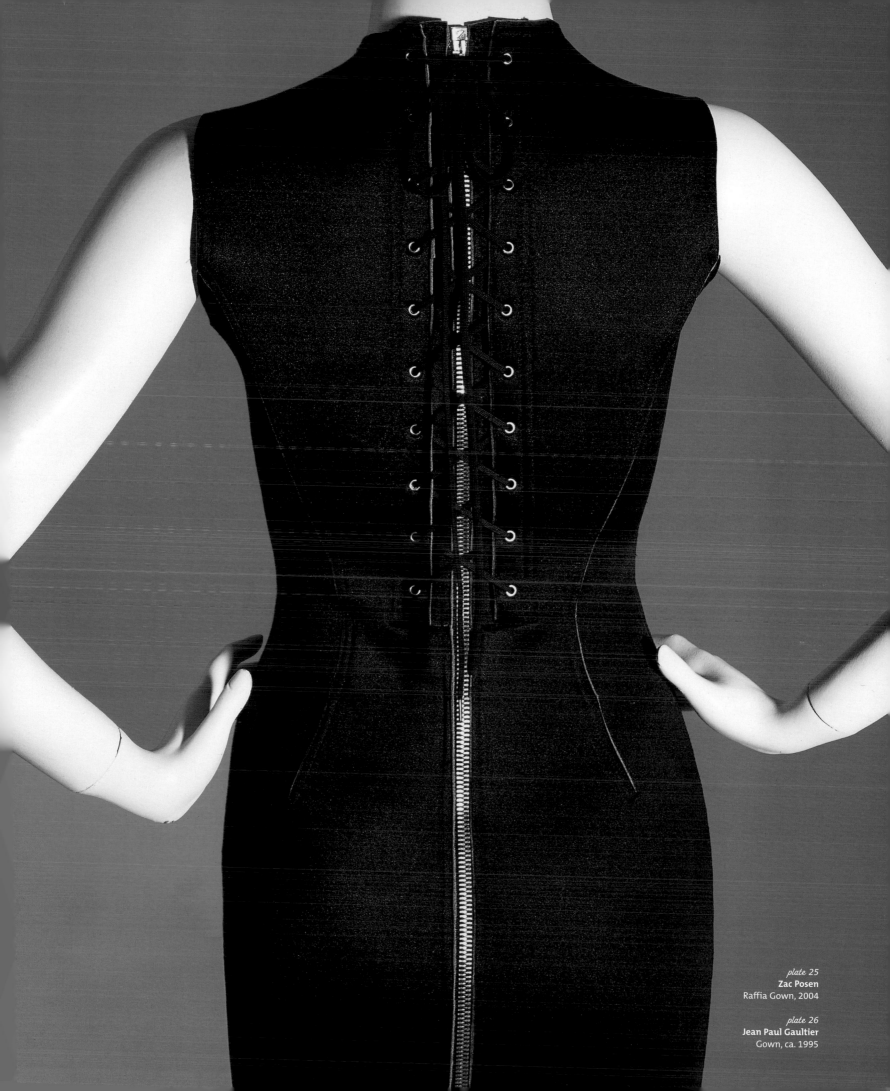

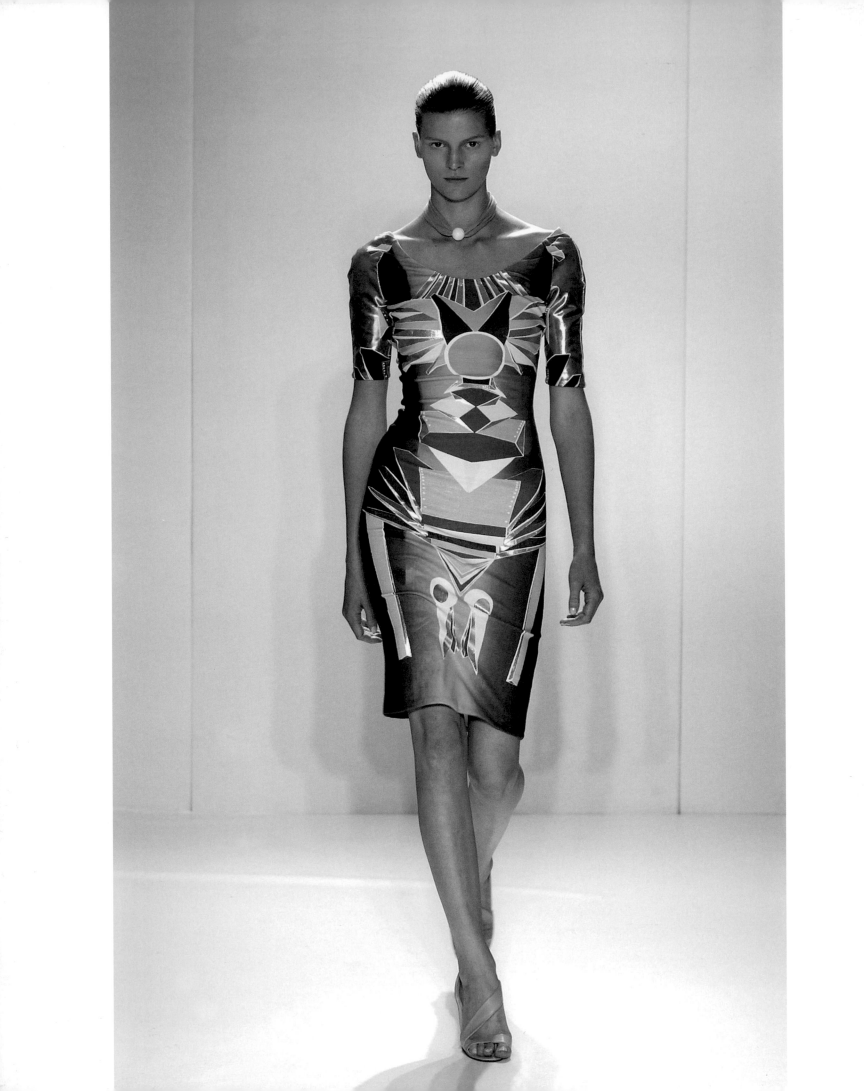

INDUSTRIAL DESIGN

industrial design

by PHIL PATTON

The grille of the 2004 Bentley Continental GT coupe (fig. 17, pl. 49) is a high-tech, laser-cut pattern of twists and turns, highlights and shadows, a complex, gleaming shape of chromed metal. It evokes the woven wire grilles of classic Bentley racers and sedans, but it is rendered at a depth made possible only by computers. It also harks back to the armor and heraldry of the days of chivalry, summing up a brand compounded of Britishness, racing, and the romance of the automobile. Dirk van Braeckel, Bentley's design director, calls the grille's glamorous pattern a "matrix."

In many ways the matrix is an apt symbol of the state of design at the beginning of the twenty-first century, as many industrial designers have begun revisiting—with a twist—the forms and patterns of the past. In a time of remakes and remixes, covers and sampling, design has become deeply implicated in the reinvention of glamour. Simultaneously, the ideal of impersonal mass production has gradually given way to the paradigm of highly personalized mass customization. For premium goods, the rarity of craft has been replaced by the precision of high technology, while patterning and decoration have returned from the exile into which Modernism drove them. No trope was more central to Modernism than the regular grid; the matrix is that grid transformed, grown dynamic and flexible, a web draped across the planet. The matrix builds on the patterns of digital networks, in which each element adds exponential value to all that precede it.

Matrix is, of course, a term with many connotations. The geologist speaks of native gems and crystals discovered in matrix. The printer drew type from a matrix. For the mathematician, the matrix is a rectangular array of numbers with an algebraic relationship; for the student of management, matrix organization is a step beyond old-style chains of command and control. And for contemporary film buffs, *The Matrix* trilogy offers an updated sci-fi vision as iconic as *Blade Runner* and *2001: A Space Odyssey* were for earlier generations.

Glamour's matrix represents the intersection of these many different meanings. Its complex, networked imagery is evident in the effulgent patterning of wall coverings, textiles, and other goods from companies such as Maharam, Louis Vuitton, and Burberry. Petra Blaisse's Knitte #1 wallpaper (pl. 44), a 2003 design for Wolf-Gordon, demonstrates a rich understanding of the glamour of pattern, as does Jürgen Mayer H.'s 2004 installation *Pretext/Vorwand SFMOMA* (pl. 48), which is inspired by the idea of a virus-protection firewall. In such intricate patterns, surface takes on a new and more ambiguous status. At once functional and ornate, it redeems decorative qualities long disdained by Modernists (as Adolf Loos famously put it, "Ornament is crime").

The new dynamics of network thinking may have reasserted the function of patterning, but the network has beauties of its own. In 1999 a number of high-tech companies developed figurative maps

figure 17 **Bentley Motors**
Bentley Continental GT Coupe, 2004
Detail of grille

tabletop like the train of a formal gown—a witticism that suggests a measuring mistake or Thomas Jefferson's famous pendulum at Monticello (the Enlightment do-it-yourselfer had to cut holes in his floor to accommodate the clock). But what the Cascade tumbles onto is the Parsons table, the most minimal of modern furniture designs; fourteen feet of crystal are brought up short by an icon of Minimalism— or is it the minimalist icon overwhelmed?[1]

In terms of the movement toward glamour in industrial design, the matrix symbolizes the dynamism of the network in contrast to the rigidity of the old grid. It represents the interactive power of the Global Positioning System in contrast to the formulaic sequence of latitude and longitude in old Mercator projection maps. It is epitomized in designs such as Mark Naden's 2003 Topos chair (pl. 43), which translates the gridded, bent-wire seat of Harry Bertoia's classic 1952 Bertoia chair into sensuous birch and maple. Even more evocative is Konstantin Grcic's 2003 Osorom bench (pl. 39). An ovoid form that plays on the image of a globe, it is a fiberglass and resin grid across which the shapes of continents are deployed.

of the Internet by tracing the frequency of connections between discrete sites (see fig. 18). The resulting matrix of associations, which resemble shimmering constellations, suggests nothing so much as Tord Boontje's 2003 Midsummer lamp (pl. 37) or Vincent Van Duysen's 2003 Cascade chandelier (pl. 35). In the wake of Ingo Maurer's poetic lighting experiments and the clever clutched bulbs of Droog Design, the lush light of these chandeliers has redeemed an entire typology, reinventing a form long associated with elegance and luxury for the new era of glamour. Commissioned by the Austrian crystal maker Swarovski for its Crystal Palace Collection, Van Duysen's chandelier tumbles onto the

Automotive grilles, the family crests of automobiles, represent one of the earliest forms of branding. Although the first examples were simply shields of wire mesh protecting the radiator from flying stones on unpaved roads, the grille soon became a car's face. In fact, automotive grilles were among the first items given over to the ministrations of industrial designers. Especially during the Depression, when sales were slow, design was seen as a way to kick-start the economy and to brighten a dark time. The business world hailed industrial designers as heroes capable of conveying attractive products—comforts and conveniences previously enjoyed only by the wealthy—to the masses. They were asked to bring glamour to the mundane, just as Hollywood brought glamour to the main streets of small towns throughout the nation.[2]

figure 18 **Lumeta**
Internet map, 1999

The American ideal of good things for all quickly evolved into great things for all. By 1933, when Huey P. Long coined his demagogic slogan "Every Man a King," the populist ideal had been pushed to its extreme in design as in all aspects of life. Americans—and increasingly others around the globe who aspired to the American lifestyle—believed that they were entitled not just to comfort and convenience, but also to something like luxury itself: the stuff of the celebrities with whom they were fascinated.

No material better symbolized the glamorizing role of the industrial designer than chrome. The key decorative element of the automobile, chrome began life as the miracle metal of the 1920s. Embodying the notion of sleek modernity, it was a product of World War I military technology. Like glass or clear plastic, chrome transcended mundane steel; it mirrored its environment, dematerializing and idealizing the forms it plated. On the steel tubes of Bauhaus furniture and lighting, it was the very symbol of Modernism. Applied to streamlined Art Deco tableware and appliances, it was the sign of the emerging Moderne. It was glamour itself, a few molecules thick.

Chrome captured the fancy of Ludwig Mies van der Rohe and Marcel Breuer, the most rigorous Bauhaus Modernists, but it was not long before its gleam came to suggest the glitz and flash of celebrity. Although Emily Post praised it as a tasteful material, chrome soon became a symbol of superficial style: "No dignity without chromium / No truth but a glossy finish," William Carlos Williams wrote skeptically in his poem "Ballad of Faith."[3]

figure 19 **Stanley Kubrick**
Still from *2001: A Space Odyssey*, 1968
Seating by Olivier Mourgue

In recent decades, even as chrome's initial luster of speed and sleekness has tarnished, industrial designers have continued to rely on the glamour of technology to bring a sense of brightness to the everyday. In the 1990s Ford's top designer, J Mays, popularized the term *retrofuturism,* a useful evocation of nostalgia for a time of forward-looking hope and romance. Mays's retrofuturism implied a self-conscious return to the optimism and, indeed, naïveté of the mid-twentieth century, when the techno-logical future still appeared promising.

In 2001, amid celebrations of Stanley Kubrick's 1968 film *2001: A Space Odyssey,* it was striking that the only objects in the movie that still seemed futuristic were the furniture pieces (see fig. 19). The designs for the doughnut-shaped space station and rocket ships had long been surpassed by reality. The companies shown in the film were quaint—Pan Am was gone, AT&T had been broken up. But Olivier Mourgue's vivid red Djinn chairs, designed in 1965, still looked fresh and exciting. At the dawn of the new century, Modernism had unquestionably become historical—and a rich source of glamour for contemporary industrial designers.

There is a certain irony in the fact that Modernism, established as the style to transcend style, has become fashionable again. Indeed, the current reappreciation of early modernist design was conditioned by the failure of mid-century technological dreams. Contemporary designers are aware that the wonders promised fifty years ago never arrived—well-designed, mass-produced, mass-marketed chairs remain as elusive a goal as recreational space stations and rocket ships. Designers' attraction to mid-century icons betrays the ambiguity of postmodernity: Their ironic nostalgia with regard to the promise of technology coexists with a more complex view of the future. Tellingly, the modernist designs being reimagined today are often described as "mid-century modern" or "classical modern." Once Modernism's basic canon of heroes—Charles and Ray Eames, Isamu Noguchi, Eero Saarinen—was established, new angles began to emerge. Jean Prouvé and Verner Panton shifted center stage, and fascinating, offbeat figures such as William Haines (see pls. 32–34) were discovered and rescued from the periphery.

Some contemporary designers, such as Christophe Pillet and Werner Aisslinger, seek to extract the essence of modernist types and iconic mid-century designs. Glamour is, after all, a form of modernist revival, and it necessarily involves a conscious attempt at reinvention and reinterpretation. Marc Newson's distinct brand of glamour inflects biomorphic, embryonic shapes with an aerodynamic line, playfully bent and crimped in his 1993 Felt chair (pl. 41) and even in his slick, tubular 021C concept car, a design unveiled by Ford in 1999. Ronan and Erwan Bouroullec, meanwhile, bring a special wit to the modernist revival. The brothers have produced an orderly version of the mid-century ideal that plays on the systems mentality of the 1950s and is as dry as a good white wine. They view much of their work as "microarchitecture"—stage sets for small domestic or office dramas. Between poetry and cartoon, at once romantic and childish,

the modular 2003 Cloud shelving unit (pl. 38) turns the grid into a honeycomb, deriving its formal system from the ultimate nonform, the cloud.

Related to the modernist revival is an aesthetic that might be termed hypermodernism: the desire to return to the engineering virtuosity that distinguished American industry in the mid-twentieth century. In the 1950s aeronautical engineer Richard T. Whitcomb famously theorized that an aircraft with a "Coke bottle waist" would be able to break the sound barrier—a discovery that led to the hourglass design of delta fighter planes. Hypermodernism's characteristic form is thus the hyperbola, a shape that migrated from aerospace technology to quotidian life via designs such as Raymond Loewy's 1955 Rosenthal tea service and 1962 Studebaker Avanti.

Ross Lovegrove, the contemporary designer with perhaps the most affirmative take on the ideals of Modernism, has a deep and genuine belief in the power of technology, and his sweet, hypermodern line has made believers of those who admire his products. Lovegrove praises "the work of the great

modernists such as Eames, Saarinen, and Nelson who combined anatomy with technology and emotion." He urges "a new movement for the twenty-first century titled Organic Essentialism that is almost biomimetic and inspired by new materials, processes, and technologies."[4] In the looping polyurethane ribbons of Lovegrove's 2003 Brasilia lounge chair (pl. 47), the virtuosity of construction plays on the unabashed technological optimism of the mid-twentieth century.[5] Like Saarinen's 1956 Tulip furniture or 1962 TWA terminal in New York, Lovegrove's design is about creating new forms, not just reviving or finessing the gestalt of established types. While the mid-twentieth century had boasted of conquering nature through technology—of defeating time and space and of controlling the landscape—Lovegrove envisions technology working in harmony with nature and humanity. He represents this view quite literally in the 2001 Agaricon Touch lamp (pl. 42): The hyperbolic form is a kind of Aladdin's lamp, illuminated magically with the touch of a hand.

In a development that runs parallel to hypermodernism, contemporary figures such as Aldo Rossi and Steven Holl have sought to distill essential formal typologies from less-pedigreed objects in the history of design. Holl's Linear chair of the 1980s, for example, is an abstract interpretation of nineteenth-century Shaker ladder-backs, in the tradition of Gio Ponti's 1957 Superleggera or Jasper Morrison's 1988 Ply. Other designers have chosen to appropriate or repurpose everyday materials. The timepiece of Brent Haas's 2003 ACE Bandage watch (fig. 20) is mounted on a screen-printed, elasticized bandage that wraps the wrist as though it were sprained or wounded. Holl and Haas demonstrate that iconic objects and deluxe materials are not the sole inspirations for designers who look toward historical precedents for an aura of glamour.

figure 20 **Brent Haas**
ACE Bandage Watch, 2003

Haines, a respected film actor who gave up his career to devote himself to designing furniture and interiors, brought the furniture of the silver screen to the real world. Pieces such as his 1955 Brentwood chair (pl. 33) could have come straight out of Lana Turner's penthouse or Joan Crawford's opulent home (see fig. 21). Stylistically noncommittal, the low chair was shaped to accommodate a woman in a voluminous evening gown.

From our present vantage point, when magazines chart every purchase of the stars, Haines seems years ahead of his time. To own the same objects as celebrities is as close as most people will get to being stars. Reflecting this fact of consumer culture, film product placement has become one of the most important marketing tools of recent decades. First came automobiles—the Jaguars and Aston Martins of James Bond films—and then came clothing, watches, and sunglasses. But even more striking is the flip side of this process—people inserting products into their lives as if they were props in a movie. Public response to the futuristic telephone concept Nokia created for the first *Matrix* film was so positive that the company had to turn out an actual product of similar configuration—the sought-after model 8110. Product placement, however, does not just propagandize the products themselves; it presents objects as indices of character. In so doing, it helps to glamorize them, transforming them into celebrity objects.

Historian Daniel Boorstin once described celebrity as the state of "being famous for being famous," and glamour has long been associated with this twentieth-century invention.[6] Celebrity grew out of new technologies, particularly the media of radio and film. Mass-audience sports, abetted by radio, film, and then of course television, made household names of Babe Ruth and Joe Louis. In 1927 the exciting technology of aviation rendered Charles Lindbergh the prototype of the modern celebrity, whose private and public lives are inseparable.

A similar breed of stardom eventually came to settle on objects—and the designers who made them. William

Even simple household items have taken on a measure of celebrity. Like ordinary citizens made millionaires by Regis Philbin or turned into pop stars on *American Idol,* ordinary products can become stars through design, as did Philippe Starck's 1990 Juicy Salif lemon squeezer, Karim Rashid's 1999 Oh chair, the Apple iPod, the new MINI Cooper automobile, Michael Graves's 1985 Whistling Bird teakettle for Alessi, and Don Chadwick and Bill Stumpf's 1994 Aeron chair for Herman Miller. Many of these celebrity products have grown out of an

figure 21 **William Haines**
Custom furniture for Joan Crawford's Brentwood, California, home, ca. 1949

Refrigerators, radios, toasters, and other "modern conveniences" easily lent themselves to a Sloanist treatment. Companies called on designers to differentiate technically similar devices into basic and luxury versions. Kodak, for example, added color and decoration to the basic black box of its Brownie camera much as GM had added color and variation to the basic black car body.

Of course, part of the Sloanist strategy was what Sloan called "the manufacture of discontent." In introducing new models each year, GM adopted the techniques of the apparel industry, creating fashions that made old models obsolete and new ones desirable. Enthusiasm for this year's model bred discontent with last year's. Sloanism thus helped answer the problems of the "saturated market," in which the falling marginal costs of standardized models led to universal ownership, limiting the potential audience for new products.[17]

Beyond Sloanism lay Swatchism. Named after the Swiss watch company Swatch, the term denotes the design of distinctive shells housing shared common mechanisms—a tactic that offers the superficial illusion of customization. Swatch founder F. A. Hayek aimed to bring a radical platform strategy to watchmaking, traditionally a luxury-oriented business relying on handicraft. Using designer names, limited production runs, and the dynamics of fashion and collectibility, Swatch established a model other industries soon adopted. Motorola issued beepers in colorful shells, and cell-phone and computer companies followed suit—most notably Apple, with its transparent, candy-colored iMac. The original black Sony Walkman was supplemented with dozens of variants in style, color, and price; the Apple iPod has moved almost as rapidly from an initial white model to a selection of colors and sizes.

Swatchism's successes and efficiencies gave Hayek total production control of key portions of the basic watch-movement mechanism. But then something surprising happened—he turned his interest to the watches of the past, acquiring a number of esteemed companies for the Swatch empire.[18] As a result, far from dooming traditional luxury watchmakers, the Swatch revolution has given them new life, and the demand for the watch as jewelry has returned with a vengeance. Recent years have seen a resurgence of high-end chronometers, platinum and gold cases, and rare, limited-edition models. The lesson is clearly that mass-produced products do not spell the end of luxury objects. Classic timepieces like the Rolex Oyster Perpetual Datejust (pl. 45) have been revived and reimagined, and Armani, Fendi, and other premier designers have joined august watchmakers such as Breitling and Bulgari in the watch trade. Like eyewear and fragrances, watches have become *de rigeur* elements of every luxury fashion brand's domain.

If the first watches were a form of high tech—early computers, in effect—it is fitting that technological advances have continued to inspire designs representing the glamour aesthetic. The computer itself has become a tool for design, directing Computer Numerical Control (CNC) milling machines to shape molds and stamps or guiding

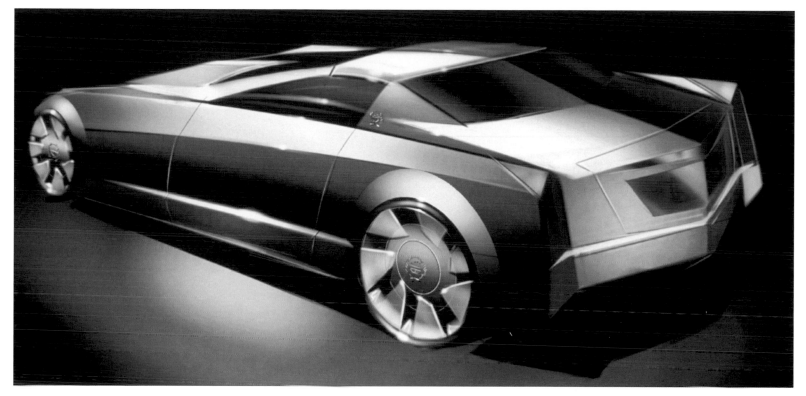

stereolithography lasers to model three-dimensional forms. Such technologies carry with them a new kind of glamour, tied not to streamlined symbols of acceleration but to the compression of the chip and the algorithms of the network.

The glamour of technology has long been important for designers of automobiles and household appliances. As noted previously, mid-century designers adopted aeronautical innovations such as the wasp waist and tailfin to imbue their products with a glamorous, technologically sophisticated sensibility. The trend continues today: For his 1999 Evoq

concept car (fig. 24), Cadillac designer Kip Wasenko took inspiration from the F-117 stealth aircraft. Taking off from the plane's faceted shape, his design laid out the basic tendencies of a corporate design philosophy known as "art and science." The F-117's facets reflect radar waves away from the source, making the plane difficult to spot.[19] As translated into Cadillac's latest product line, the look takes glamour from a novel combination of sources, suggesting military high tech as well as the facets of precious gemstones.

Stealthlike faceting is also visible in the stunning 118 WallyPower yacht (pl. 46), developed in 2003 by Wally founder Luca Bassani Antivari. With a body made largely of carbon fiber, the stuff of fighters and Formula One race cars, the 118 has been called "Darth Vader's yacht" and was described by one boating magazine as "psycho origami."[20] The boat uses modified helicopter engines to achieve a top speed of sixty knots. Carbon fiber and light-colored wood line

figure 24 **General Motors**
Cadillac Evoq Concept Roadster, 1999

a sleek interior by Lazzarini Pickering Architects. The 118's hydrodynamic design has an important functional role: Its facets carefully direct water into the jets of the yacht's power plant. As any gap in the flow could lead to erratic performance or engine failure, prototypes were systematically tested in water tanks and in Ferrari's wind tunnel in Marinello, Italy.

Even the luxury, "bespoke" world of vehicles such as Rolls-Royce and Bentley has embraced the glamour of technology—an evolution embodied by the Bentley Continental GT. Aimed at attracting a wider audience to the classic British brand, the sporty, aggressive 2004 coupe marks a new relationship between luxury and mass production as well as a reinvention of the tradition of personalized luxury cars. The most affordable Bentley ever produced, the Continental GT required a significant uptick in the company's production capacity: Bentley aims to turn out approximately two thousand Continental GTs annually, whereas in past years it had only built five to seven hundred of the stately Arnage. The Continental GT's engine—a W-shaped, twelve-cylinder machine supercharged to reach 550

horsepower—was built around research and development for the larger Volkswagen family. Only corporate synergy offers the economies of scale that can sustain the feasibility of the Bentley brand.

Bentley's fame was forged in the 1920s at the legendary races of Le Mans. Walter Owen Bentley, the creator of the car, gathered around him the wealthy young men known as "the Bentley boys." These devil-may-care drivers dashed across Europe competing in races that began with champagne breakfasts in Paris hotels and ended, via ferry, with dinner in London gentlemen's clubs.[21] The cars they drove were huge and powerful, with leather hood straps and tall radiators featuring distinctive chain-wire grilles. But then came the Depression. In 1931 Bentley's founder declared bankruptcy and Rolls-Royce took over the company; Bentley became a secondary brand, the poor rich man's alternative to the Rolls. In 1998 Bentley was sold to Volkswagen, whose chair, Ferdinand Piech, loved the cars and drove one daily. Meanwhile, Rolls became part of BMW. Clearly, it was no longer possible to create such expensive vehicles without the support of a larger company.

Updating Sloan's strategy, Volkswagen called upon designers to differentiate makes and models that shared basic chassis and engines as well as water pumps and door handles. Bentley was able to retain its key craft-based virtues, but production was now abetted by technology. Lasers cut wood veneer as thin as parchment and computers scanned cowhide, avoiding imperfections and using materials with a minimum of waste. For all its production synergies, however, Bentley still required a distinctive character, which is where Dirk van Braeckel entered the picture.

Before coming to Bentley, van Braeckel, who was educated at the Royal College of Art in London, honed his skills in the studios of Audi and Skoda, Volkswagen brands with their own distinct traditions and

personalities. Although his Continental GT is not obviously retro, it evokes the "blower Bentleys" of the 1920s and the flowing lines of the 1952 R-Type Continental. Van Braeckel designed the car to resemble a crouching animal. The use of chrome is limited to the grille, where the brightwork is muted and controlled. But the design also lays claim to the wider British tradition of sleek, racing-inspired sports cars such as the classic Jaguar E-Type (pl. 31) or Aston Martin.

With its matrix grille, the Bentley Continental GT signals a radical repositioning of the Bentley brand. For years Bentley had been distinguishing itself from Rolls-Royce as the car you drove yourself rather than the car in which you were driven. Then, in the 1990s, Bentley regained—almost by accident—the glamour of its early days, becoming popular with actors, athletes, and musicians, especially rap artists. As much as it might shock traditional Bentley drivers, hip-hop "gangstas" are modern-day versions of the Bentley boys, with their wild parties and dashing races. In many ways, the world of hip-hop and bling-bling offers the apotheosis of chrome—and a fresh, almost parodic take on the notion of luxury.

figures 25–26 **West Coast Customs**
Bentley Arnage customized for Tracy McGrady, 2002

While Bentley has its own coach builder, Mulliner, to customize cars to the desires of its customers—offering choices of wood, leather, and other luxury appointments—many buyers who wish to glamorize their new acquisitions take them to shops such as West Coast Customs, Unique Autosports, and 310 Motoring, which tailor custom cars for the stars of sport and entertainment (see figs. 25–26). In the spirit of Harley Earl's auto bodies for 1920s Hollywood celebrities, the cars modified by such firms often feature the signatures or initials of their owners—a trend that represents a sort of cobranding, a near parody of Lincoln designer editions bearing the Givenchy, Cartier, or Bill Blass name. Basketball luminary Shaquille O'Neal ordered up a Superman-style S logo for the grilles of his many custom vehicles.

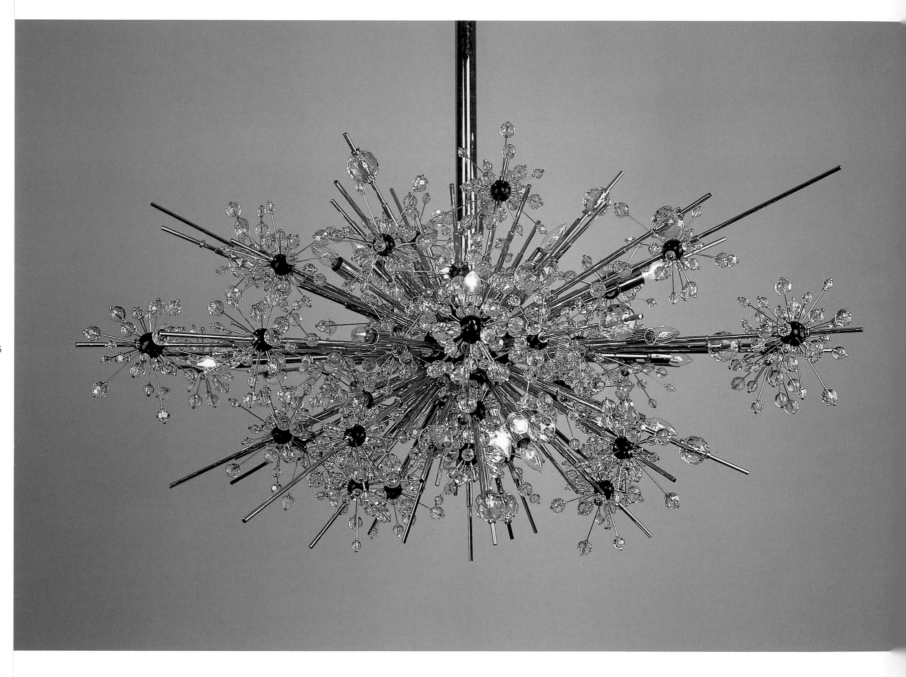

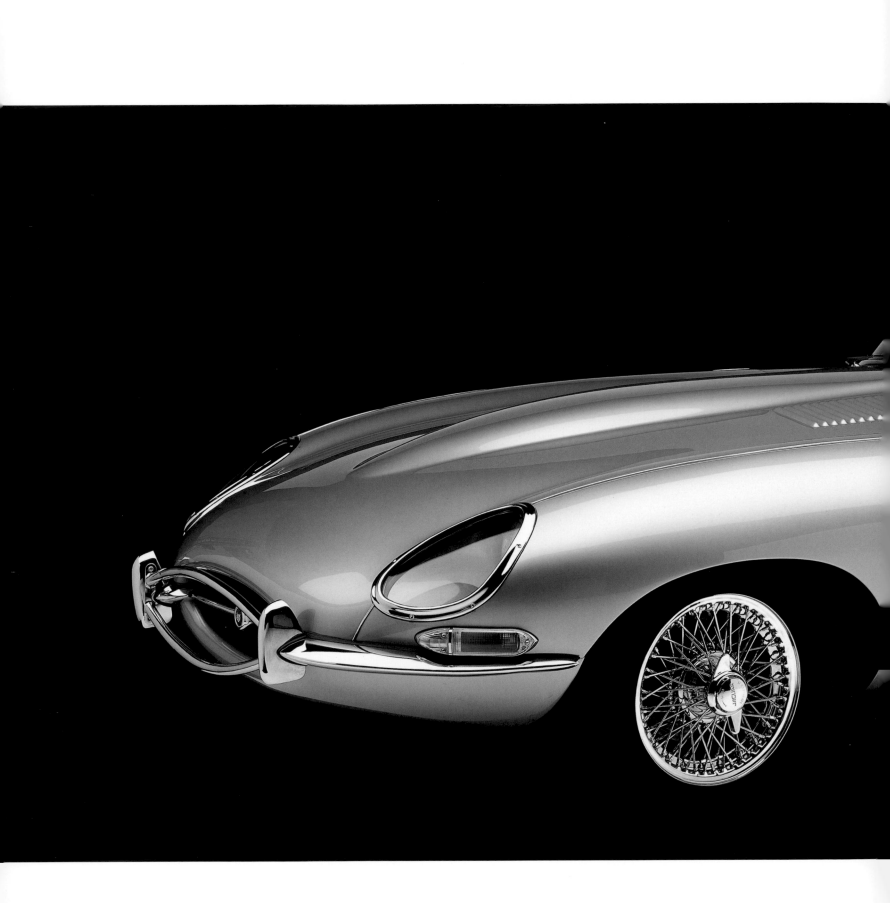

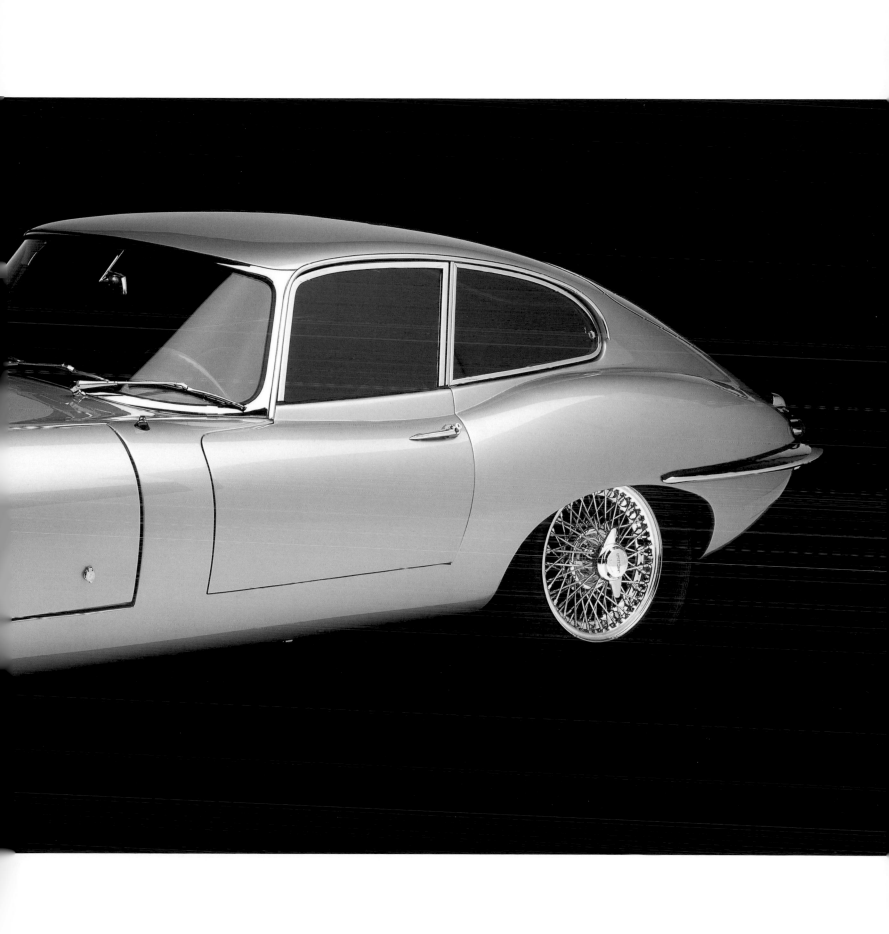

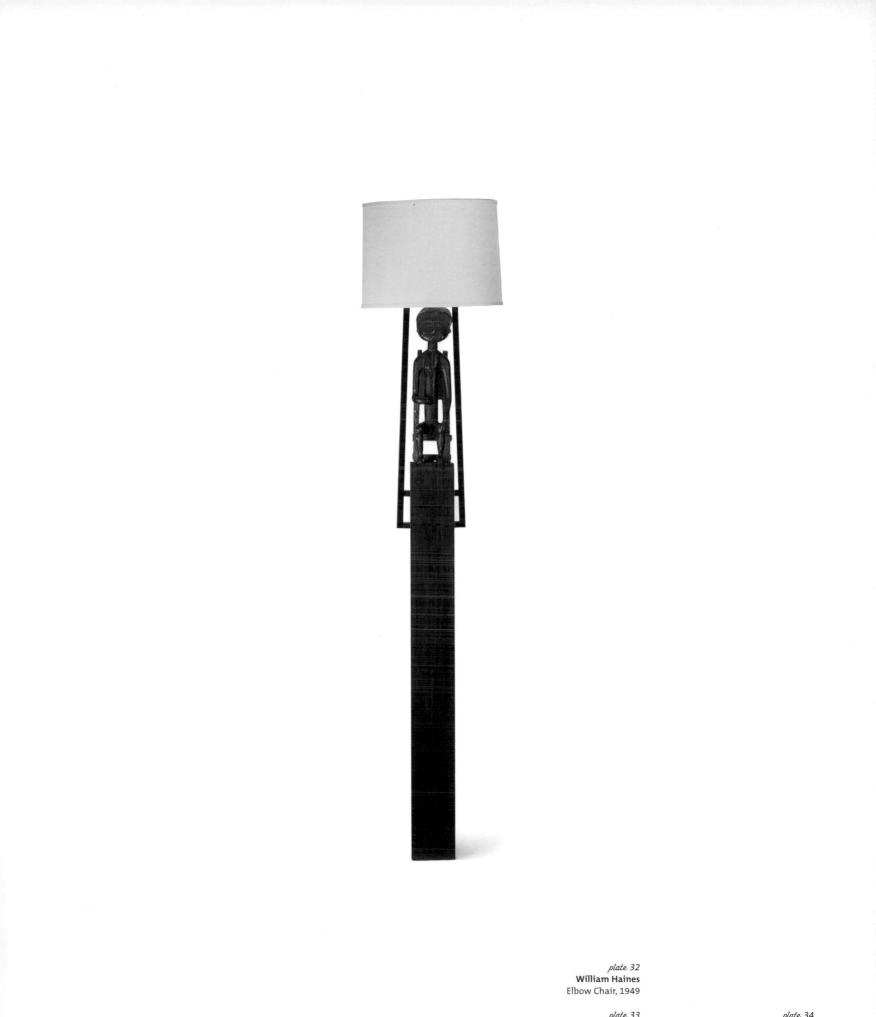

INDUSTRIAL DESIGN *in focus*

<div align="right">*by* RUTH KEFFER</div>

For industrial designers working at mid-century, glamour was a characteristic defined outside the context of Modernism. While many avant-garde designers continued to champion the machine aesthetic and the populist appeal of mass-produced goods, the market for luxury items was also thriving. The qualities that made such objects expensive—exotic materials, handcrafting, richly patterned surfaces, and figurative or sculptural flourishes—were antithetical to the modernist notion of pure function. For the designers who embraced it, glamour was not just an ideological posture, but an opportunity to celebrate traditions of opulence and excess.

The essential purpose of much of this design, whether for objects or for spaces, was to flourish in an environment of spectacle, of visual delight for its own sake. William Haines became an interior designer after a successful movie career in the 1920s and 1930s. His designs reflect his sense of theatricality—the furnishings create a stage-set ambiance, amplifying the presence of a room's occupant. The 1955 Brentwood chair (pl. 33), for example, is specifically suited to a Hollywood-style social milieu. The chair, covered in printed cotton upholstery, is low, wide, and armless, allowing partygoers in elaborate gowns to sit comfortably.

Designed in 1966 for the Metropolitan Opera House, New York, Hans Harald Rath's Metropolitan chandelier (pl. 29) adorns both the auditorium, home to that most extravagant of theatrical forms, and the lobby, where opera attendees create their own theater of display as they mingle before and after performances. The chandelier is an exuberant form, an explosion of tiny glass spheres radiating out-ward like fireworks caught in midair. The lighting fixture is itself a celebration of light in sculptural form.

Some designers took inspiration from anthropomorphic shapes, rejecting the industrial aesthetic even when it seemed most logical. Malcolm Sayer, the creator of the seminal Jaguar E-Type coupe (pl. 31), first released in 1961, started with a design rooted in the car's racing history, and the vehicle is indeed streamlined. But the contours are more animalistic than machine-based, emphasizing the emotional appeal of the car's Le Mans pedigree rather than the engineering features that make its speed—up to 150 miles per hour—possible. The design is both voluptuous and eccentric: The forty-eight-inch windshield is wide enough to require three wipers, and the hood is an exaggerated, almost ridiculous seventy-six inches long.

John Dickinson's interior furnishings also reflect an attraction to animal forms. His 1977 Bone game table (pl. 30) is one of a series of pieces that feature hoofed feet or skeleton legs. These features are purely ornamental, but they add an unconventional, fantastic dimension to an otherwise ordinary genre of design, turning the rooms they occupy into theatrical spaces. Though the works allude vaguely to primitive or mythological narratives, their true purpose was to indulge the designer's—and the user's—imagination.

In contemporary industrial design, glamour is still associated with traditional marks of luxury: expensive materials, labor-intensive construction, and sophisticated design. But today the display of these features—the spectacle of style—has become a value in its own right. Glamour can now be constructed through associative strategies such as branding and marketing, in which an object often bestows status by referencing, mimicking, or even slyly mocking tradition.

Glamour can be strongly linked to a brand name, even as a company's designs evolve. Bentley's 2004 Continental GT coupe (pl. 49) is produced for about half the price of a standard Bentley, thanks to the digital milling of signature elements such as the front grille (fig. 17). The design—a sportier, lighter take on the monumental Bentley style—borrows the sleek contours of classic racing cars such as the

Jaguar E-Type. Though the car is marketed to a younger consumer than the traditional Bentley buyer, the company name still brands the car as a luxury item and a key symbol of the owner's opulent lifestyle. The 118 WallyPower (2003; pl. 46) offers another example of glamour migrating across product lines. The 118-foot-long powerboat, manufactured by a company renowned for luxury yachts, is infused with high-end features: a six-cabin living space, a galley featuring Miele and Boffi appliances, a glass-enclosed salon with sliding roof panels, and a deck lined in teak. But beneath these glamorous surfaces is a vessel designed for performance: The 118 has an angular, carbon-fiber structure designed to slice through heavy currents, and a 370-horsepower engine helps the craft attain a top speed of sixty-five knots.

Though glamour has always been closely associated with expensive materials and artisanship, contemporary luxury items may be defined simply through stylistic references to those qualities. Mark Naden's 2003 Topos chair (pl. 43), made of birch and maple, has a convex shape and a complex, perforated surface that would be extremely labor-intensive to produce by hand. Digital technology, however, allows the chair to be mass-produced while retaining the look of traditional handcrafts-manship. With Petra Blaisse's 2003 wallpaper line (pl. 44), the illusion of luxury is even more literal. The vinyl wallpaper is printed with close-up photographs of fine or handcrafted materials—fur, felted wool, braided fabric—to create an allover two-dimensional pattern. The result is a decorative surface that is visually arresting but physically no different than ordinary wallpaper.

The emphasis on aesthetics in the contemporary design market acknowledges that seductive formal qualities have an emotional appeal that lies outside functionality. Ron Arad's Nina Rota bed (pl. 36), commissioned by Cappellini in 2002, exemplifies this kind of willful indulgence in irrational design. The oversize circular form is inefficient both for the space it occupies and for the sleepers who share it. Nevertheless, the round bed, long an icon of a decadent lifestyle, signifies its owners' willingness to experiment and their ability to splurge. The Cascade chandelier (pl. 35), designed by Vincent Van Duysen in 2003, is a relatively simple household fixture whose function is greatly overshadowed by its form. Rather than merely lighting a room from above, the chandelier literally overflows: Ten-foot strands of crystal spill over the table below, bathing the space in glass as well as light.

Contemporary designers have become quite sophisticated in expanding and manipulating the parameters of glamour. Compare a classically glamorous wristwatch by Rolex, for example, with other contemporary jewelry designs. Rolex's 2002 Oyster Perpetual Lady Datejust (pl. 45), studded with a grid of diamonds set in gold, maintains the company's long and still very successful tradition of unapologetic ostentation—the watch is a proclamation of well-earned success. By contrast, the 2003 Rattle rings and bracelet (pl. 40), designed by John Reinhold with Marc Jacobs, are the very antithesis of spectacle: Brilliant-cut diamonds are hidden inside tiny chambers built into the encircling gold band. The gems are invisible to everyone, including their owner, yet can gently announce their presence if the wearer wishes. The Rattle jewelry suggests that glamour, paradoxically, can be so intrinsic that it requires no public display at all.

In recent years new technology has made a novel range of eccentric or subjective design choices viable—and marketable—within the domain of glamour. An aesthetic once associated strictly with handmade luxury objects is now applied, with both elegance and ease, to an array of mass-produced items. Within this increasingly diverse marketplace, the definition of glamour continues to expand and evolve.

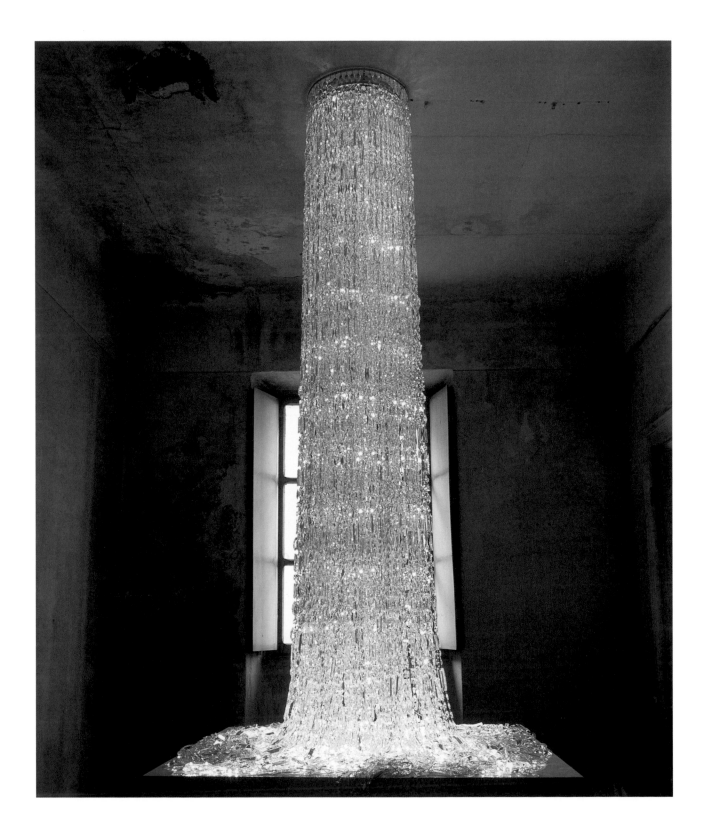

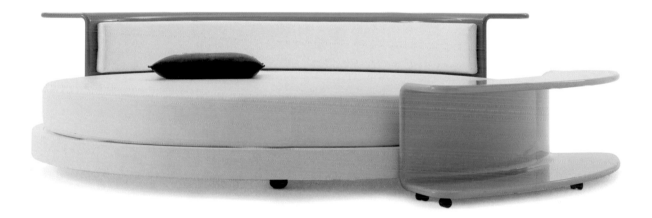

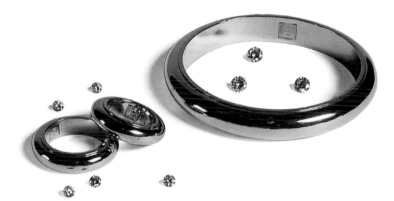

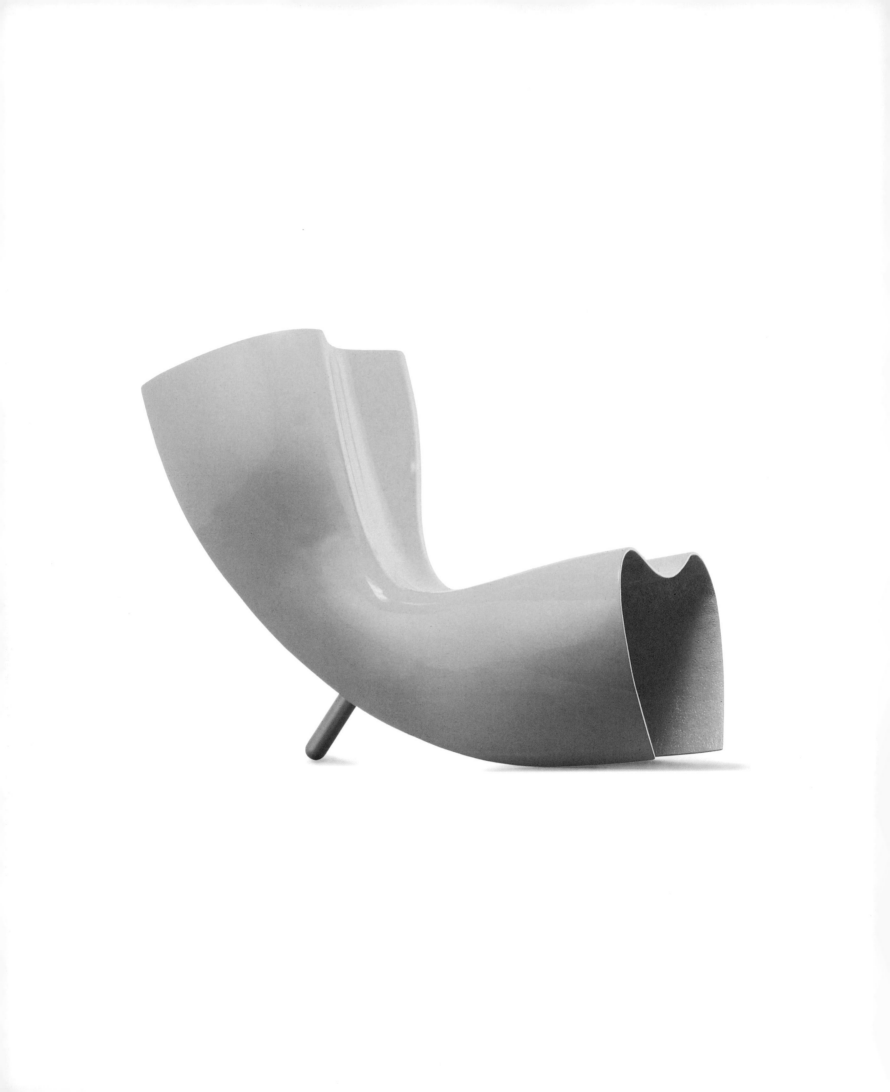

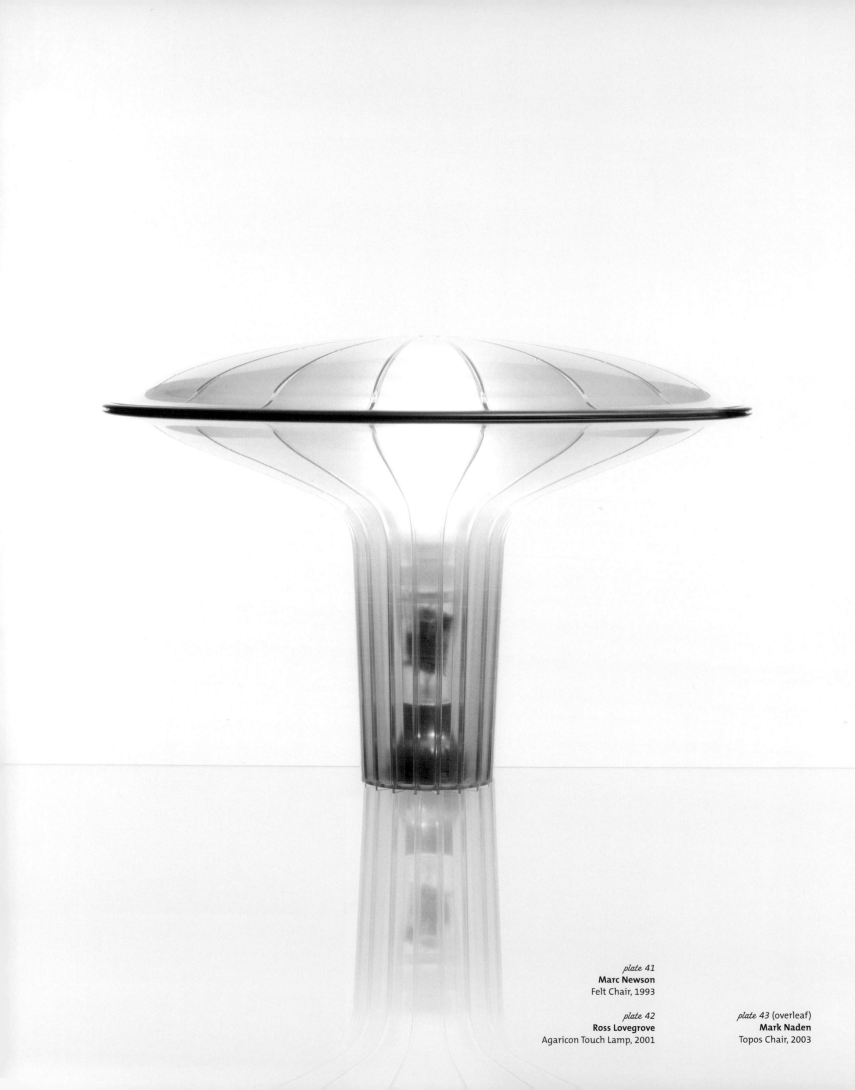

plate 41
Marc Newson
Felt Chair, 1993

plate 42
Ross Lovegrove
Agaricon Touch Lamp, 2001

plate 43 (overleaf)
Mark Naden
Topos Chair, 2003

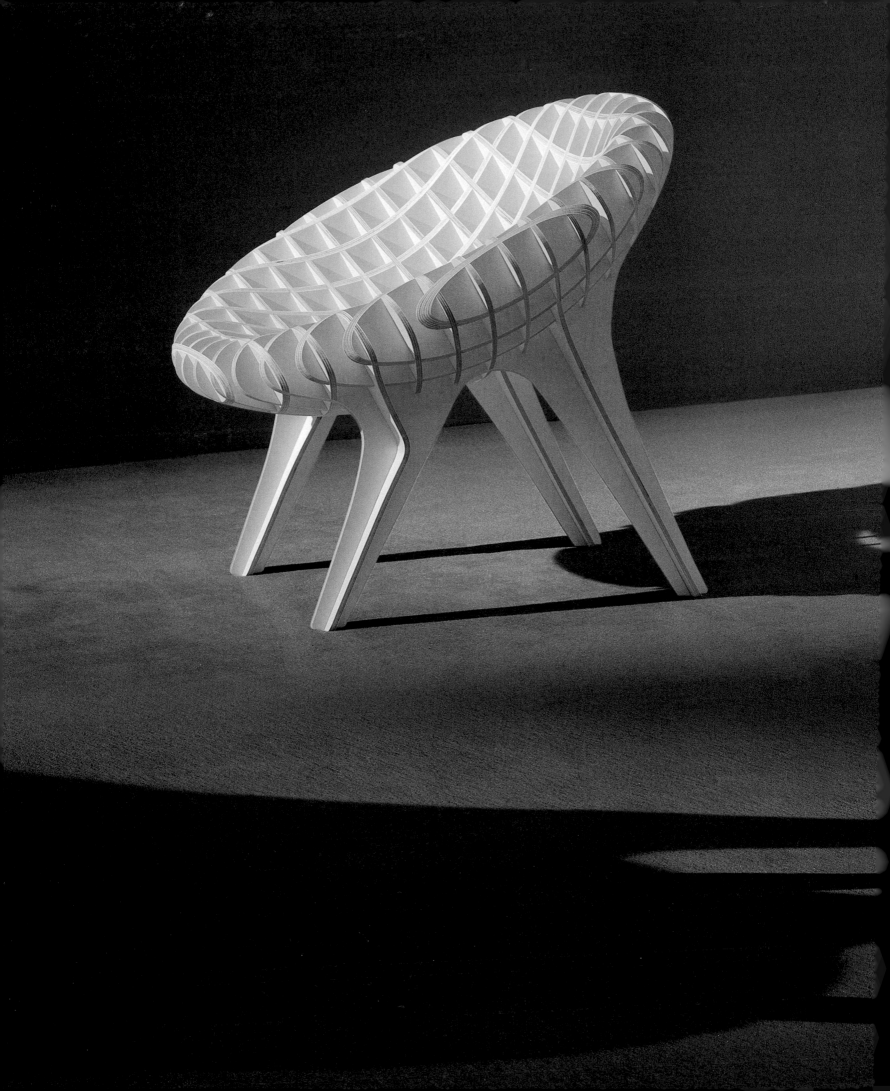

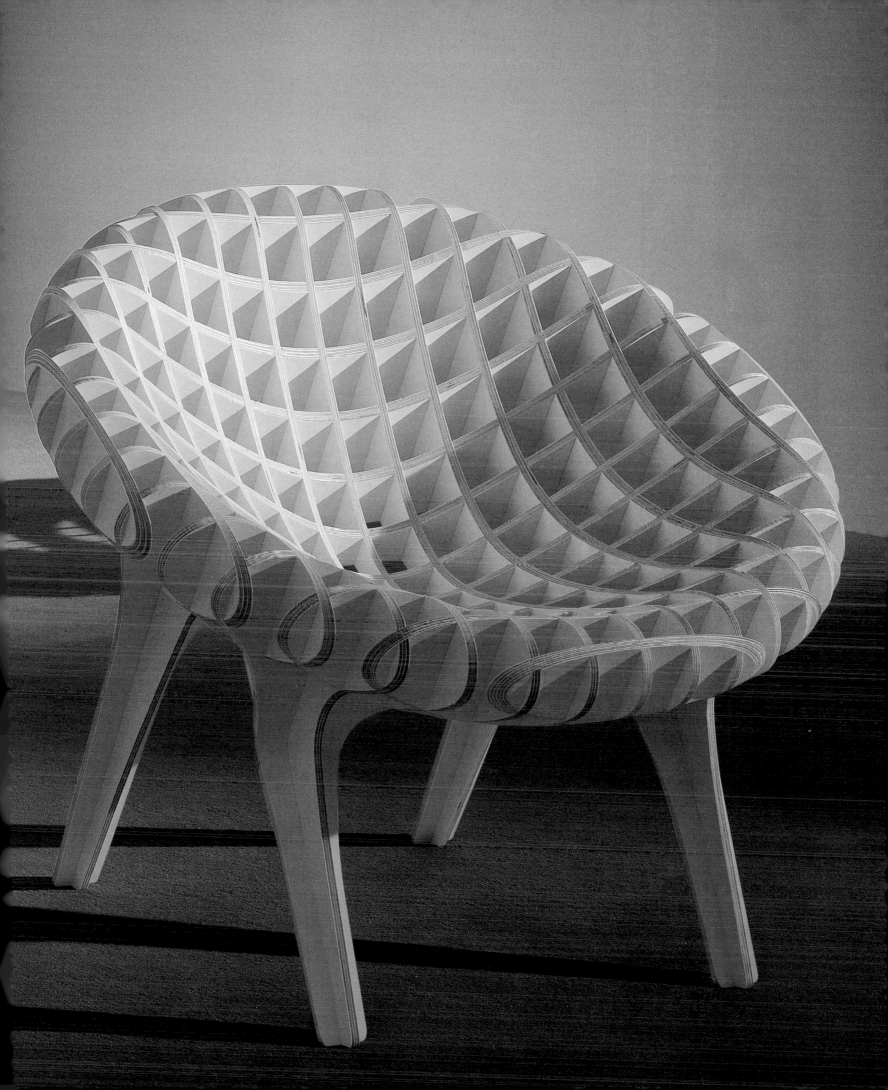

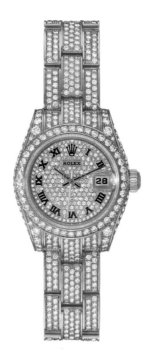

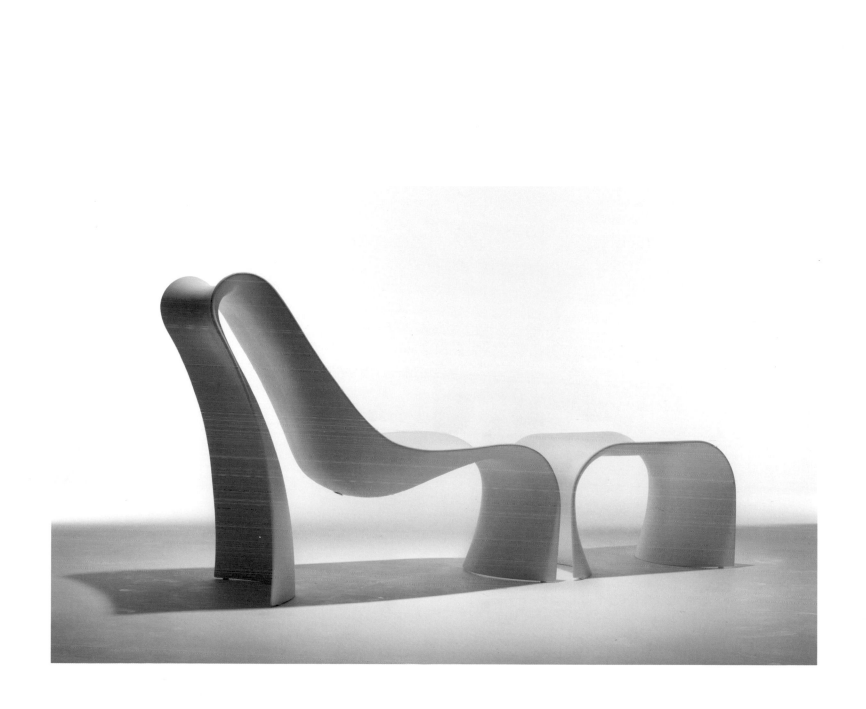

plate 46
Wally with Lazzarini Pickering Architects
118 WallyPower Powerboat, 2003

plate 47
Ross Lovegrove
Brasilia Lounge Chair, 2003

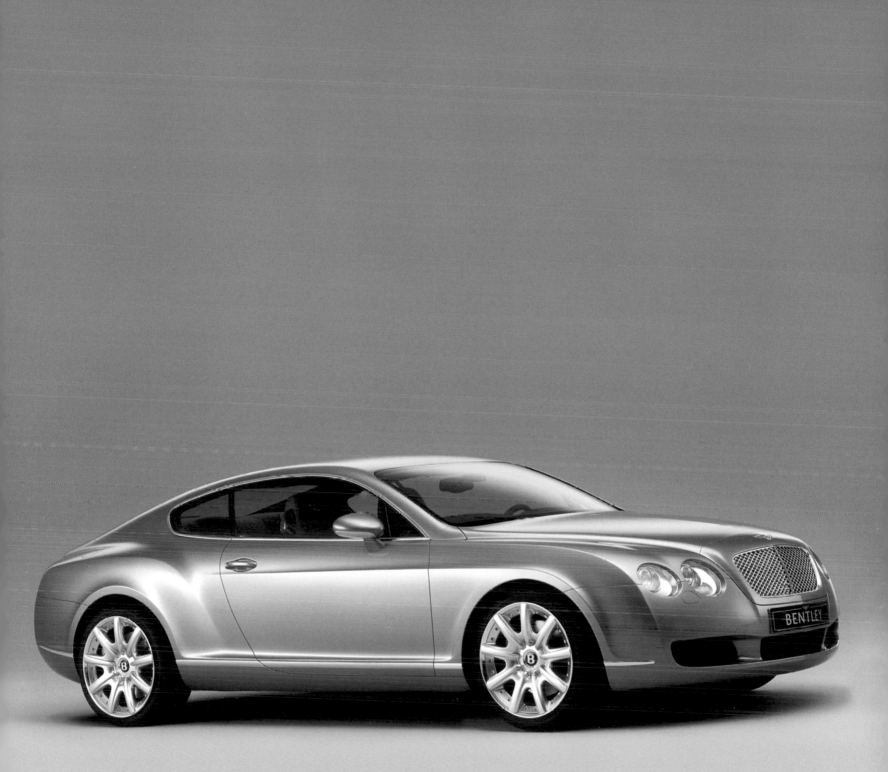

ARCHITECTURE

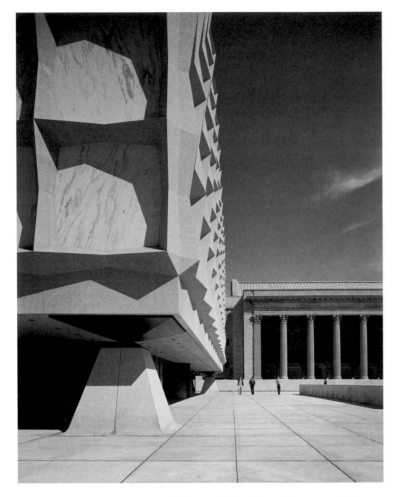

sections externally and precast marble-concrete sections internally, so that the masonry [walls are] counterfeit. The four recessed corner piers contribute to this paradox. . . . Consequently the Beinecke Library is far more devious about its purpose and its structure than any of the older buildings that surround it, and in comparison with its neighbors it suffers doubly because of its scalelessness.[3]

Roth deemed the building a failure because of the "scalelessness" of its massing in comparison to adjacent campus structures that epitomize historical monumentality (see fig. 28). Indeed, facades that confound traditional notions of scale would become a primary characteristic of the glamour aesthetic in architecture. Though critics took an adverse view of scalelessness, some thirty years later "bigness" would be recast as a positive attribute of modern public architecture.[4]

For some commentators, modern architecture never really supplanted the Beaux-Arts; it merely suppressed it until the 1950s. This tone was best summarized by William J. R. Curtis in his 1982 publication *Modern Architecture: Since 1900*:

In the United States the expansive, optimistic, and indeed, imperial undercurrents of the post-war years were manifest in many commissions for large-scale monuments. This was no doubt part of a general mood of dissatisfaction with the restrictive minimalism of the American version of the International Style. Thus architects like Edward Durell Stone (the American Embassy in New Delhi [designed in 1954]), Philip Johnson (the Sheldon Memorial Art Gallery in Lincoln, Nebraska, 1963) and Wallace Harrison and Max Abramovitz (with Johnson, The Lincoln Center in New York, 1961–65) indulged in grand axes, symmetry, expensive materials or tell-tale arches to disguise an essentially bogus skin-deep understanding of the nature of monumentality.[5]

architects. At the time, however, Roth found Bunshaft's approach antithetical to the historical trajectory of the International Style, and he blamed Bunshaft and his generation for having diluted the movement's ideological integrity:

Bunshaft formed the self-supporting walls of the outer box of welded trusses filled with translucent marble slab panels. The frame was then covered by carved marble

figure 28 **Gordon Bunshaft with Skidmore, Owings, & Merrill** Beinecke Rare Book Library, 1963

Despite the disapproval of the majority of architectural critics and historians, over the following decades a hybrid version of the International Style featuring repetitively patterned surfaces became the preferred mode for corporate, civic, and institutional buildings. This aesthetic also proliferated in regions where seasonal homes or large estates were clustered, such as California and Florida. However, the most interesting deployment of the style is found in the American embassies built abroad during the Cold War. The seminal example is Stone's embassy in New Delhi (fig. 29), which became a potent symbol for postwar democracy. As Stone noted, "the fact that the [exterior screen wrapping the perimeter of the embassy building had] texture and pattern concerned some people because it was immediately called decorative, which is as vulgar as tattooing in some circles."[6]

Creighton, of course, had used Stone's embassy as his foremost example of sensual delight in "The New Sensualism." In a follow-up essay he introduced two more categories, one of which, "neo-liberty," comprised current designs that recalled historical idioms.[7] The term had been coined by Italian architecture critic Paolo Portoghesi in 1958 "to describe the retreat of many Italian architects to a 'liberty' [style] based on *art nouveau* imitations"[8]—a comment suggesting that a similar aesthetic movement was also taking shape in Europe. Creighton, however, redefined neo-liberty for the American market, discounting as hubristic all aesthetic gestures drawing on premodern styles:

> *Under this apt title we might lump all of the neo-eclectic moves and various "retreats" from modernism, which justify themselves by an appeal for sensual liberty. To these practitioners . . . there seems no worthwhile freedom to be discovered within the contemporary movement. The return has been to taste at its queasiest and most cowardly. In the United States we have Stone and his Venetian palace–rooted [Huntington] Hartford [Gallery] . . . and, at a different level of taste, the client-pleasing rationale of Morris Lapidus with his Miami Beach hotels. While it may seem far-fetched to bring these ravelings together with the other threads of his survey, they serve the purpose of indicating one aspect of the dangers and risks that lie in New Sensualism.*[9]

Importantly, although Creighton's essays represent the most sustained attempt to index examples of the glamour aesthetic in postwar architecture, he completely negated the ideologies of the individual architects. Thus, in the span of two months, Stone went from the poster child for sensual delight to the most tasteless exemplar of neo-liberty.

figure 29 **Edward Durell Stone**
United States Embassy, New Delhi, India, 1959

It is interesting to note that although Creighton alluded to Lapidus, the essay included no illustrations of his work. Lapidus occupied the opposite end of the taste spectrum from Stone; in many ways he operated outside the architectural canon, creating designs for hotels that flamboyantly juxtaposed architectural idioms. In 1971 art critic Mary Josephson coined the phrase "pornography of comfort" to describe his aesthetic. "Many of Lapidus' contrasts of soft (furniture, deep rugs, occasional walls) and hard (glistening highlights, mirrors opening up dim voids) seem designed to engage an oral or tactile idealism," she wrote. "[T]he bastardization of styles becomes a medium for visceral and tactile fulfillment."[10]

The 1955 Eden Roc Hotel (pl. 56) in Miami Beach, Florida, is a perfect example of Lapidus's "architecture of excess"; such projects, as Josephson pointed out, "contribute substantially to the 'dream state' induced by his surroundings, which in turn is connected to bourgeois *gloire*." It was this essay that first drew a connection between Lapidus's architecture and its aspirational qualities, a rhetorical move that suggests why his work is such an important model for contemporary proponents of the glamour aesthetic:

Lapidus, with perfect instinct, has summoned the mood and décor of 1930s and '40s movies. . . . In the capitalist society movies are the opium of the suburbs, and Lapidus encourages this role-playing and self-dramatization. People find satisfaction in being someone else, or appearing as someone else to others, who are also being someone else. It is only appropriate that this ghostly traffic is reflected in mirrors.[11]

Though Lapidus's architecture of excess was antithetical to postwar minimalist architecture, Josephson compared his work with that of Philip Johnson, one of the founding fathers of the International Style. Furthermore, in charting the mainstreaming of the International Style from the 1920s to the 1960s, she raised a valid question: What is the future of modern architecture if Ludwig Mies van der Rohe's rigid ideology was the definitive model? "Where does an architect begin? Mies's solutions are all found within a rigid idealism. Philip Johnson begins with an idea of perfect taste (late Johnson is the Lapidus of good taste, just as Lapidus is the Johnson of bad taste). All in one way or another handle the morality of form and function, the puritan armature of modernist architecture."[12]

Mainstream International Style lacked one inherent characteristic that has always been essential to avant-garde movements in architecture: an alliance with art practice. The last significant example of a fertile cross-disciplinary relationship had been Le Corbusier and Amédée Ozenfant's collaboration in 1918. In 1966 Robert Venturi's definitive book *Complexity and Contradiction* co-opted the figurative aesthetic of Pop art as a means to reinterpret vernacular modern architecture. Then, in 1971—the same year as Josephson's article on Lapidus in *Art in America*—Peter D. Eisenman published his seminal *Casabella* essay "Notes on Conceptual Architecture," resituating modern architecture in the context of Conceptual art: "[A]spects of

painting and sculpture, especially in the domain of what is loosely called 'conceptual art,' continue to have an important although undefined influence on architectural thinking," he wrote. "While the influence of painting and sculpture would have been commonly accepted in a treatise on the architecture of the 1920s and 30s, this relationship to post-1950 architecture, except in its most literal interpretations, has rarely been the subject for discussion."[13]

Eisenman's own work reflected this ideology, borrowing from linguistic theory to generate a revised framework for contemporary architecture. The gridlike serial forms of his influential 1967–88 House series (see fig. 30) demonstrate the influence of American artist Sol LeWitt and of Italian architect Giuseppe

figure 30 **Peter D. Eisenman**
House II (Falk House), Hardwick, Connecticut, 1969–70

Terragni.[14] Inspired by the linguistic theories of Noam Chomsky, Eisenman considered architecture, like language, to have a "deep structure" or grammar in which finite elements such as walls, columns, and beams could take on infinite meanings or act simply as signs. Disregarding conventional ideas of context, site, and function, Eisenman's architecture directly opposed the mid-century rhetoric of form follows function.

One of the first critics to write on Eisenman's postfunctionalist notion of architecture was Mario Gandelsonas. In "On Reading Architecture," published by *Progressive Architecture* in March 1972, Gandelsonas remarked that "in recent years, there has been a re-examination of the functionalist tradition. . . . [A]n emerging tendency [is Eisenman's approach, which] views . . . architecture as a system of cultural meaning [that] attempts to explain the nature of form itself, through viewing the generation of form as a specific manipulation of meaning within a culture."[15] Only four years later, Gandelsonas announced the death of functionalism, calling it a "negative and regressive ideology":

129

> *In its time, functionalism was a progressive ideology—perhaps one of the most progressive to have developed in the history of architecture—providing both the definitive demise of classical architecture and the creation of a new architectural language. Functionalism, created in the particular historical conjunction of the inter-war period, seemed to be the most efficient means of creating a language of architecture. Asserting that function and technology constituted the basis for the generation of form in architecture, it thereby eliminated contemporary academic conceptions of meaning and symbolism. [However,] a radical ideology that grows out of a particular historical conjunction might well become "regressive," when applied twenty or thirty years later in a different context.*[16]

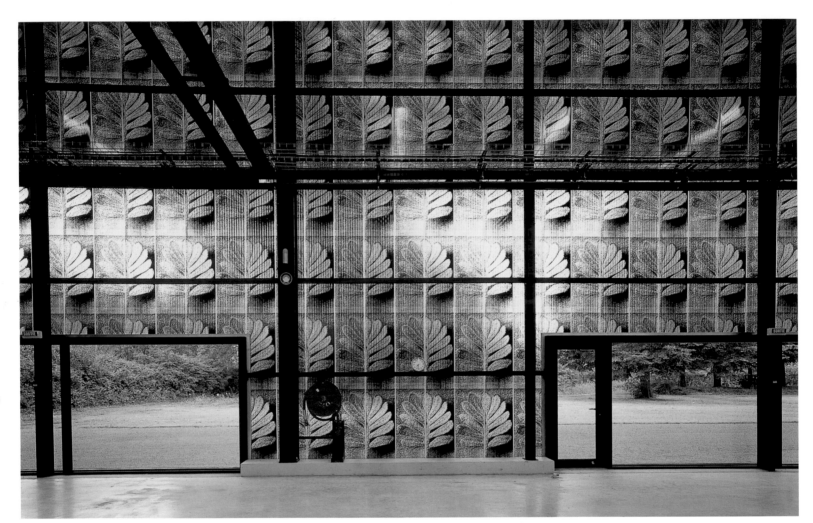

As Gandelsonas's comments demonstrate, by the early 1970s architects and critics were beginning to apprehend that the International Style no longer offered a valid reflection of current social or ideological conditions. This realization inspired a significant shift in the pedagogy and practice of architecture—a sea change heralded, once again, by Eisenman. Unlike Josephson, who persisted in equating modernist functionality with an implied morality, Eisenman asserted that "the functionalist predicament . . . given to formal arrangements was a moral imperative that is no longer operative within contemporary [architecture]."[17] One of the few historians to align himself with this stance was Colin Rowe. In his introduction to the 1972 book *Five Architects: Eisenman, Graves, Gwathmey, Hejduk, Meier,* Rowe traced the historical devolution of architecture away from mainstream form follows function to a critical methodology that allows for meaning and symbolism.[18] Though all of the architects discussed in Rowe's book could be equated with twentieth-century

figure 31 **Herzog & de Meuron**
Ricola Europe Factory and Storage Building,
Mulhouse-Brunnstatt, France, 1993

antecedents in architecture and in art, Philip Johnson's postscript to the volume cited Eisenman as the "most original in his search."[19]

In many ways, Eisenman's explorations paved the way for a collection of buildings that may now also be viewed as precedents for the digital glamour aesthetic. All of these transitional projects reconsidered once-transgressive tendencies such as seriality, scalelessness, excess, and tattooing. Eisenman's House series, for example, experimented with the notion of an autonomous architecture via the formal motif of seriality. Also celebrating serial forms, Jean Nouvel's 1987 Institut du Monde Arabe in Paris was the first civic building to employ a mechanical facade. The building's intricate and nearly scaleless south front features a vast sunscreen with apertures that open and close, like camera lenses, to shade the interior. Referencing traditional Islamic architecture and other predigital structures, the sunscreen's patterning infuses the building's modern vocabulary with religious and cultural significance. Another important building that would once have been derided for its decorative tattooing is Herzog & de Meuron's 1993 Ricola Europe factory and storage building in Mulhouse-Brunnstatt, France. The architects' elegant reconception of the banal factory type updates historical models of transparency, patterning, and excess. The main facade and its vast cantilevered overhang, clad in translucent polycarbonate panels silkscreened with repetitive plant motifs (fig. 31), form a surface that curtains the interior while offering a metanarrative for the herbal remedies produced and housed inside the building.

Projects such as these lay the groundwork for more recent designs that would have been inconceivable without contemporary advances in digital technology and methods of fabrication. Indeed, one of the defining features of the new digital glamour is the transposition of decorative pattern into structural form, a tendency that emerged in the mid-1990s. This approach to surface articulation merges pattern with the building's support, transforming serial motifs from mere ornamentation into structural envelope. Intermediate columns inside the mass of the building are digitally folded into the perimeter and internal core, allowing interior spaces to be nearly void of visible support (the result is similar to a monocoque structure, in which the form bears its own weight, providing column-free interiors). Most of these buildings are clad in, or fabricated from, materials that are integral to their form and light in appearance. Over the past decade, as digital architecture has matured, architects' fascination with producing blobs and other non-Cartesian forms has given way to more refined investigations of typologies such as boxes and folds.

One of the earliest designs to display characteristics of digital glamour was dECOi's 1996 Pallas House project (pl. 64). Mark Goulthorpe, dECOi's principal, proposed a seemingly simple rectangular house wrapped in a complex, curving, repetitively perforated screen designed to filter the tropical climate of Kuala Lumpur, Malaysia.[20] While the skin's modules appear to be a standard size, no two panels are the same. With a nod to the owner's Chinese background, the

screen's perforated pattern—facilitated by digital production and Computer Numerical Control (CNC) milling processes—recalls the richly carved surfaces of ancient Chinese ceremonial bronzes, reconciling the austere vocabulary of Modernism with a symbol of the client's cultural heritage. Further exploration into surface systems can be seen in dECOi's 1999 *Aegis Hyposurface* (pl. 67). Originally designed as a cantilevered wall for the Birmingham Hippodrome in England, this dynamically reconfigurable installation is capable of real-time response to events taking place in the surrounding environment, allowing interior or exterior building surfaces to reflect a range of conditions, including sound and physical movement.

The idea of a nonfigurative patterned surface concealing something rather more complex is the guiding principle behind Herzog & de Meuron's Prada Aoyama Tokyo boutique (pl. 65). Completed in 2003, the six-level, five-sided building is enclosed by a translucent, honeycomb-patterned skin that wraps the entire structure, including the chamfered roof planes. All functions are concealed within the central core volume

and enclosed circulation zones at the perimeter walls, producing a complex interior that only truly reveals itself at night, when the building is illuminated. The transparency of this elegantly deceptive surface challenges the enclosure's visual boundaries, allowing the whole building to operate as a retail display.

Although mid-century critics expressed distaste for "decorative" architecture, their counterparts today are supportive of glamour's avant-garde. Soon after the opening of Prada's Tokyo boutique, Deyan Sudjic published words of praise in *Domus*. The store, he wrote, "serves to define [a] new building type: part advertising billboard, part architectural gift-wrapping." Sudjic identified the architects as unconventional thinkers who establish new standards for each project they design, "inventing a dazzling series of building types and new ways of building that sustain a whole school of followers."[21] Julie V. Iovine of the *New York Times,* meanwhile, called Herzog & de Meuron's design an "exercise in brand-building," describing the structure as a "bubble-wrapped crystalline extravaganza." She also pointed out that the "building's off-kilter rhomboid shape has been compared by the architects to . . . a bursa, the knotted leather sack used in medieval times to hold precious jewels. And it does seem firmly lodged between architecture and bauble."[22]

On one level, Herzog & de Meuron's honeycomb-patterned curtain wall pays visual homage to mid-century architecture such as Bunshaft's Beinecke Library, Stone's American Embassy in New Delhi, and Yamasaki's 1958 Reynolds Metals Building (pl. 55) in Southfield, Michigan. However, the formal similarity ends there, for within the rectangular confines of the Prada building are highly complex interior spaces: "[T]he interiors are all of a piece. They are solidly white with plaster wall surfaces as powdery smooth as bleached bones, shelving that protrudes like ribs and display tables of molded fiberglass laced with a network of

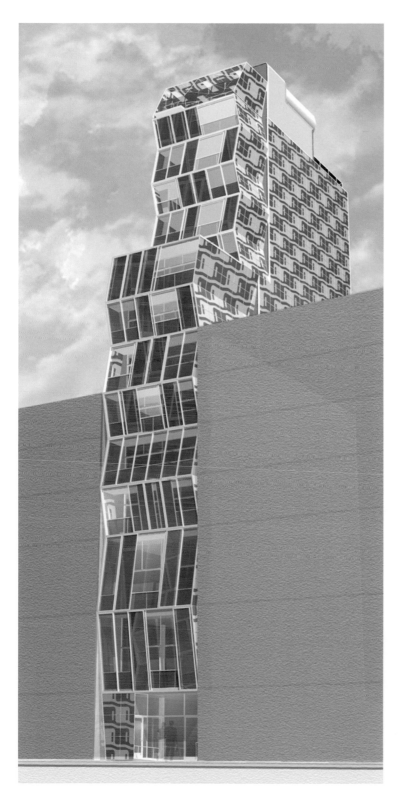

optic fibers glowing within like nerve endings in a synaptic frenzy," Iovine noted. "But with white wool rugs, rubbery silicone fixtures and fur-covered clothes racks, the effect is more Barbarella than biological."[23]

Indeed, the way in which the structure folds organically into surfaces and floors within a simple, rectangular building mass suggests the emergence of a new typology: the monocoque box. Prior to digital modeling in architecture, rectangular buildings (in which surface is applied to structure) were antithetical to the definition of monocoque construction (in which structure is integral to surface and hence self-supporting), which was equated with curved forms. Today, digital fabrication makes monocoque architecture increasingly feasible and also allows typologies such as boxes to be structurally reinterpreted. Another example of this development is the Radiant Hydronic House (pl. 72) in Los Angeles. Designed in 2002 by Tom Wiscombe, the principal of EMERGENT, the house is a relatively simple rectangular volume with little surface articulation. Inside, however, the structure appears to morph into surface as it dynamically unfolds into adjacent spaces and opens onto the surrounding landscape.

Until recent advances in digital fabrication and production, the vocabulary and structural typologies of modern architecture had remained essentially unchanged since the early twentieth century. Today, however, designers are developing structural models that are altering the very language of architecture as well as its assembly. Neil Denari's 2001 proposal for the Union Square Loft Building (fig. 32, pl. 68) in New York combines existing construction techniques with new methodologies. The building's party walls rise past adjacent structures and appear to undulate at each floor plate, endowing the gridded facades that wrap the structure with a sense of variety. Providing views of the city and beyond, the walls are clad in glass and tattooed with a highly graphic, repetitive pattern that screens direct sunlight. Inventive digital

133

fabrication of the building's canted curtain wall and the glass's silkscreened sun protection result in a visually delightful design that marries the patterning of the screen system with the seriality of the building's structure.

While boxlike, rectangular structures may have the closest formal relationship to mid-century architecture, the glamour aesthetic has informed a variety of other typologies articulated through digital technologies. Bernard Tschumi's 2001 design for the athletic center at the University of Cincinnati, Ohio (pl. 66), is an apparently simple building that is extremely complex in its siting and fabrication. The structure, which Tschumi calls a "contextual freeform"[24] and expects to complete in 2006, is squeezed between two other campus buildings on a very narrow strip of land.

In plan the building resembles a teardrop clad in precast concrete; though this material is quite common, the challenge of cladding a compound, curved building required the architect, contractor, and fabricator to work together to achieve the elegant enclosure. The overall exterior of the building is wrapped in a series of stacked, triangulated forms,

playing off the notion of scalelessness to produce a sense of "bigness" in relation to the vast adjacent sports field. The building's five-story interior atrium serves as public common space and is accessible from entrances at the north and south.

Like Tschumi's athletic center, which adapts conceptually to the residual space between other campus buildings, Joel Sanders's 2003 project for the expansion of the Fashion Institute of Technology (pl. 74) in New York responds sensitively to the existing urban fabric. The new building sits parallel to earlier campus structures and creates a new atrium space between them. One of the design's most significant features is the patterned exterior surface of the digitally fabricated cladding system. The rectangular, woven aesthetic of the building's glass walls extends to built-in LED displays, which make the surface a billboard for events taking place at the school.

If patterning is a ubiquitous feature of digitally designed buildings, it can sometimes disengage from form to become its own structural element, as in *Lattice Archipelogics* (pl. 70), a 2002–3 project by servo. This reconfigurable installation is assembled from a series of patterned components that illuminate the space and represent a digitally augmented return to seriality in modern architecture. The project is comprised of translucent, pressure-formed plastic modules, LEDs, and a surround-sound system that maps physical movement through the space with light and audio effects.

As repetitive, nonfigurative forms have become more prevalent in the conception of digital glamour, architects have begun to isolate and emphasize elements once regarded as merely decorative, endowing them with a primary status divorced from structural characteristics. Designed for a sloped site on the island of Corsica, France, Jakob + MacFarlane's 2002 H House (pl. 69) is intended to double as a corporate center for the owner's business clients, and it can easily be converted

to accommodate up to eight private sleeping areas. The house is composed of a series of triangulated surfaces that deform the landscape, blurring the boundaries between structure and surroundings. The roof is intended to be a synthetic landscape contextualizing the house to the site, while serially modulated wall surfaces are clad in translucent plastic that can be unzipped and removed, opening the building to its environment.

Among the few designs in this genre to have been realized is Rem Koolhaas/Office for Metropolitan Architecture's Central Library in Seattle (pl. 71). Completed in 2004, Koolhaas's library is not only designed to be user-friendly, it is also a convertible space that can be reconfigured according to future needs. Celebrating public space and its own civic presence, the eleven-story building, clad in a diamond-patterned system of glazed structural elements, occupies an entire city block; glowing by night, the faceted skin transforms the library into a visual gem in the Seattle skyline. More than any other contemporary architect, Koolhaas demonstrates how the once-negative attribute of scalelessness might be reinterpreted via "bigness"—

a positive spin that indicates the importance of innovative architecture in today's densely populated urban fabric.

Contemporary critics have rallied behind the aesthetic and ideological virtues of Koolhaas's library. *The New Yorker*'s Paul Goldberger has called it "the most important new library to be built in a generation, and the most exhilarating." He also honed in on the design's integration of structure and decoration, a condition that is essential to the digital glamour aesthetic: "The complex polygonal form sheathed in a diamond-shaped grid-pattern . . . is actually seismic bracing, engineered to protect the building in the event of an earthquake or strong winds." [25] *New York Times* critic Herbert Muschamp has cited the library as "the most exciting new building it has been my honor to review" in more than thirty years. "The first impression is pure bling-bling: an urban montage of starburst images. . . . With a faceted exterior of glass and steel, this is a big rock candy mountain of a building, twinkling in the middle of office buildings." Muschamp draws a direct correlation between the library's exterior facades and "decorative" mid-century architecture:

> The library's exterior is an angular composition of folded planes. Walls are of glass, supported by a diagonal grid of light blue metal that covers almost the entire surface. At first glance, the irregular angles, folds and shapes seem arbitrary. The building's structure is hard to discern, and the overall grid pattern looks like a perverse exaggeration of the abstract geometries used by mid-20th-century architects for decorative relief. [26]

As indicated by Muschamp's ardent review, Koolhaas's building offers a new model for civic architecture that filters its precedents through a contemporary lens, blurring the boundaries between high-end design and street culture and democratizing the glamour aesthetic for the visually literate masses.

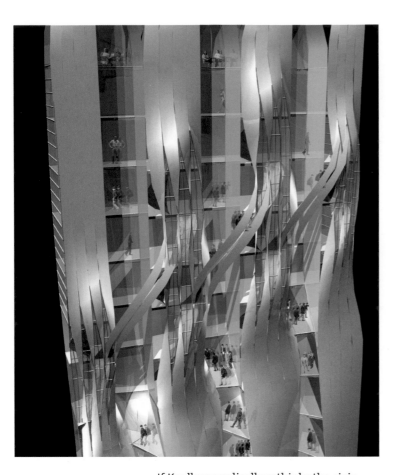

literally weaves vertical and horizontal elements into the building's structure (see fig. 33). The resulting megastructure decentralizes the tower's program and systems, allowing for extreme attenuation while furthering the possibilities of digital architecture.

The more figurative approach of Greg Lynn and Hernán Díaz Alonso suggests another viable direction facilitated by digital conception and production. Both architects create plans that are symmetrically disposed in terms of massing and articulation of form, and their designs are highly informed by contemporary art practice. Lynn's interest in figuration is rather formal, revealing an affinity for patterns found in nature that recalls the highly decorative nineteenth-century aesthetic of Victor Horta and Art Nouveau; Díaz Alonso's darker brand of figuration reveals telltale signs of the influence of contemporary artist Matthew Barney.

The overall site plan for Lynn's 2002 Ark of the World Museum (pl. 73) is a study in symmetry and patterning vis-à-vis digital methodology. Designed for Carara National Park, a mountainous rain forest near San José, Costa Rica, the project demonstrates Lynn's fascination with repetitive natural forms. The shapes and colors of the building—which houses a natural history museum, an ecology center, and a contemporary art gallery—are inspired by indigenous tropical flora and fauna, and Lynn's siting is both deliberate and sequential. Primary access is through a garden with an arcade of treelike columns, which are filled with water to keep the site moist and cool (see fig. 34). The symmetrical ground floor extends into the landscape to form an outdoor stage and amphitheater at the museum's far end. The triple-height public space is dominated by a dramatic helicoid stair that leads to an observation deck sheltered by a fiberglass-reinforced fabric canopy. Figuration and symmetry—tendencies condemned by mid-century critics for their associations with

If Koolhaas radically rethinks the civic function of the public library, Marcelo Spina, the principal of PATTERNS, reconsiders the future of the skyscraper in densely populated cities. In his 2002 proposal for the New Busan Tower in Busan, South Korea (pl. 76), Spina deconstructs the postwar skyscraper, with its central core housing stairs, elevators, and mechanical systems, separating these functions into identical elements. He also reconfigures spatial allocations, generating a brilliant framework that

figure 33 **PATTERNS/Marcelo Spina**
New Busan Tower Project, Busan, South Korea, 2002

nineteenth-century movements such as Art Nouveau—are key elements of Lynn's architectural language. More importantly, his design for the Ark of the World illuminates the possibilities of a contextually sensitive deployment of digital glamour.

Díaz Alonso's 2002 Landmark Tower/U2 Studio project for Dublin (pl. 75) exemplifies what architecture can achieve when digital design and fluid thinking merge. As proposed by Díaz Alonso's firm, Xefirotarch, the vast tower transcends traditional notions of architectural programming; disposed diagonally as well as horizontally and vertically, it is more like a city than a typical office building. Conceptually, the building comprises three visually discrete

structural forms that merge together to generate a nonhierarchical high-rise. The top of the tower's canted prow is a private recording studio, while the ground-floor lobby is open to the city, serving as a kind of enclosed public space. The floor plates between the two are allocated to mixed-use functions: offices, live/work lofts, and a restaurant, nightclub, and bar. Díaz Alonso refers to the building as *Arach* (Gaelic for "dragon"), emphasizing the figurative metaphor that underlies the complex, sculptural, and generally symmetrical form. The building's tendency toward excess and its ambiguous, almost anthropomorphic qualities betray the architect's strong interest in the baroque sculpture and film work of Matthew Barney, in which characters can mutate dramatically between human and animal form. Its relentlessly sensual, undulating mass blurs visual and spatial boundaries between surface articulation, decoration, structure, and enclosure, translating the signature signs of glamour into an original, distinctly figurative architectural vocabulary.

137

Liberated from the prescriptive thinking of mainstream Modernism, today's architectural avant-garde has opened the discipline to endless possibilities for decades to come. As architects have begun to test the more radical capabilities of digital design, glamour has emerged as something more than a marginal offshoot of the International Style. And it is no surprise that the term *sensual,* so central to Edward Durell Stone's notion of emotional delight, has reentered the architectural discourse, most recently in a comment by Jacques Herzog in the *New York Times*: Prada Tokyo, he noted, "is about . . . cheering you up in a sensual, simple way."[27] This newfound respect for the expressive and decorative qualities of architecture suggests how profoundly technology has changed the ways in which designers approach the very act of making—intellectually, culturally, and physically. For now, glamour remains best understood as a formal tendency or aesthetic— namely, an architectural vocabulary that celebrates patterning,

figure 34 **Greg Lynn**
Ark of the World Museum Project, Carara National Park, Costa Rica, 2002

seriality, excess, and "bigness"—but it is not inconceivable to think that it may soon evolve into a more concrete movement, one as important as the International Style in terms of its influence on future production.

notes

1 Thomas H. Creighton, "The New Sensualism," *Progressive Architecture,* September 1959, 145.

2 William Jordy, "The Formal Image: USA," *Architectural Review,* March 1960, 157–65.

3 Leland M. Roth, *A Concise History of American Architecture* (New York: Harper & Row, 1979), 304–5.

4 See Cynthia C. Davidson, ed., "The Bigness of Rem Koolhaas: Urbanism vs. Architecture," special issue, *ANY* 9 (1994).

5 William J. R. Curtis, *Modern Architecture: Since 1900* (Englewood Cliffs, NJ: Prentice Hall, 1982), 516–17.

6 Quoted in Paul Heyer, *Architects on Architecture: New Directions in America* (New York: Walker & Company, 1979), 175. For more on embassy architecture during the Cold War, see Jane C. Loeffler, *The Architecture of Diplomacy: Building America's Embassies* (New York: Princeton Architectural Press, 1998).

7 Thomas H. Creighton, "The New Sensualism II," *Progressive Architecture,* October 1959, 180–87.

8 Paolo Portoghesi, "Dal Neorealismo al Neoliberty," *Communità,* December 1958, quoted in ibid., 184.

9 Creighton, "New Sensualism II," 184.

10 Mary Josephson, "Lapidus' Pornography of Comfort," *Art in America,* March 1971, 109.

11 Ibid.

12 Ibid.

13 Peter D. Eisenman, "Notes on Conceptual Architecture: Towards a Definition," *Casabella,* December 1971, 49.

14 Four houses from the series have been built: House I (Barenholtz Pavilion, 1967–68) in Princeton, New Jersey; House II (Falk House, 1969–70) in Hardwick, Connecticut; House III (Miller House, 1969–70) in Lakeville, Connecticut; and House VI (Frank House, 1972) in Cornwall, Connecticut.

15 Mario Gandelsonas, "On Reading Architecture," *Progressive Architecture,* March 1972, 69.

16 Mario Gandelsonas, "Neo-Functionalism," *Oppositions* 5 (Summer 1976); reprinted in K. Michael Hays, ed., *Oppositions Reader* (New York: Princeton Architectural Press, 1998), 7.

17 Peter D. Eisenman, "Post-Functionalism," *Oppositions* 6 (Fall 1976); reprinted in Hays, 10.

18 Colin Rowe, introduction to *Five Architects: Eisenman, Graves, Gwathmey, Hejduk, Meier* (New York: Wittenborn & Company, 1972), 3–9.

19 Philip Johnson, "Postscript," in ibid., 138.

20 The intricate screen was developed using special software produced by Bernard Cache of Objectile. For more on Cache see Bernard Cache, "Objectile: The Pursuit of Philosophy by Other Means?," *Architectural Design,* September–October 1999, 66–71; Cache, *Earth Moves: The Furnishing of Territories,* Writing Architecture Series (Cambridge, MA: MIT Press, 1995).

21 Deyan Sudjic, "Commerce and Culture," *Domus,* July/August 2003, 48.

22 Julie V. Iovine, "Forget the Clothes: Prada's Latest Design Isn't for Sale," *New York Times,* June 22, 2003.

23 Ibid.

24 See K. Michael Hays, Giovanni Damiani, and Marco de Michelis, *Tschumi* (New York: Universe, 2003), 136.

25 Paul Goldberger, "High-Tech Bibliophilia," *The New Yorker,* May 24, 2004, 90–92.

26 Herbert Muschamp, "The Library That Puts on Fishnets and Hits the Disco," *New York Times,* May 16, 2004.

27 Quoted in Iovine.

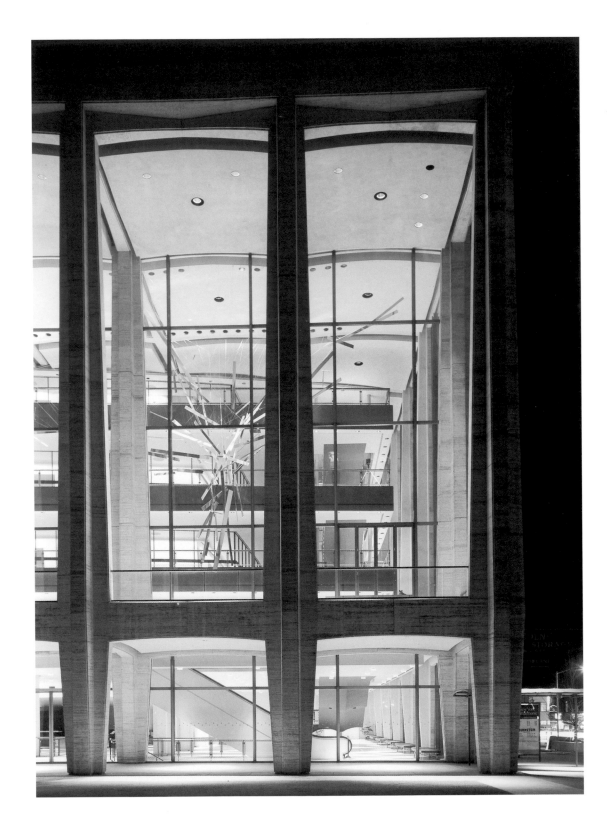

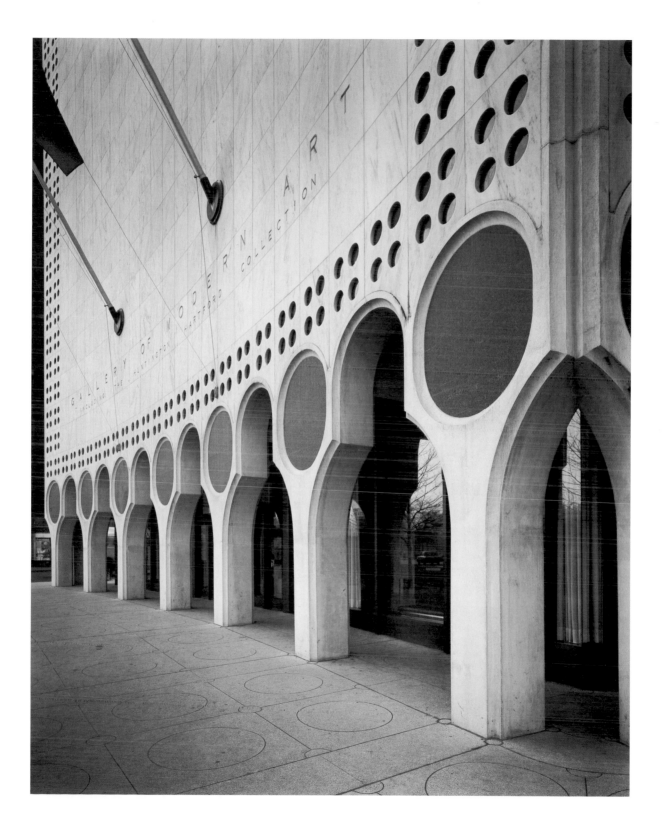

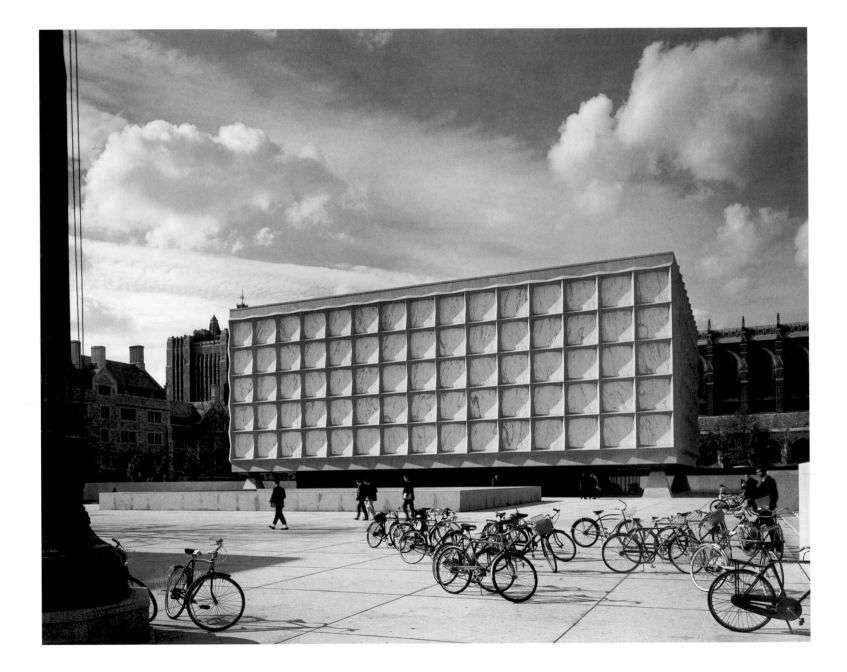

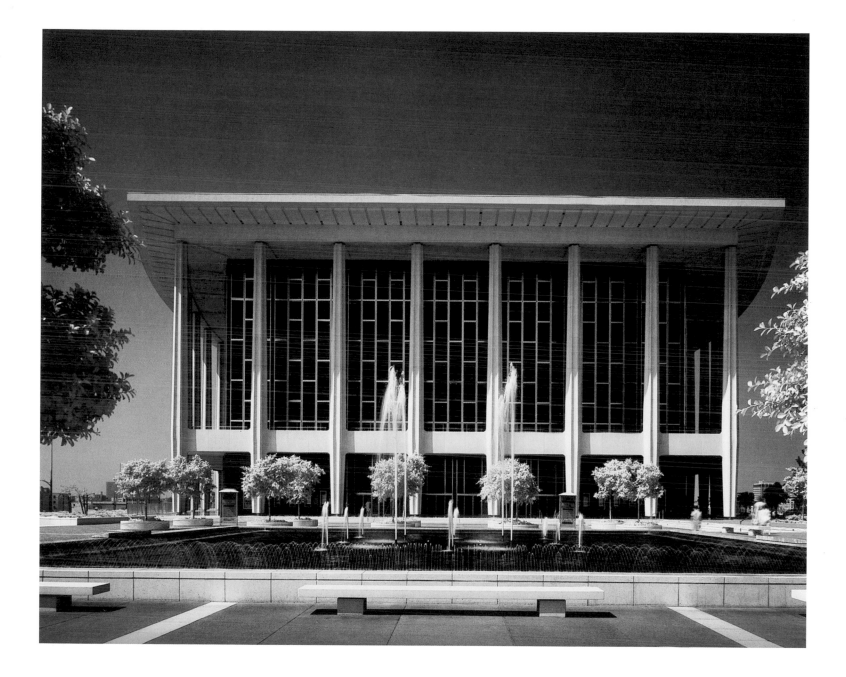

plate 52
Gordon Bunshaft with Skidmore, Owings, & Merrill
Beinecke Rare Book Library,
Yale University, New Haven, Connecticut, 1963

plate 53
Welton Becket
Dorothy Chandler Pavilion, Los Angeles, 1964

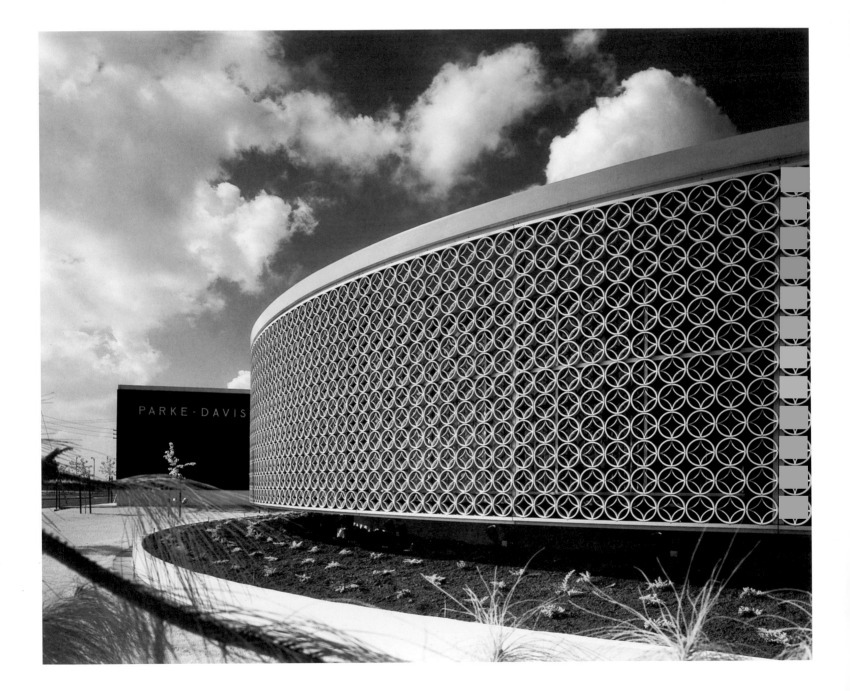

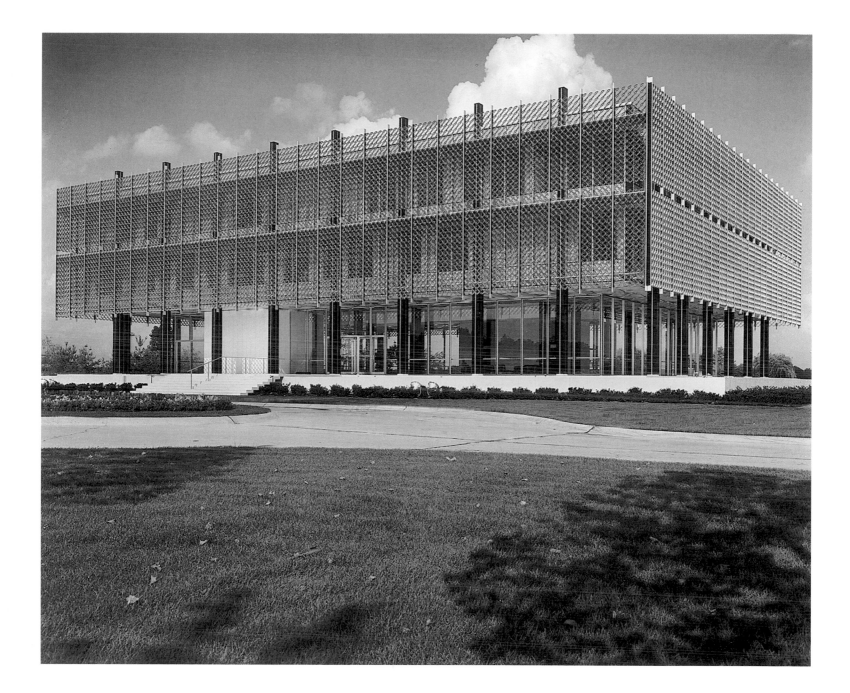

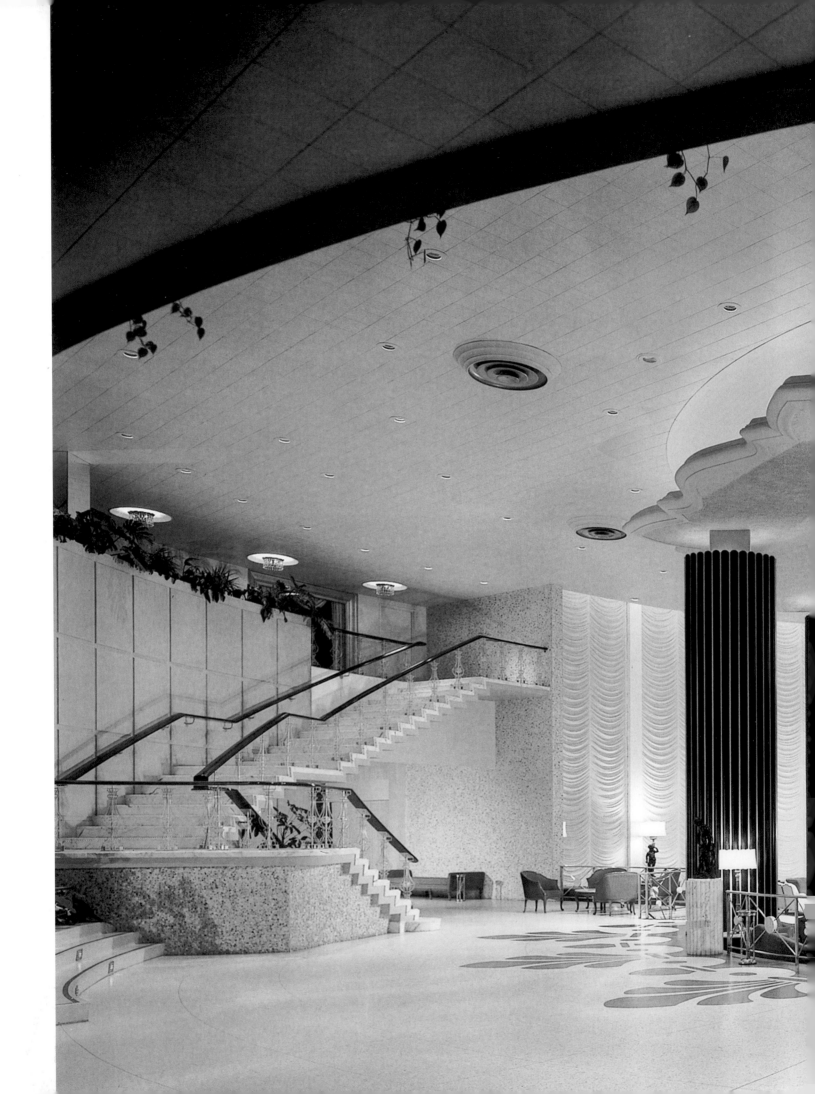

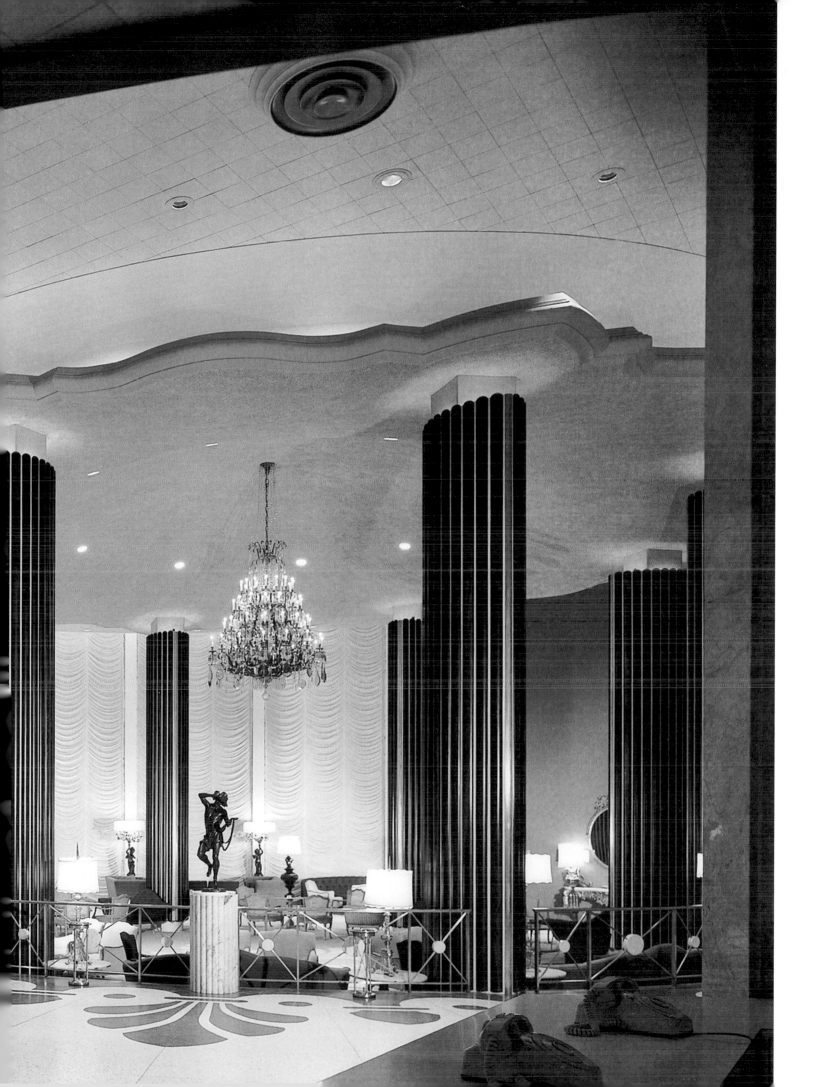

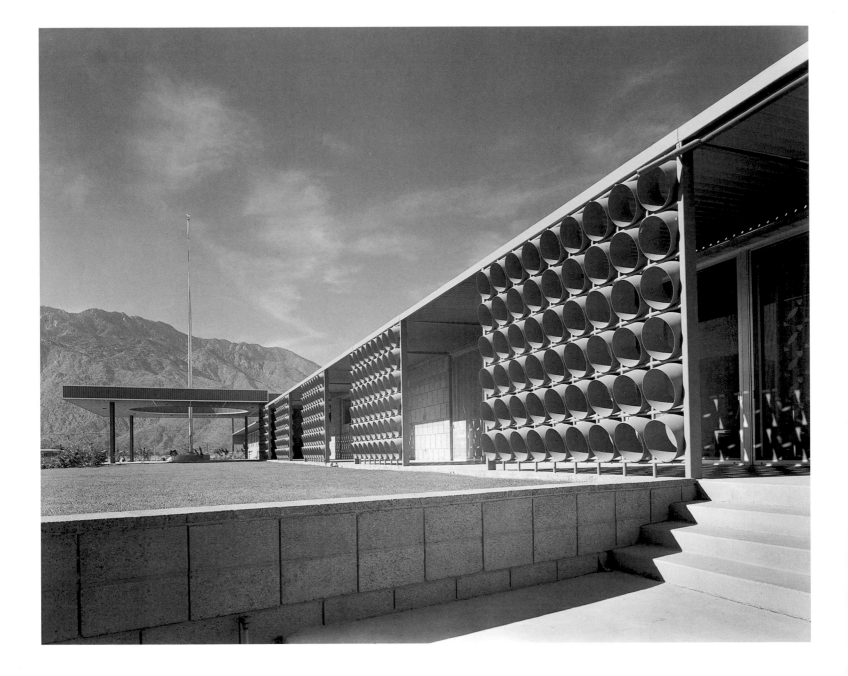

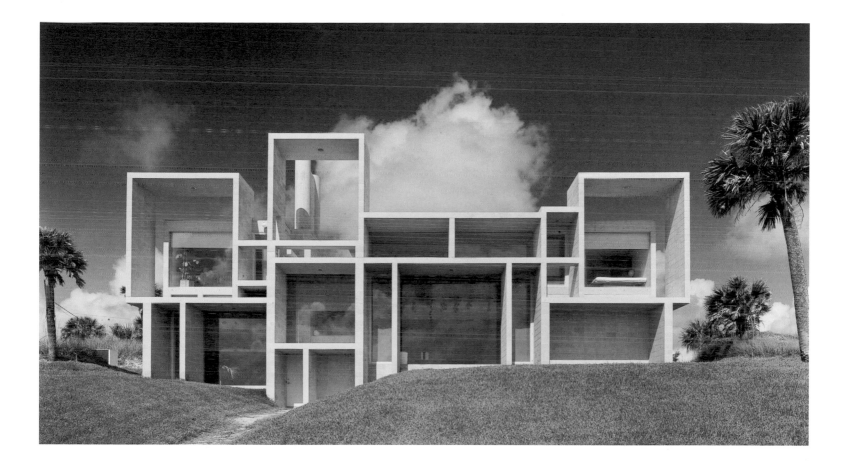

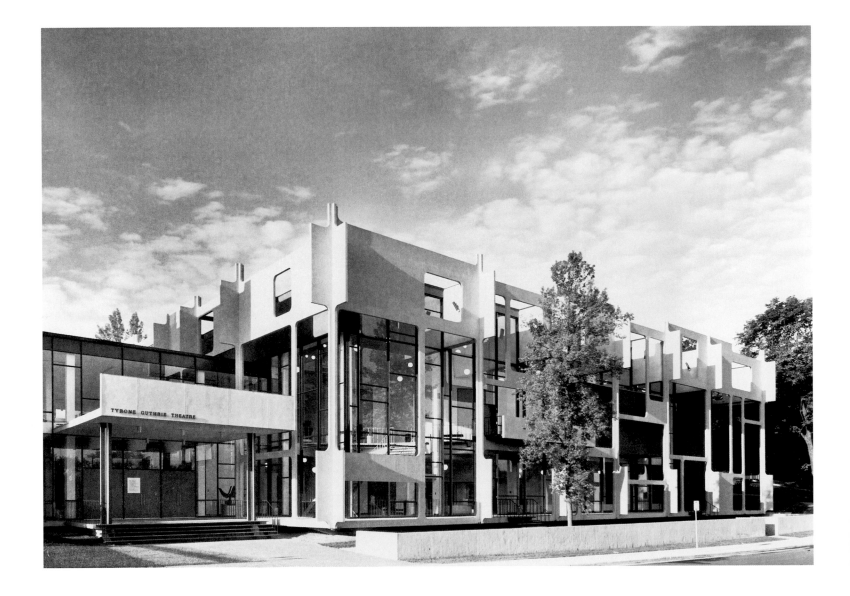

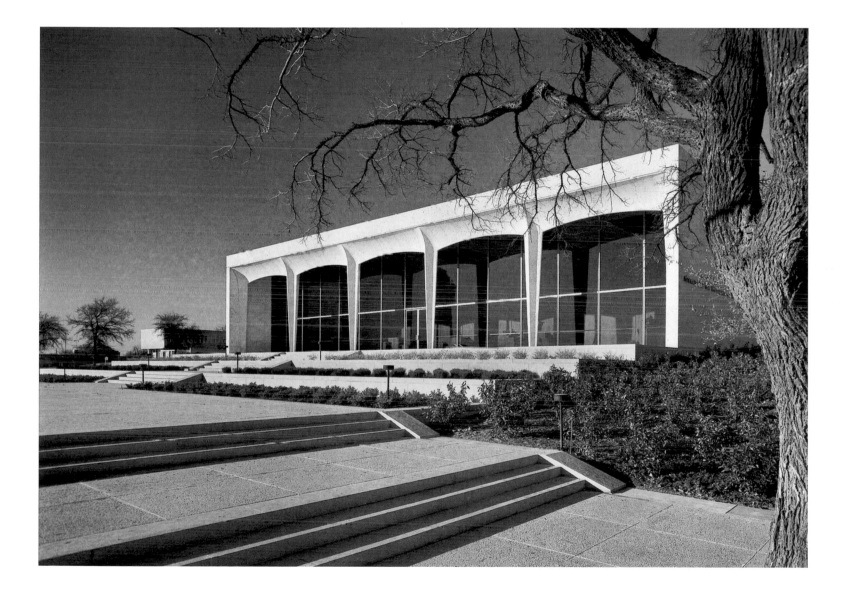

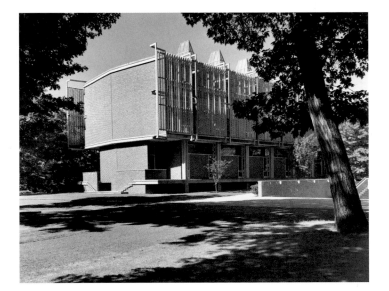

plate 61
Albert C. Martin
Department of Water and Power
Headquarters, Los Angeles, 1965

plate 62
Paul Rudolph
Jewett Arts Center, Wellesley College,
Wellesley, Massachusetts, 1958

plate 63
Wallace Harrison
Metropolitan Opera House, Lincoln
Center, New York, 1966

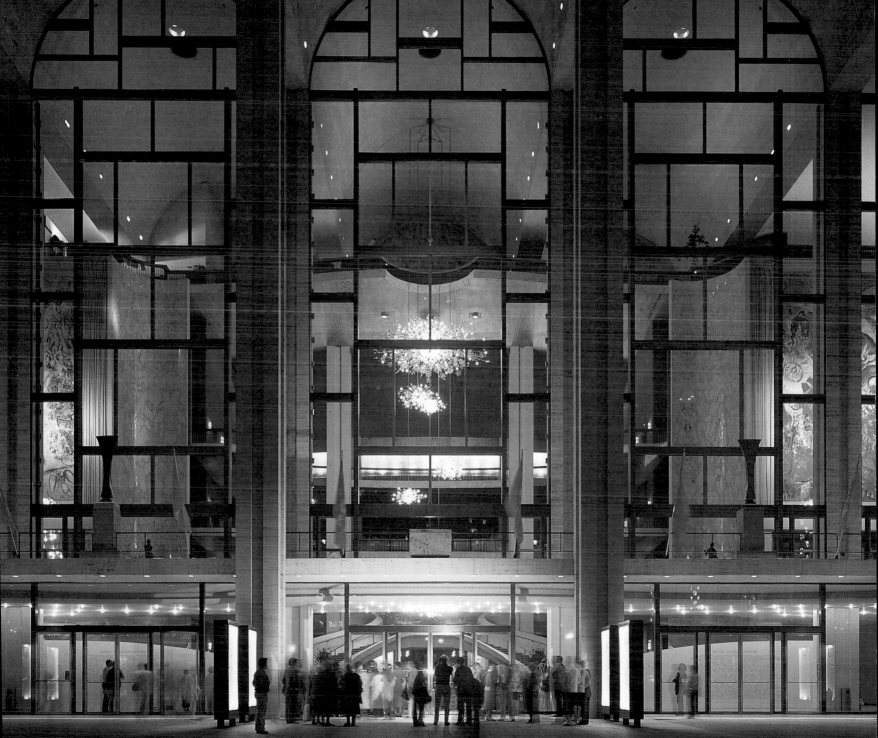

ARCHITECTURE *in focus*

by RUTH KEFFER

By the 1950s the modernist mandate "form follows function" thoroughly monopolized the architecture profession, dictating an aesthetic of streamlined forms void of ornament, historical reference, or gratuitous sensuality. But not all architects chose to work within these confines. A few practitioners, risking the disdain of critics and their peers, designed buildings with calculated elements of glamour: decorative or sculptural flourishes intended to seduce the eye and stimulate the emotions. These architects adopted a design philosophy, seen as transgressive at the time, in which sensory delight played as important a role as pure function.

For many of these architects, a building's facade—its public dressing—was the principal site for adornment and emphasis. Minoru Yamasaki chose to wrap the 1958 Reynolds Metals Building (pl. 55), near Detroit, with a decorative scrim of gold-anodized aluminum. This perforated metal screen adorns the structure—an otherwise modernist box—like an industrial textile, referencing the company's products and the building's function through a purely aesthetic gesture. Paul Rudolph, in his design for the 1962 Milam Residence (pl. 58) in Ponte Vedra Beach, Florida, treated the facade as a kind of sculptural exercise. Rudolph, a proponent of the architect's responsibility to design for "visual delight," created an asymmetrical, Mondrian-like grid of extruded boxes for the front of the house. Despite their resemblance to a brise soleil, the massed boxes do not function as sun barriers; instead they serve as visual references to the eccentric interior layout of the home.

The adoption of historical styles was another way for architects to engage the senses and emotions of their audiences. With its marble facade gently curving along the contours of Columbus Circle in Manhattan, the Huntington Hartford Gallery (pl. 51), designed by Edward Durell Stone in 1964, was meant to evoke a Venetian palazzo. From the double-height loggia at the top, a vertical string of round windows punctures the corners of the building, descending to an arcaded entrance where the porthole motif is echoed in the columns. The building, with its eccentric blend of historical forms, represents a defiant rejection of corporate America's favored International Style.

Some architects created spaces in which functionality was merely a backdrop for spectacle and drama. Gordon Bunshaft, in designing Yale University's Beinecke Rare Book Library (figs. 27–28, pl. 52) in 1963, turned the idea of a simple repository into a treasure house. The structure, clad in a grid of marble and granite and perched on four full-story, tapered pilotis, has a monumental presence. Inside, books are housed within a central glass-walled column. The translucent marble and glass transform the space into a theater of light in which the books are the centerpieces. Morris Lapidus's sumptuous interiors, such as that of the 1955 Eden Roc Hotel (pl. 56) in Miami Beach, were unapologetically aimed at stimulating and gratifying the senses. With its winding staircase to nowhere, faux columns, and abundance of flowing, curving, sweeping forms, the Eden Roc's lobby was purposely designed to resemble a stage set, a place where visitors could see and be seen.

Lapidus and his peers were vilified for their rejection of modernist austerity. The modernist argument against their forays into aesthetic indulgence was simple: Any decorative feature that is not structurally necessary is architecturally dishonest. Architects working today, however, are spared this quandary. They have been rescued by the advent of digital technologies, both in design software and in manufacturing processes, that allow for the integration of pattern, texture, ornament, and

sculptural form—even the most extravagant or eccentric gestures—into the very structure of a building. As they merge with functional elements, decorative details no longer require justification; in fact, they are celebrated as evidence of the sheer power of these digital tools. It is within this often ostentatious showcasing of technological prowess that glamour has reemerged.

In many new designs, spectacular decorative facades perform an essential structural role. In Joel Sanders's 2003 proposal for the expansion of the Fashion Institute of Technology (pl. 74) in New York, the exterior is an undulating expanse of glass panels, what the architect calls a "breathable membrane" that mediates light and air. The panels are tattooed with a repeating graphic element that gives the facade the look of patterned fabric. Woven horizontally through this surface are long, narrow LED panels that turn the exterior into a constantly changing display space. The facade of the Pallas House (pl. 64) in Kuala Lumpur, designed by dECOi in collaboration with Objectile in 1996, updates local customs for screening out the harsh tropical climate. The volume of the house is encased in a single curving plane of metallic panels that form the walls and roof. Like a traditional hanging fabric, this scrim filters the sun and elements, but does so through a complex pattern of perforations configured using custom-designed software.

As digital technology has made possible an almost unlimited vocabulary of architectural form, the notion of historical reference or allusion has greatly expanded. Hernán Díaz Alonso's 2002 Landmark Tower/ U2 Studio project (pl. 75) for Dublin is an extreme exercise in architecture as metaphor. The building houses a variety of residential and commercial spaces inside a monumental, animal-like form: a multistory, glass-encased shape that the architect describes as a dragon. The design reinforces the organic intermixing of programs within the structure; even more importantly, it engages its occupants' emotions and imaginations, forging its own narrative context to connect inhabitant, structure, and site.

A number of contemporary architects are transforming the notion of architectural space as a theatrical or narrative setting, allowing the structured activity within to dictate the aesthetics of form. In Herzog & de Meuron's design for the Prada Aoyama Tokyo boutique (pl. 65), completed in 2003, surface, structure, and function become one. The external "skin" of the building is a grid of glass panels set on a scaffolding of steel. The rhombus-shaped panels, alternately flat, concave, and convex, give the facade a visually tantalizing sculptural quality, while the glass itself lends a feeling of transparency and lightness. The result is a kind of glass gift box—a crisply adorned edifice to house the ritual of shopping.

The question of aesthetics is central to the work of Greg Lynn, whose studio, FORM, began designing the Ark of the World Museum project (fig. 34, pl. 73) in 2002. The structure's podlike contours, inspired by Costa Rica's indigenous plant and animal life, create an eccentric, almost mutant volume. The asymmetrical forms, colored muddy red and moldy green, reflect Lynn's rejection of what he calls "lifestyle-magazine" aesthetics. The structurally and visually complex forms must be built with extreme precision; indeed, the design represents the apex of technological expertise in contemporary architecture.

In some ways Greg Lynn, with his deliberately unaesthetic forms, is the antithesis of Morris Lapidus, working a half-century earlier in pursuit of opulence and glamour. Both generations of architects, however, have rejected the constraints of professional norms in favor of the possibilities of extraordinary design.

155

plate 64
dECOi in collaboration with Objectile
Pallas House Project, Kuala Lumpur, Malaysia, 1996

plate 65
Herzog & de Meuron
Prada Aoyama Tokyo, 2003

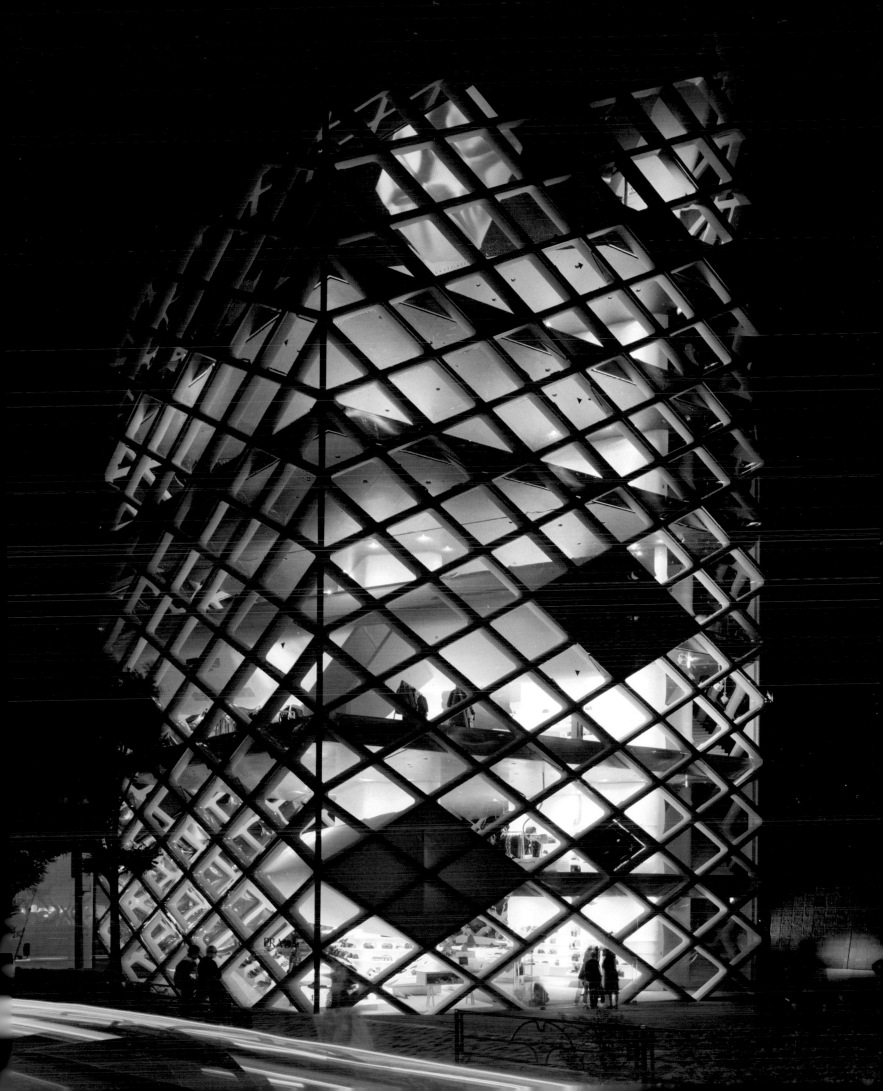

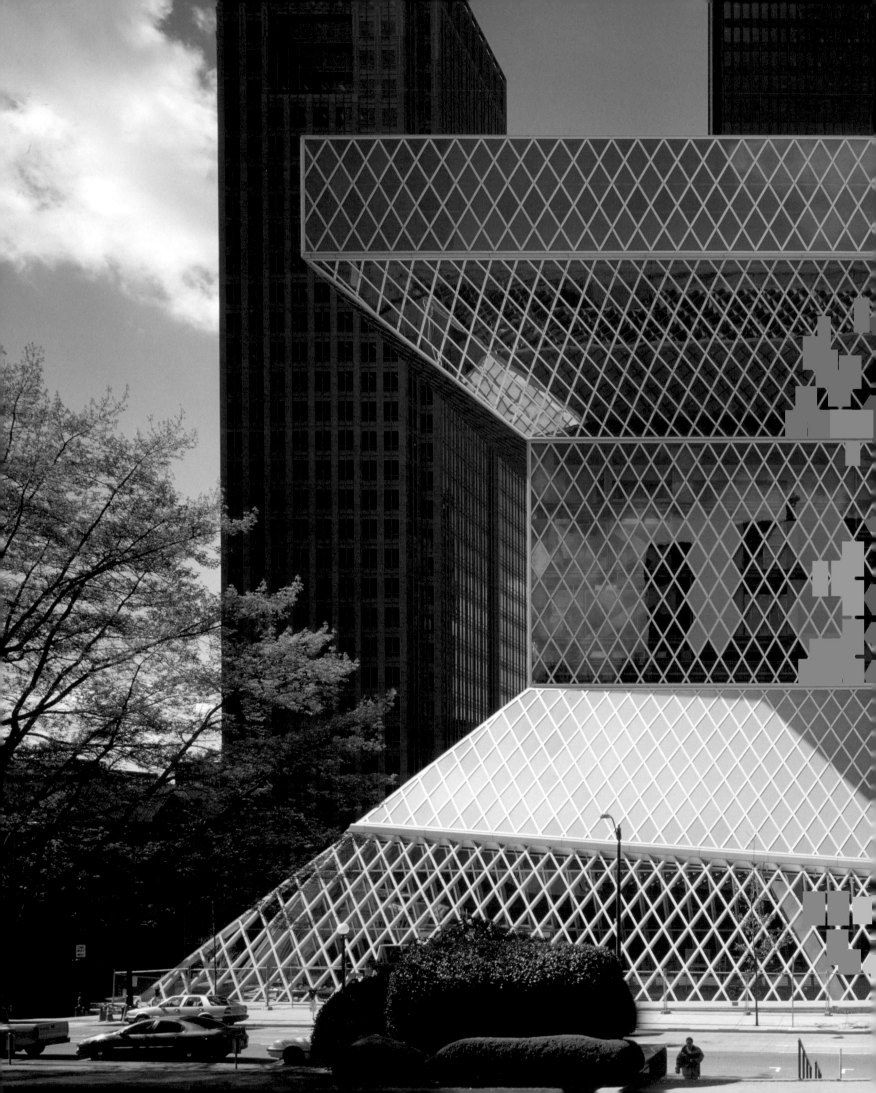

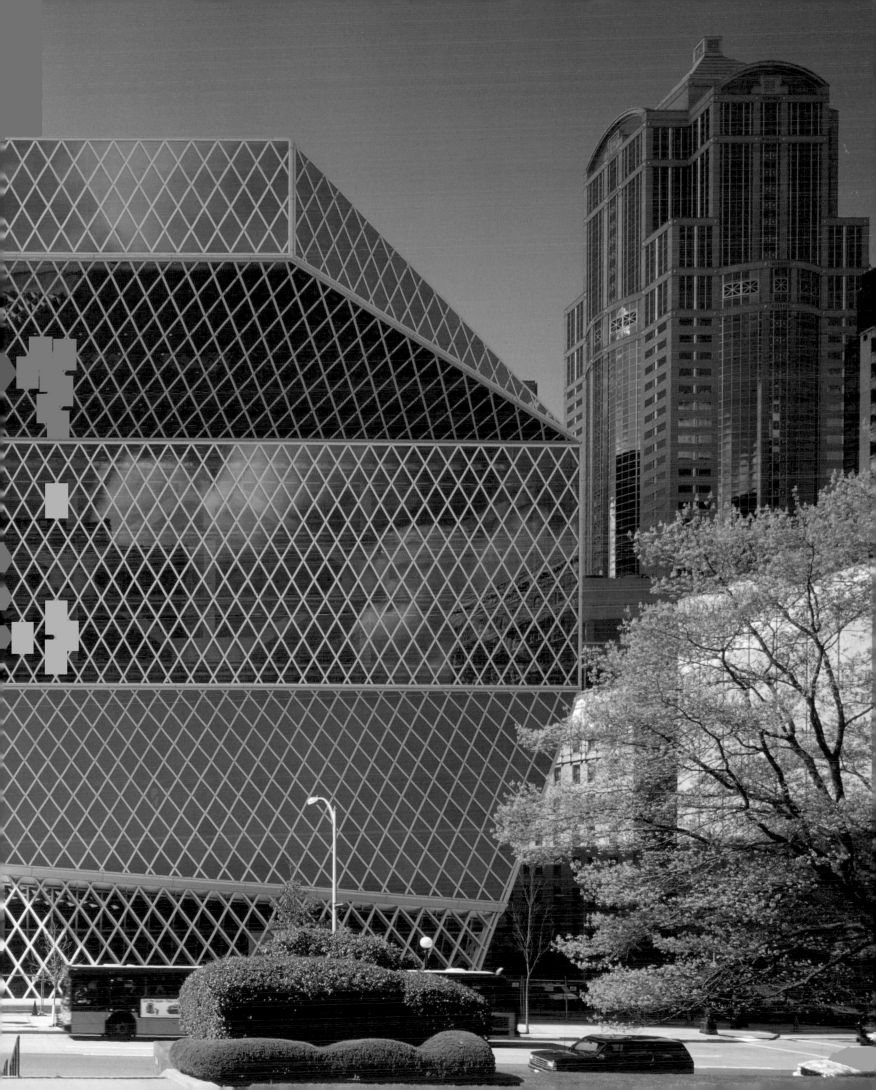

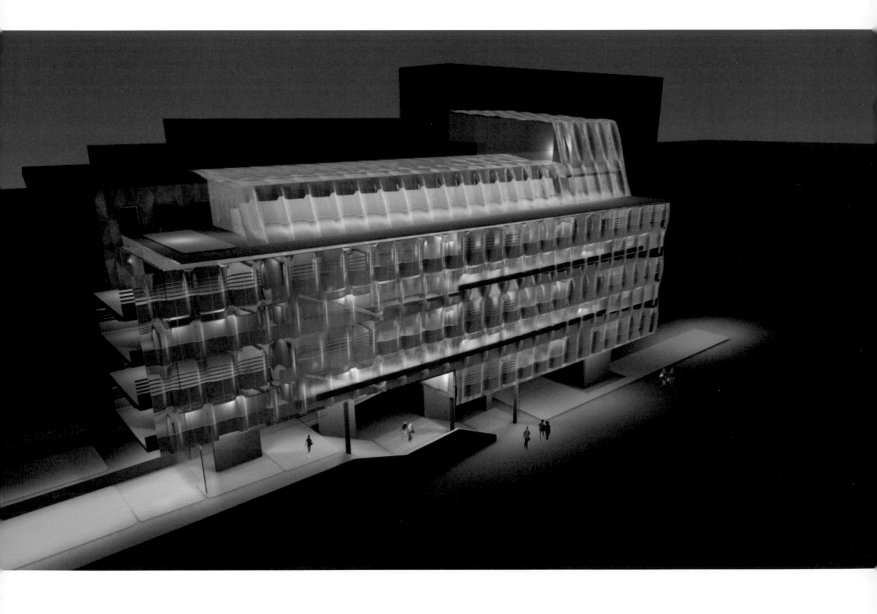

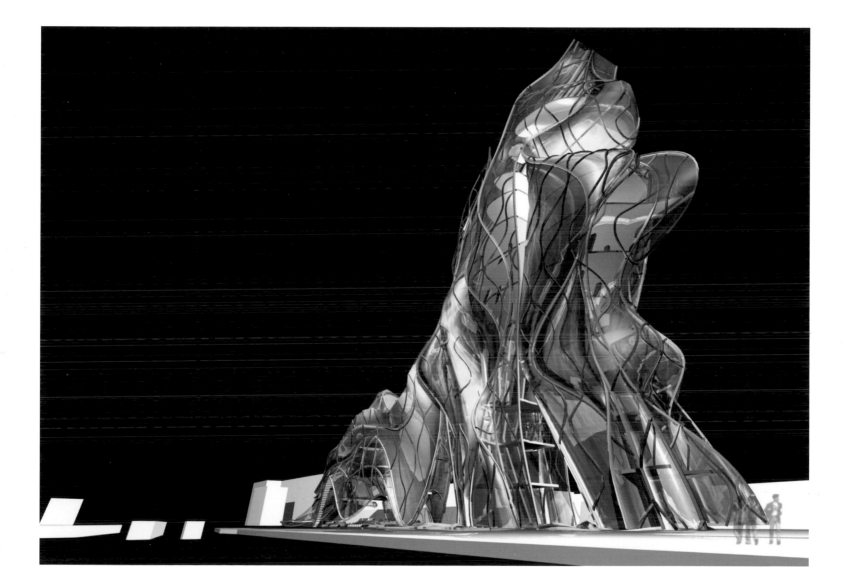

CATALOGUE OF THE EXHIBITION

fashion

Adrian
American, 1903–1959

Gown, 1952 (pl. 1)
Sequined tulle
Collection of Lily et Cie

Cristóbal Balenciaga
Spanish, 1895–1972

Gown, ca. 1956 (pl. 4)
Silk
Collection of Lily et Cie

Christian Dior
French, 1905–1957

Dress, 1955 (pl. 2)
Tulle
Collection of Lily et Cie

Giorgio di Sant'Angelo
Italian, 1936–1989

Gown, ca. 1986 (pl. 14)
Elasticized tulle and plastic and
 metal sequins
Collection of Lily et Cie

Dolce & Gabbana
Domenico Dolce: Italian, born 1958;
Stefano Gabbana: Italian, born 1962

Gown, 1996 (pl. 13)
Silk chiffon
Collection of Dolce & Gabbana

Jacques Fath
French, 1912–1954

Dress, 1951
Silk taffeta and velvet
Collection of Lily et Cie

James Galanos
American, born 1924

Gown, ca. 1975 (pl. 12)
Silk jersey
Collection of Lily et Cie

John Galliano for Christian Dior
British, born 1960

Gown, 1999 (pl. 16)
Silk tulle and polyester
Collection of Mrs. John N. Rosekrans Jr.

Jean Paul Gaultier
French, born 1952

Gown, ca. 1995 (pl. 26)
Nylon, polyurethane, and spandex
Collection of Lily et Cie

Madame Grès
French, 1903–1993

Gown, ca. 1960 (pl. 3)
Silk jersey
Collection of Lily et Cie

Christian Lacroix
French, born 1951

Gown, 1996–97 (pls. 21–22)
Silk peau de soie
Collection of Lily et Cie

Karl Lagerfeld for Chanel
German, born 1938

Gown, ca. 1982 (pl. 15)
Silk organza, tulle, and lace
Collection of Lily et Cie

Karl Lagerfeld for Fendi

Gown with Hooded Jacket, ca. 1985 (pl. 18)
Leather and fox fur
Collection of Lily et Cie

Alexander McQueen
British, born 1969

Feather-Print Corseted Dress, 2003
(pl. 20)
Silk chiffon, silk, and rayon
Collection of Jennifer Raiser

Thierry Mugler
French, born 1948

Suit, ca. 1985 (pl. 19)
Polyurethane and polyester
Collection of Lily et Cie

Zac Posen
American, born 1980

Raffia Gown, 2004 (pl. 25)
Raffia and cotton
Collection of Zac Posen

Prada
Founded 1913, Milan

Bustier and Skirt, 1999 (pl. 24)
Bustier: Shetland wool; skirt:
 Shetland wool with appliqué
Collection of Prada

Emilio Pucci
Italian, 1914–1992

Two-Piece Gown, ca. 1965 (pls. 9–10)
Beaded silk
Collection of Lily et Cie

Paco Rabanne
French, born Spain, 1934

Gown, ca. 1965 (pls. 5–6)
Plastic sequins and metal mesh
Collection of Lily et Cie

Gown with Tunic, ca. 1975 (pl. 8)
Gown: velvet; tunic: aluminum
 and plastic
Collection of Lily et Cie

Yves Saint Laurent for Christian Dior
French, born 1936

Dress, 1957 (pl. 7)
Silk peau de soie
Collection of Lily et Cie

Jacket, 1960 (pl. 11)
Alligator skin and mink fur
Collection of Lily et Cie

Jonathan Saunders
Scottish, born 1977

Totem-Print Tube Dress, 2004 (pl. 27)
Rayon and Lycra
Collection of Jonathan Saunders

Donatella Versace
Italian, born 1959

Gown, 1999–2000 (pl. 28)
Silk gazar
Collection of Gianni Versace S.p.A.

Gianni Versace
Italian, born 1946

Gown, 1991–92 (pl. 17)
Silk crepe
Collection of Gianni Versace S.p.A.

Vivienne Westwood
British, born 1941

Dress, 1994 (pl. 23)
Boulle tulle and shredded tulle
Collection of Lily et Cie

173

industrial design

Ron Arad
British, born Israel, 1951

Nina Rota Bed, 2002 (pl. 36)
Metal, wood, fabric, and
 polyurethane foam
Courtesy Cappellini S.p.A.

Bentley Motors
Founded 1919, London

Bentley Continental GT Coupe, 2004
 (pl. 49)
Exterior: pillarless steel body with
 digitally milled front grille; engine:
 6 liters, 12 cylinders, 550 horsepower;
 interior: leather, walnut, chrome-
 plated steel, and stainless steel
Courtesy Bentley Motors Inc.
 (design director: Dirk van Braeckel;
 exterior styling: Raul Pires; interior
 styling: Robin Page)

Petra Blaisse
Dutch, born 1955

Knitte #1 Black Wallpaper, 2003 (pl. 44)
Printed vinyl
Courtesy Wolf-Gordon Inc.

Tord Boontje
Dutch, born 1968

Midsummer Lamp, 2003 (pl. 37)
Tyvek paper
Private collection

Ronan and Erwan Bouroullec
French, born 1971;
French, born 1976

Cloud Shelving Unit, 2003 (pl. 38)
Polystyrene
Courtesy Cappellini S.p.A.

John Dickinson
American, 1920–1982

Bone Game Table, 1977 (pl. 30)
Painted wood
San Francisco Museum of Modern Art,
 gift of Macy's California

Konstantin Grcic
German, born 1965

Osorom Bench, 2003 (pl. 39)
Fiberglass and resin
Courtesy Moroso S.p.A.

Brent Haas
American, born 1965

ACE Bandage Watch, 2003 (fig. 20)
Timepiece and screen-printed
 elasticized cotton
Courtesy haasprojekt

William Haines
American, 1900–1973

Brentwood Chair, 1955 (pl. 33)
Walnut and printed cotton
Collection of Lindley Associates Inc.,
 Los Angeles

Elbow Chair, 1949 (pl. 32)
Walnut and sheared mouton
Collection of Lindley Associates Inc.,
 Los Angeles

Floor Lamp, 1945 (pl. 34)
Walnut, iron, and linen
Collection of Lindley Associates Inc.,
 Los Angeles

Ross Lovegrove
Welsh, born 1958

Agaricon Touch Lamp, 2001 (pl. 42)
Injection-molded polycarbonate,
 aluminum, and electronic sensors
Private collection

174

Brasilia Lounge Chair, 2003 (pl. 47)
Polyurethane
Courtesy the artist

Jürgen Mayer H.
German, born 1965

Pretext/Vorwand SFMOMA, 2004 (pl. 48)
Installation
Courtesy the artist

Mark Naden
Australian, born 1962

Topos Chair, 2003 (pl. 43)
Finnish birch and maple
Courtesy Malofancon

Marc Newson
Australian, born 1963

Felt Chair, 1993 (pl. 41)
Fiberglass and aluminum
Courtesy Cappellini S.p.A.

Hans Harald Rath
Austrian, 1904–1968

Metropolitan Chandelier, 1966 (pl. 29)
Wood, brass with nickel finish, and
 crystal glass
Courtesy J. & L. Lobmeyr, Vienna

John Reinhold with Marc Jacobs
American, born 1944;
American, born 1963

Men's Rattle Ring, 2003 (pl. 40)
Diamonds and eighteen-karat
 white gold
Courtesy John Reinhold

Rattle Bracelet, 2003 (pl. 40)
Diamonds and eighteen-karat
 yellow gold
Courtesy John Reinhold

Women's Rattle Ring, 2003 (pl. 40)
Diamonds and eighteen-karat
 yellow gold
Courtesy John Reinhold

Rolex
Founded 1908, London and
La Chaux-de-Fonds, Switzerland

Oyster Perpetual Lady Datejust Watch,
 2002 (pl. 45)
Eighteen-karat yellow gold and
 diamonds
Courtesy Rolex Watch USA Inc.

Malcolm Sayer
British, 1901–1985

Jaguar Series 1 E-Type Fixed-Head Coupe,
 1965 (pl. 31)
Exterior: monocoque steel body with
 glass headlight covers; engine: 4.2
 liters, 6 cylinders, 265 horsepower;
 interior: leather, walnut, aluminum,
 and vinyl
Collection of Gregory D. Chew

Vincent Van Duysen
Belgian, born 1962

Cascade Chandelier, 2003 (pl. 35)
Crystal glass
Courtesy Swarovski Crystal Palace
 Collection

Wally with Lazzarini Pickering Architects
Founded 1993, Monte Carlo, Monaco

118 WallyPower Powerboat, 2003 (pl. 46)
Digital video on flat-screen monitor
Courtesy Wally

175

architecture

Welton Becket
American, 1902–1969

Dorothy Chandler Pavilion, Los Angeles,
 1964 (pl. 53)
Photograph by Julius Shulman
*San Francisco Museum of Modern Art,
 Accessions Committee Fund purchase*

**Gordon Bunshaft with Skidmore,
 Owings, & Merrill**
American, 1909–1990

Beinecke Rare Book Library, Yale
 University, New Haven, Connecticut,
 1963 (fig. 27, pl. 52)
Photographs by Ezra Stoller
*San Francisco Museum of Modern Art,
 Accessions Committee Fund purchase*

dECOi
Founded 1991, Paris

Aegis Hyposurface, 1999 (pl. 67)
Digital video on flat-screen monitor
Courtesy the architects

dECOi in collaboration with Objectile
Founded 1991, Paris; founded 1996, Paris

Pallas House Project, Kuala Lumpur,
 Malaysia, 1996 (pl. 64)
Digital drawings
Courtesy dECOi

Neil Denari
American, born 1957

Union Square Loft Building Project,
 New York, 2001 (pl. 68)
Digital drawings
Courtesy the architect

Hernán Díaz Alonso
Argentinian, born 1969

Landmark Tower/U2 Studio Project,
 Dublin, 2002 (pl. 75)
Digital drawings and model
Drawings: San Francisco Museum of
 Modern Art, Accessions Committee
 Fund purchase; model: courtesy
 Xefirotarch, Los Angeles

EMERGENT
Founded 1999, Los Angeles

Radiant Hydronic House Project,
 Los Angeles, 2002 (pl. 72)
Digital drawings and model
Courtesy Tom Wiscombe

Albert Frey
Swiss, 1903–1998

City Hall, Palm Springs, California, 1957
 (pl. 57)
Photograph by Julius Shulman
*San Francisco Museum of Modern Art,
 Accessions Committee Fund purchase*

Harrison & Abramovitz
Active 1945–1976, New York

Philharmonic Hall, Lincoln Center,
 New York, 1962 (pl. 50)
Photograph by Ezra Stoller
*San Francisco Museum of Modern Art,
 Accessions Committee Fund purchase*

176

Wallace Harrison
American, 1895–1981

Metropolitan Opera House,
 Lincoln Center, New York, 1966 (pl. 63)
Photograph by Wolfgang Hoyt
San Francisco Museum of Modern Art,
 Accessions Committee Fund purchase

Herzog & de Meuron
Founded 1977, Basel, Switzerland

Prada Aoyama Tokyo, 2003 (pl. 65)
Digital drawing and photographs by
 Todd Eberle
Drawing: courtesy the architects;
 photographs: courtesy Todd Eberle

Jakob + MacFarlane
Founded 1992, Paris

H House Project, Corsica, France, 2002
 (pl. 69)
Digital drawings
Courtesy the architects

Philip Johnson
American, born 1906

Amon Carter Museum of Western Art,
 Fort Worth, 1961 (pl. 60)
Photograph by Ezra Stoller
San Francisco Museum of Modern Art,
 Accessions Committee Fund purchase

New York State Theater, Lincoln Center,
 New York, 1964 (fig. 2)
Photograph by Ezra Stoller
San Francisco Museum of Modern Art,
 Accessions Committee Fund purchase

Rem Koolhaas/Office for
Metropolitan Architecture
Dutch, born 1944

Central Library, Seattle, 2004 (pl. 71)
Photographs by Lara Swimmer
Courtesy Esto Photographics

Morris Lapidus
American, born Russia, 1906–2001

Eden Roc Hotel, Miami Beach, Florida,
 1955 (pl. 56)
Photograph by Ezra Stoller
San Francisco Museum of Modern Art,
 Accessions Committee Fund purchase

Charles Luckman
American, 1909–1999

Parke-Davis Building, Los Angeles, 1960
 (pl. 54)
Photograph by Julius Shulman
San Francisco Museum of Modern Art,
 Accessions Committee Fund purchase

Greg Lynn
American, born 1964

Ark of the World Museum Project,
 Carara National Park, Costa Rica, 2002
 (fig. 34, pl. 73)
Digital drawings and model
Courtesy Greg Lynn FORM

177

Albert C. Martin
American, 1879–1960

Department of Water and Power
 Headquarters, Los Angeles, 1965
 (pl. 61)
Photograph by Julius Shulman
San Francisco Museum of Modern Art,
 Accessions Committee Fund purchase

Wallace Neff
American, 1895–1982

Groucho Marx House, Beverly Hills,
 California, 1956
Photograph by Maynard L. Parker
Collection of the Huntington Library

PATTERNS/Marcelo Spina
Argentinian, born 1970

New Busan Tower Project, Busan,
 South Korea, 2002 (fig. 33, pl. 76)
Digital drawings
Courtesy PATTERNS, Los Angeles

Ralph Rapson
American, born 1914

Tyrone Guthrie Theater, Minneapolis,
 1963 (pl. 59)
Photograph by Warren Reynolds
Collection of Rapson Architects

Paul Rudolph
American, 1918–1997

Jewett Arts Center, Wellesley College,
 Wellesley, Massachusetts, 1958 (pl. 62)
Photograph by Wayne Andrews
San Francisco Museum of Modern Art,
 Accessions Committee Fund purchase

Arthur W. Milam Residence, Ponte Vedra
 Beach, Florida, 1962 (pl. 58)
Photograph by Bill Maris
San Francisco Museum of Modern Art,
 Accessions Committee Fund purchase

Joel Sanders
American, born 1956

Fashion Institute of Technology
 Expansion Project, New York, 2003
 (pl. 74)
Digital drawings and model
Courtesy the architect

**servo in collaboration with Smart
 Studio/Interactive Institute**
Founded 1999, Los Angeles, Zurich,
 New York, and Stockholm; founded
 1999, Stockholm

Lattice Archipelogics, 2002–3 (pl. 70)
Installation
Collection of servo

Edward Durell Stone
American, 1902–1978

Stuart Company Plant and Office
 Building, Pasadena, California, 1956
Photograph by Julius Shulman
San Francisco Museum of Modern Art,
 Accessions Committee Fund purchase

Huntington Hartford Gallery, New York,
 1964 (pl. 51)
Photograph by Ezra Stoller
San Francisco Museum of Modern Art,
 Accessions Committee Fund purchase

Bernard Tschumi
French, born 1944

Athletic Center, University of Cincinnati,
 Ohio, 2001 (projected completion
 2006) (pl. 66)
Digital drawings
Courtesy the architect

Minoru Yamasaki
American, 1912–1986

Reynolds Metals Building, Southfield,
 Michigan, 1958 (pl. 55)
Photograph by Wayne Andrews
San Francisco Museum of Modern Art,
 Accessions Committee Fund purchase

Noble, Charles. *Philip Johnson*. New York: Simon & Schuster, 1972.

Ockman, Joan. "Toward a Theory of Normative Architecture." In *Architecture of the Everyday,* edited by Steven Harris and Deborah Berke. New York: Princeton Architectural Press, 1997.

Ockman, Joan, and Edward Eigen, eds. *Architecture Culture 1943–1968: A Documentary Anthology*. New York: Columbia University Graduate School of Architecture, Planning, and Preservation; New York: Rizzoli, 1993.

Office for Metropolitan Architecture et al. *S, M, L, XL*. New York: Monacelli Press, 1996.

Panofsky, Erwin. *Three Essays on Style*. Edited by Irving Lavin. Cambridge, MA: MIT Press, 1995.

Pavitt, Jane. *Brilliant: Lights and Lighting*. London: V&A Publications, 2004.

Postrel, Virginia. *The Substance of Style: How the Rise of Aesthetic Value Is Remaking Commerce, Culture, and Consciousness*. New York: HarperCollins, 2003.

Rawsthorn, Alice. *Marc Newson*. London: Booth-Clibborn Editions, 1999.

Réthy, Esmeralda de, and Jean-Louis Perreau. *Christian Dior: The Early Years, 1947–1957*. New York: Vendome Press, 2001.

Rohan, Timothy M. "The Dangers of Eclecticism: Paul Rudolph's Jewett Arts Center at Wellesley." In *Anxious Modernisms: Experimentation in Postwar Architectural Culture,* edited by Sarah Williams Goldhagen and Réjean Legault. Montreal: Canadian Centre for Architecture, 2000.

Rosa, Joseph. *Albert Frey: Architect*. New York: Rizzoli, 1990.

———. *A Constructed View: The Architectural Photography of Julius Shulman*. New York: Rizzoli, 1994.

———. *Next Generation Architecture: Folds, Blobs, and Boxes*. New York: Rizzoli, 2004.

Roth, Leland. *A Concise History of American Architecture*. New York: Harper & Row, 1979.

Sanders, Joel. "Curtain Wars: Architects, Decorators, and the Twentieth-Century Domestic Interior." *Harvard Design Magazine*, no. 16 (Winter/Spring 2002): 1–9.

Saunders, William S. *Modern Architecture: Photographs by Ezra Stoller*. New York: Harry N. Abrams, Inc., 1990.

Schor, Juliet B., and Douglas B. Holt, eds. *The Consumer Society*. New York: New Press, 2000.

Scott, Felicity. "Underneath Aesthetics and Utility: The Untransposable Fetish of Bernard Rudofsky." *Assemblage* 38 (April 1999): 58–89.

Seeling, Charlotte. *Fashion: The Century of the Designer 1900–1999*. Cologne, Germany: Könemann Verlagsgesellschaft, 1999.

Simitis, Matthew J., and Zeynep E. Celik, eds. "Fashion." Special issue, *Thresholds* 22 (Summer 2001).

Snodin, Michael, and Maurice Howard. *Ornament: A Social History Since 1450*. New Haven, CT: Yale University Press, 1996.

Somol, R. E., ed. *Autonomy and Ideology: Positioning an Avant-Garde in America*. New York: Monacelli Press, 1997.

Spindler, Amy M. "Hollywood and Divine: Along with a Vintage Piece of Billy Haines Furniture Comes a Little Bit of Stardust." *New York Times Magazine,* September 12, 1999, 83, 92.

Steele, Valerie. *The Corset: A Cultural History*. New Haven, CT: Yale University Press, 2001.

Stone, Edward Durell. *The Evolution of an Architect*. New York: Horizon Press, 1962.

Sudjic, Deyan. *Ron Arad*. London: Laurence King Publishing, 1999.

Tafuri, Manfredo. *Theories and History of Architecture*. New York: Harper & Row, 1980.

Tapert, Annette. *The Power of Glamour*. New York: Crown, 1998.

Tschumi, Bernard. *Event-Cities*. Cambridge, MA: MIT Press, 1994.

———. *Event-Cities 2*. Cambridge, MA: MIT Press, 2000.

———. "Six Concepts." In *Columbia Documents of Architecture and Theory* 2 (1993): 73–97.

Twitchell, James B. *Living It Up: America's Love Affair with Luxury*. New York: Simon & Schuster, 2002.

Underwood, David. *Oscar Niemayer and the Architecture of Brazil*. New York: Rizzoli, 1994.

182

Ursprung, Philip, ed. *Herzog and de Meuron: Natural History*. Montreal: Canadian Centre for Architecture, 2002.

Veblen, Thorstein. *The Theory of the Leisure Class*. New York: Dover, 1994.

Vidler, Anthony. *The Architectural Uncanny: Essays in the Modern Unhomely*. Cambridge, MA: MIT Press, 1992.

Votolato, Gregory. "Industrial Drama: The Custom Car Myth." In *American Design in the Twentieth Century: Personality and Performance*. Manchester, U.K.: Manchester University Press, 1993.

Wallace Neff, 1895–1982: The Romance of Regional Architecture. San Marino, CA: Huntington Library, 1989.

Wigley, Mark. *White Walls, Designer Dresses: The Fashioning of Modern Architecture*. Cambridge, MA: MIT Press, 1995.

Wilcox, Claire. *Vivienne Westwood*. London: V&A Publications, 2004.

Wollen, Peter, and Joe Kerr, eds. *Autopia: Cars and Culture*. London: Reaktion Books, 2002.

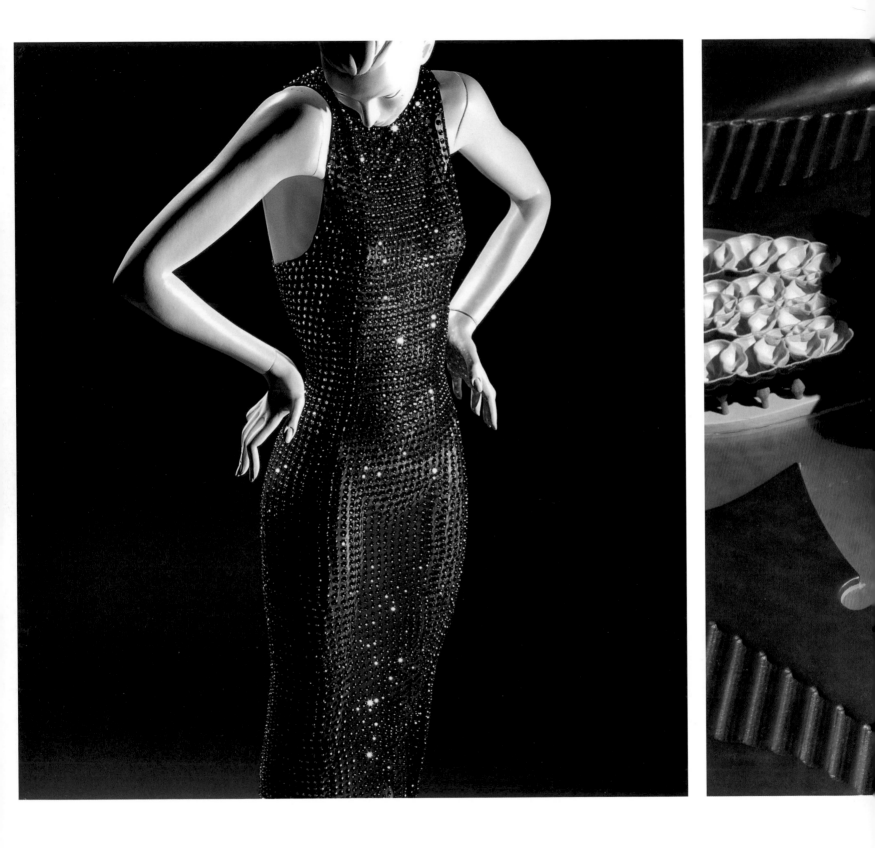

Glamour
DESIGN – 3 – Contemporary
GL-10